Impressionists on the Water

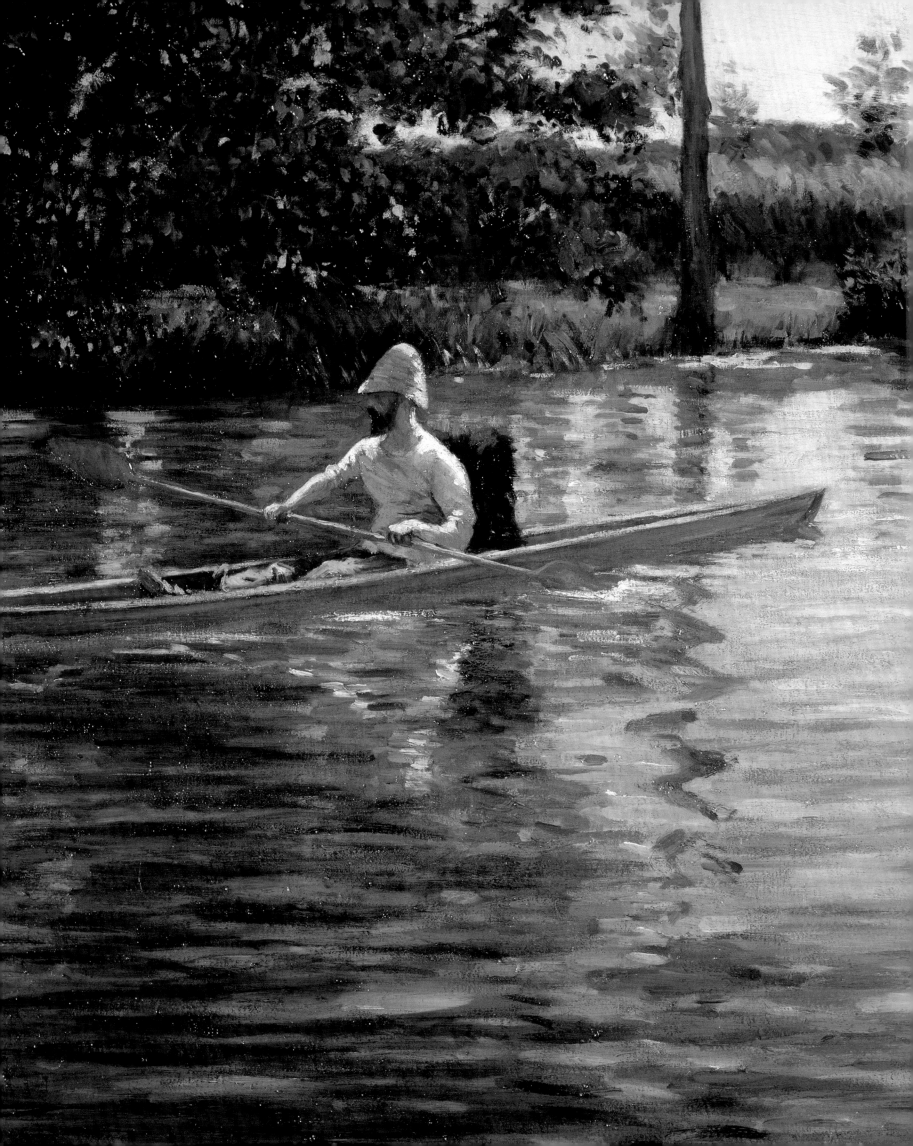

Christopher Lloyd

Daniel Charles

Phillip Dennis Cate

with a contribution by Gilles Chardeau

Impressionists

ON THE WATER

Fine Arts Museums of San Francisco

SKIRA RIZZOLI
NEW YORK

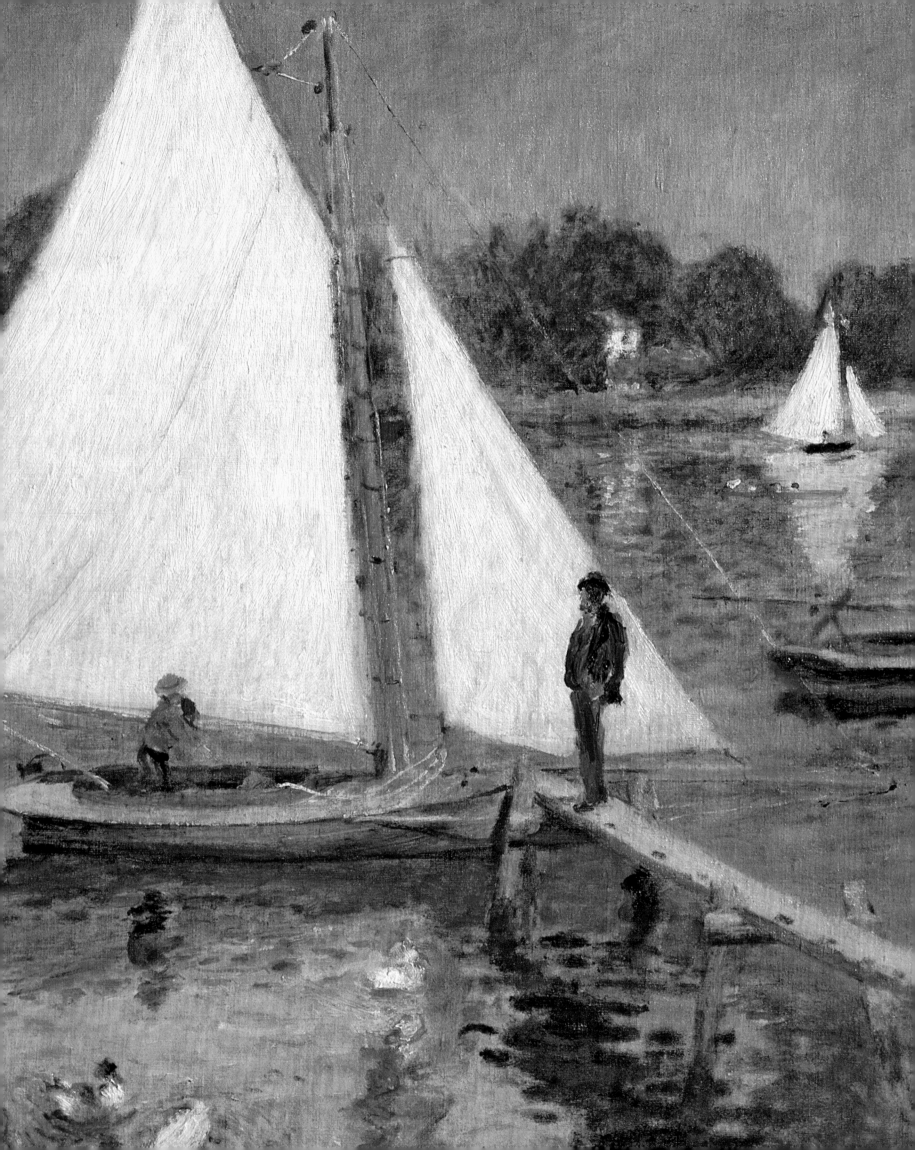

CONTENTS

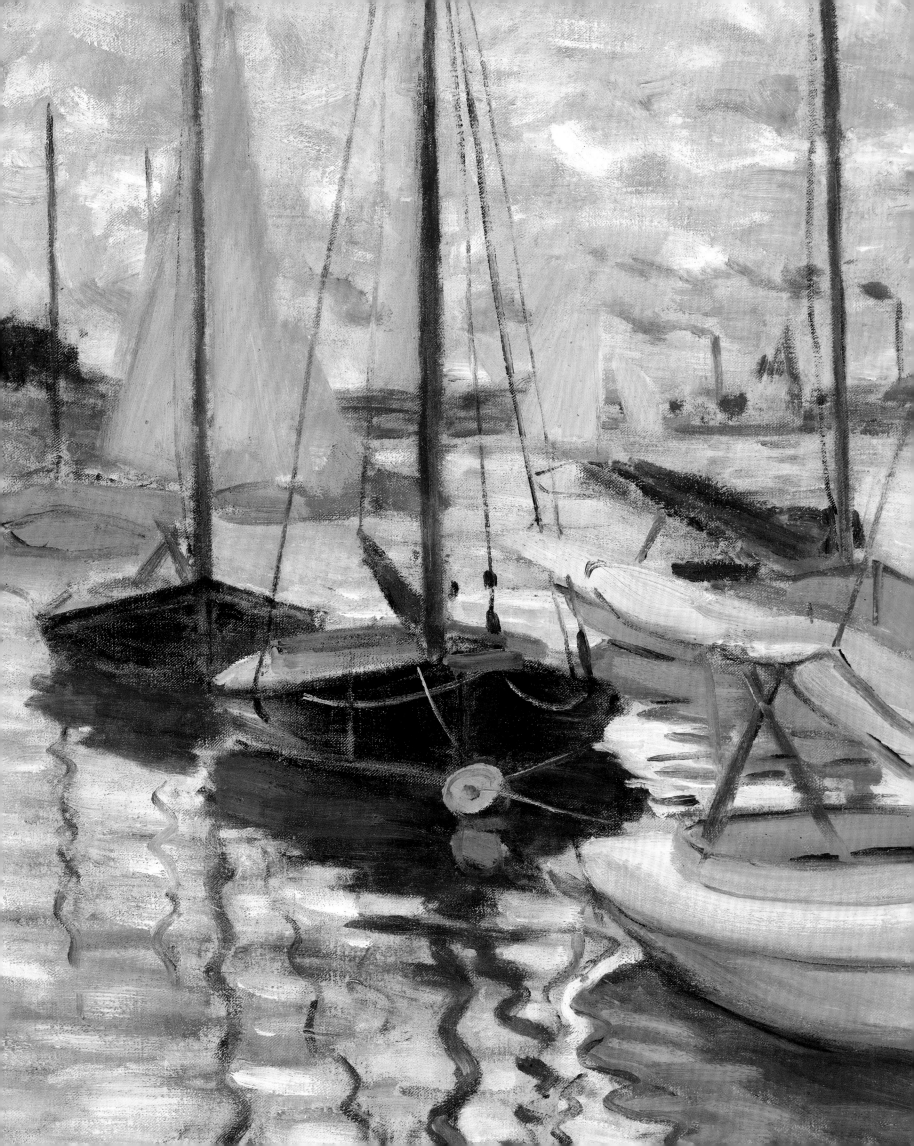

FOREWORD

Painting outside and employing broad gestural techniques, the Impressionists captured the vibrancy and movement inherent in the natural world. Their focus on shifting visual effects found its perfect outlet in works displaying the boating activities enjoyed on French waterways. Rippling water, dancing reflections, and sailboats pushed along by strong winds animate the art of Manet, Monet, Renoir, Pissarro, Sisley, Seurat, Signac, Van Rysselberghe, and so many others. Our audience knows these artists well, but here we introduce aspects of their work not often explored—their dazzling depictions of boating and their deep understanding of, and engagement with, this enterprise on the water. This charming book and its companion exhibition celebrate the Impressionists' fascination with the fashionable sport of pleasure sailing.

This project was originally conceived by Phillip Dennis Cate (former Director of the Jane Voorhees Zimmerli Art Museum at Rutgers University) and renowned marine historian Daniel Charles, and further expanded upon by Christopher Lloyd (former Surveyor of Queen Elizabeth II's collection). The visions of our guest curators illuminate the personal interactions of leading French artists with sailing, a leisure activity and competitive sport that emerged in the 1850s. Illustrated by a sequence of sparkling paintings, this publication adds scholarly dimension to our understanding of the development of pleasure boating as a reflection of the fast-paced lifestyle and rapidly changing culture of nineteenth-century France.

The artists-yachtsmen discussed here understood this world of evolving technical innovation and incorporated their firsthand knowledge of the mechanics of sailing into their art. They made careful notations, even if in the most summary shorthand, of the design elements that distinguished each type of sailing craft. Intriguingly, Caillebotte, a painter of startling modernity, even designed a new class of boat that he sailed in the late 1880s, dominating the racing circuit with numerous wins. Planned to coincide with the America's Cup races on San Francisco Bay in the summer of 2013, this book will remain an important contribution to the social and artistic history of late-nineteenth-century France. It is my pleasure to introduce you to this intriguing subject, artfully presented in this publication and beautiful exhibition.

Diane B. Wilsey
President, Board of Trustees
Fine Arts Museums of San Francisco

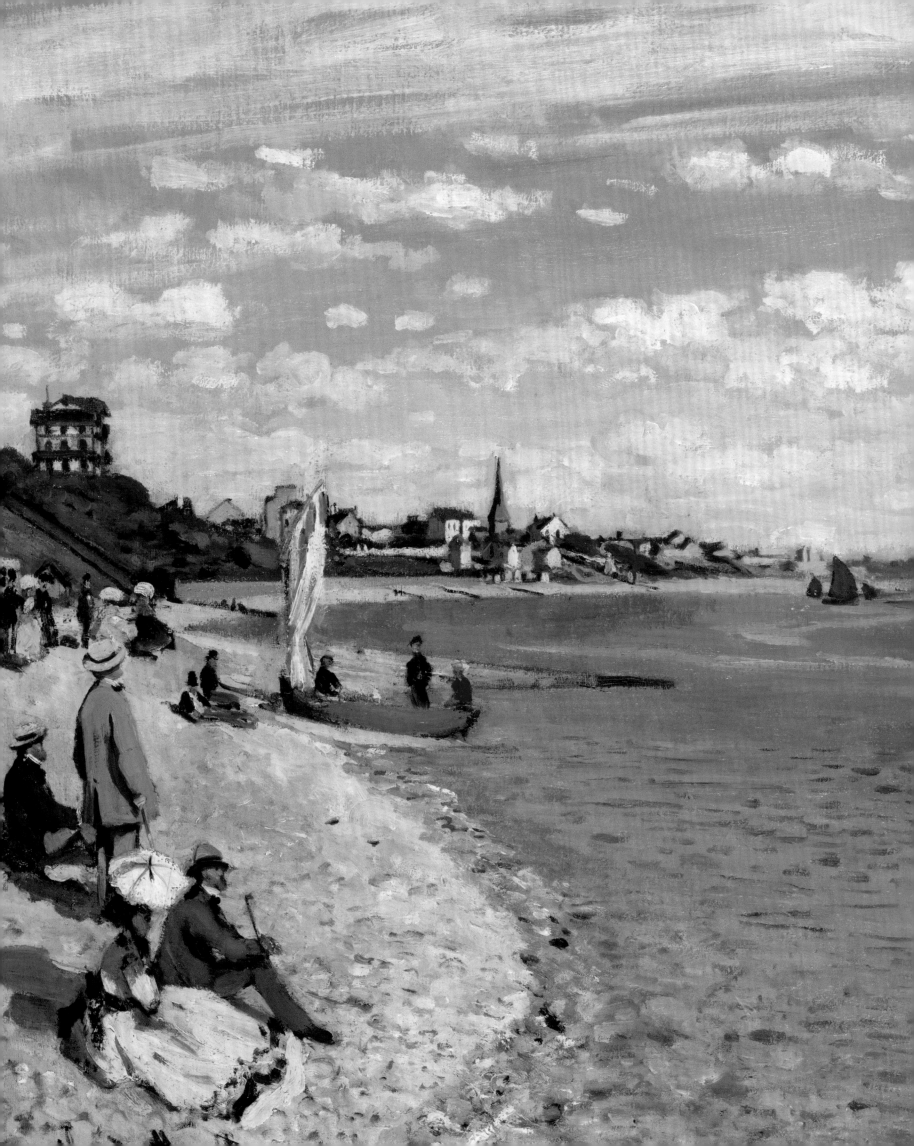

Coastal Adventures, Riparian Pleasures

THE IMPRESSIONISTS AND BOATING

Christopher Lloyd

The Impressionists changed the course of art—the way it was made and the way it was seen. Having challenged the orthodoxies and shibboleths of official art upheld by the Académie des Beaux-Arts in Paris (founded in 1648), Impressionism stood at the threshold of modern art. The radicalism of the Impressionists lay as much in what they chose to depict as in their style, which involved a more direct and personal means of expression than that found in academic painting.[1] They declared their independence by mounting eight exhibitions between 1874 and 1886, held in protest to the stranglehold of the official, long-established Salon exhibitions administered by the French state.[2] Distinct from the large public spectacle of the Salon, these alternative exhibitions—organized by the artists themselves, without recourse to a jury—were located in privately owned premises, whose limited space restricted the number of items on display, and were of short duration.[3] Although at first the Impressionists had a few loyal supporters among dealers, collectors, and critics, the widespread popularity that their art enjoys today was slow in coming. In reality, the appreciation of the work of Claude Monet, Pierre-Auguste Renoir, Paul Cézanne, Edgar Degas, Camille Pissarro, Alfred Sisley, Mary Cassatt, Gustave Caillebotte, Paul Gauguin, Georges Seurat, and Paul Signac is a comparatively modern phenomenon.

The eight Impressionist exhibitions caused dismay among the more cautious critics and outrage among the more conventional public. Indeed, the word *Impressionism* that is so freely and approvingly used today began as a term of disapprobation and opprobrium (see ill. 1).[4] Scorn was poured on

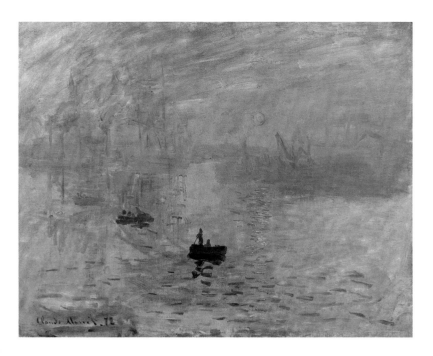

1. Claude Monet

Impression. Sunrise (Impression, soleil levant), 1872
Oil on canvas
18⅞ × 24¾ in. (48 × 63 cm)
Musée Marmottan, Paris. Inv. 4014
(DW263)

artists who chose not to paint subjects inspired by religion, history, or mythology, preferring contemporary scenes that were characterized by what seemed to be a visual incoherence derived from the use of unusual viewpoints, uneven brushstrokes, and strong colors. Such pictures looked like improvisations, appearing to be fragmentary or unfinished.[5] Although by the end of the nineteenth century some collectors in Europe had started to take works by the Impressionists seriously, it was only at the beginning of the twentieth century, when American collectors had an impact on the market, that the universal popularity of what began as an avant-garde movement became apparent.[6]

The artists who participated in the eight Impressionist exhibitions were a loosely affiliated group. It was easy for them to identify what they rejected in art, but it was altogether a different proposition for them to decide on what they hoped to achieve. What affinities they did have stemmed from the modernity of their subject matter, which was based on individual perceptions inspired by nature and expressed in a direct style, unencumbered by the rules and precepts preached by the Académie des Beaux-Arts. There was never any deep-seated attempt to establish uniformity, and the chief characteristic of the eight Impressionist exhibitions was, in fact, their diversity. It is significant, for example, that the unofficial "leader" of the Impressionists—Édouard Manet—never showed in any of the group's exhibitions held during his lifetime. Tensions arose quite quickly between artists, such as Degas and Cassatt, who were predominantly figure painters, and those, such as Monet and Pissarro, who specialized in landscape. Personal differences exacerbated the situation, as did preferences in the use of media and the choice of format. A further dilemma as to how Impressionism might be developed emerged when younger artists were invited to participate. Seurat introduced a scientific approach in the eighth exhibition, held in 1886, with his huge canvas *A Sunday Afternoon on the Island of Grande Jatte* of 1884–1886 (ill. 2), painted with a pointillist technique; concurrently, Gauguin began to pursue a highly imaginative interpretation of subject matter in unified compositions painted in a deliberately simplified style. Both artists built upon the potential that was inherent within Impressionism, indicating ways forward that led to Post-Impressionism.

The choice of subject matter drawn from contemporary life, an emphasis on spontaneity, and innovation of artistic technique defined the Impressionists' output. Nonetheless, although they advocated change they were not inherently disrespectful of the past.[7] For them, the two great luminaries among French artists of the first half of the nineteenth century were Jean-Auguste-Dominique Ingres and Eugène Delacroix, who were the principal representatives of the stylistic polarities in painting at that time—Neoclassicism and Romanticism, respectively. Indeed, Degas saw

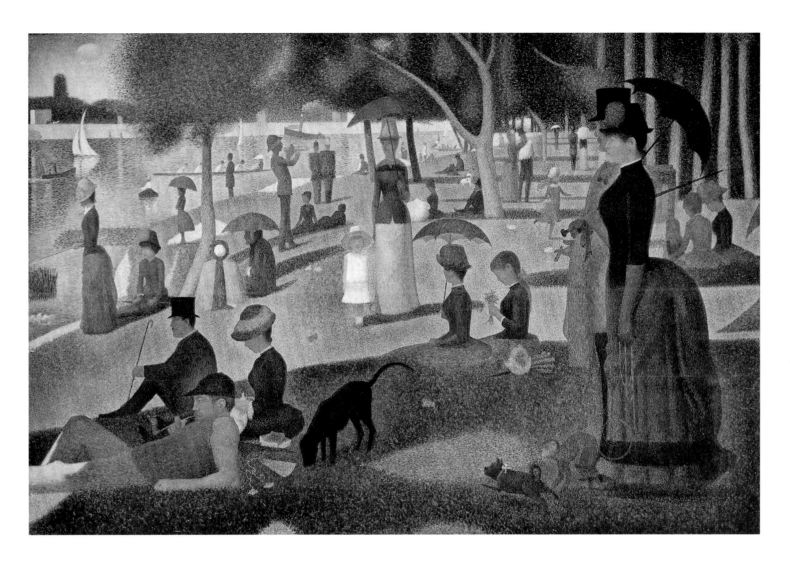

2. Georges Seurat
A Sunday Afternoon on the Island of Grande Jatte (Un dimanche après-midi d'été à l'Île de La Grande Jatte), 1884–1886
Oil on canvas
81¾ × 121¼ in. (207.6 × 308 cm)
Art Institute of Chicago. Helen Birch Bartlett Memorial Collection, 1926.224
(D&R162)

himself as in direct line of succession from Ingres, and Cézanne wanted to be the heir of Delacroix. Additionally, throughout his career Manet looked further back in time, measuring himself against such old masters as Peter Paul Rubens, Diego Velázquez, and Francisco de Goya; Renoir became increasingly obsessed by the eighteenth century; Degas and Cézanne each made several hundred copies after earlier art of all kinds; and Pissarro extolled the virtues of ancient Egyptian, Chinese, Persian, and Japanese art. No form of art can ever be created completely *ex novo*, and in many ways the Impressionists mediated the present through the examples of the past. To the more conservative of their contemporaries, this process was so radical that it seemed as though the art of the past was being used as a weapon against itself. But as Cézanne wrote in 1905, "To my mind one does not put oneself in place of the past, one only adds a new link."[8]

One of the most debated traditions in French painting that the Impressionists needed to come to terms with was the art of landscape, which in itself had not always had a high ranking in the hierarchy of subjects favored by the Académie des Beaux-Arts. The influence of the balanced, harmonious compositions that Nicolas Poussin and Claude Lorrain used in the seventeenth century for the imaginary settings of their religious, historical, and mythological scenes persisted into the nineteenth century. Then,

3. Alexis Joly

Ruins of the Château Gaillard (Ruines du Château Gaillard), pl. 183 (I.F.F. XI, p. 466) from *Voyages pittoresques: Normandie 11* (Paris, 1825), 1824
Lithograph
12¾ × 9⅞ in. (32.4 × 25.2 cm)
Boston Public Library

Neoclassical theorists, such as Pierre-Henri de Valenciennes, advocated a more direct approach to nature in the form of studies made *en plein air*. By the 1820s and 1830s the work of two British landscape artists — John Constable and Joseph Mallord William Turner — was becoming known in France, ushering in elements of Romanticism. This approach was enshrined in France in the multivolume publication *Voyages pittoresques et romantiques dans l'ancienne France*, initiated in 1819 by Baron Isidore Taylor and Charles Nodier, but never completed. As its title suggests, the prints in the volumes of the *Voyages pittoresques* recorded the ancient monuments, architectural masterpieces, and natural scenery of the various regions of France (see ill. 3) — *la France historique*. The prints were made by a team of French and British artists that included Eugène Isabey (see ills. 74 and 84), Richard Parkes Bonington, Thomas Shotter Boys, and James Duffield Harding.[9]

A highly significant part of the official geographical patrimony of France is the Forest of Fontainebleau, located to the southeast of Paris, where the Barbizon School of painters established themselves during the 1830s and 1840s. The extensive forest is characterized by a varied terrain dotted with such villages as Chailly, Marlotte, and Barbizon. Designated as an area of natural beauty, it attracted artists who later influenced the Impressionists, notably Jean-Baptiste-Camille Corot, Jean-François Millet, Charles Jacque, Théodore Rousseau, and Charles-François Daubigny. Working in a manner that evokes comparison with Dutch seventeenth-century painting, these artists were inspired not only by views of natural beauty far removed from any kind of urban development but also by scenes of rural life. However, both the choice of the landscape itself as a subject and the depiction of the varied activities of peasant life had wider, some-times political, connotations during the first half of the nineteenth century in France.[10] This was particularly the case in the interpretation of Millet's work.[11] Monet (see ill. 4), Pissarro, Renoir, Sisley (see ill. 5), and Frédéric Bazille all painted in the Forest of Fontainebleau during the late 1860s, attracted as much by the rural motifs it offered as by the radicalism of the Barbizon School painters, who, despite their rejection of the conventions of academic painting, were accepted at the Salon on a regular basis. Indeed, the younger generation undertook such paintings in the hope of showing them at the Salon.

The Barbizon School painters also looked beyond the Forest of Fontainebleau. Corot and Daubigny, in particular, sought out motifs along the banks of the Seine and its many tributaries. As with their views of the forest, it was the quieter, more reflective stretches of water that became the chief subject of their paintings. Daubigny's *The Village of Gloton* of 1857 (ill. 88) is a sweeping, panoramic composition with reflections of buildings in the undisturbed water. Although there are signs of habitation and human activity, there is little indication of urgency. Similarly, Corot's famous *The Bridge at Mantes* of 1868–1870 (ill. 6) is a skillfully composed image of the town viewed across the river through trees. But Corot eschews any of the more modern elements of the town and prefers to emphasize its medieval

4. Claude Monet

*The Bodmer Oak, Fontainebleau Forest,
the Chailly Road (Un chêne au Bas-Bréau
[i.e. Bodmer]),* 1865
Oil on canvas
37⅞ × 50⅞ in. (96.2 × 129.2 cm)
The Metropolitan Museum of Art, New York.
Gift of Sam Salz and Bequest of Julia W.
Emmons, by exchange, 1964, 64.210
(DW60)

5. Alfred Sisley

*Village Street at Marlotte, near
Fontainebleau (Rue de village à Marlotte
près de Fontainebleau),* 1866
Oil on canvas
25 × 36 in. (64.8 × 91.4 cm)
Albright-Knox Art Gallery, Buffalo, New
York. General Purchase Finds, 1956:1
(FD3)

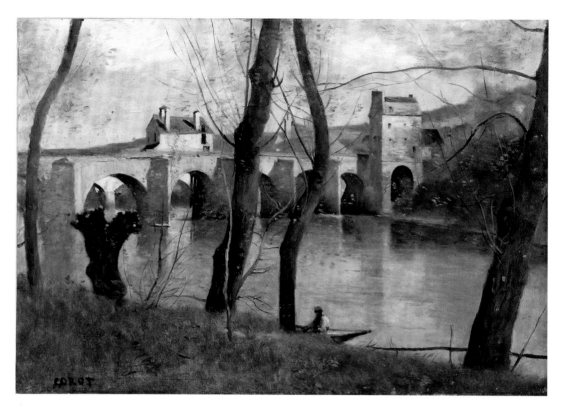

6. Jean-Baptiste-Camille Corot
The Bridge at Mantes (Le pont à Mantes),
1868–1870
Oil on canvas
15⅛ × 21⅞ in. (38.4 × 55.6 cm)
Musée du Louvre, Paris
(AR1516)

7. Camille Pissarro
Banks of the Marne at Chennevières (Bords de la Marne à Chennevières), 1864–1865
Oil on canvas
36 × 57¼ in. (91.5 × 145.5 cm)
National Gallery of Scotland, Edinburgh.
Inv. 2098
(P&D-RS103)

8. Claude Monet

River Scene at Bennecourt (Au bords de l'eau, Bennecourt), 1868

Oil on canvas

32¹⁄₁₆ × 39⅝ in. (81 × 100 cm)

Art Institute of Chicago. Potter Palmer Collection, 1922.427

(DW110)

aspects, as if mesmerized by recollections of the past, thereby creating a sense of timelessness. Pictures like these, among many of their kind painted by Daubigny and Corot, were much admired by the young Impressionists who were sympathetic to the Barbizon School's less hidebound attitude toward landscape and personal identification with nature. Pissarro's *Banks of the Marne at Chennevières* of 1864–1865 (ill. 7), Cézanne's *View of Bonnières* of 1866, and Monet's *River Scene at Bennecourt* of 1868 (ill. 8) seem trapped in a time warp in which nature is embalmed, the human spirit tranquilized, and the artist becalmed. Although these pictures were undertaken in the belief that their subject matter would not alarm the public at the Salon or be open to political interpretation, in fact, their brushwork, use of color, and treatment of light herald stylistic change. Parallels for these pictures exist not only in contemporary photography but also in the extensive travel literature of the day. A comparison with the publications of Émile de La Bédollière dating from the 1860s and those of Louis Barron and Augustus Hare dating from the 1880s reveals the great variety of approach and diversity of interest waiting to be explored in the French landscape.[12]

The apparent stasis found in nature, as recorded in pictures dating from the 1860s, recurs throughout the careers of the Impressionists with startling persistence. For instance, Sisley captures it first at Bougival (see ill. 135), then at Saint-Mammès, and finally at Moret-sur-Loing (see ill. 137), as does Monet in the quieter reaches at Argenteuil, then at Vétheuil (see ill. 65), and finally at Giverny.[13] Other Impressionists moved farther afield for a wider and more thorough exploration of nature: Pissarro to the banks of the Epte in Normandy, Renoir to the Côte d'Azur in the south of France, Cézanne to Provence, and Gauguin to the islands of the Pacific Ocean.

At no point, however, was Impressionism an art of escapism. On the contrary, it was an art of confrontation. The novelty of Impressionist art stemmed in large part from its response to the speed of change in nineteenth-century France. Such change was symbolized by the modernization of Paris by Baron Haussmann during the 1850s and 1860s. Another factor was the alarming degree of political uncertainty, resulting in rapid fluctuations between imperialism, monarchy, and republicanism. As respected hierarchies began to be eroded they were replaced by greater social mobility. Belief in progress and trust in technology, fostered by the growth of business and developments in industry, as well as an optimism placed in finance, signaled the arrival of the modern world and introduced new standards of morality. The first priority of the Impressionists was to observe a world in flux, and in so doing they sought out the transient and the fugitive rather than the permanent and the immutable. They were keen in their pictures to engage with contemporary issues rather than with eternal verities. It is true that artists such as Jean Béraud (see ill. 9) and Luigi Loir (see ill. 10), whose

9. Jean Béraud
The Banks of the Seine (Bords de la Seine),
ca. 1880
Oil on canvas
18⅛ × 22⅛ in. (46 × 56 cm)
Musée Carnavalet, Paris. Acquired 1935

10. Luigi Loir
*The Island of Grande Jatte (L'Île de la
Grande Jatte)*, ca. 1892
Gouache, watercolor, and gum arabic
on paper
12½ × 19 in. (31.7 × 48.1 cm)
Private collection

work was more acceptable to the taste of those who visited the
Salon, also engaged with modern subject matter, but they
did not do so in a challenging avant-garde style that beto-
kened a different approach to art.

Change was not limited to Paris and other cities in
nineteenth-century France. It was also evident in the country-
side. Pissarro's *The Route d'Auvers on the Banks of the Oise,
Pontoise* of 1873 (ill. 136) is a painting loaded with meaning.
The medieval town of Pontoise is situated some nineteen miles
to the northwest of Paris on the banks of the Oise, which is a
tributary of the Seine. At the time of Pissarro's arrival the town
had begun to thrive on the basis of a busy barge port, exten-
sive agricultural development, and a number of small indus-
tries. These circumstances are reflected in Pissarro's
landscape, which combines traditional modes of transport (the
carriage) with modern ones (the barge), and balances agricul-
ture and industry in the background. By contrasting these
different kinds of movement through the landscape, the
picture denotes social and economic recalibration.

Throughout history the sheer size of France dictated
that its rivers served as the country's main arteries.[14] Rivers
were, in effect, the principal and most efficient means of
communication and transportation. Canals were built in
response to the need for an integrated system of waterways,
which was closely linked to the demands of economic progress.
Roads gave direct access to Paris, but an integrated roadway
system was slow to develop and maintenance remained a
recurrent problem. Travel by road, therefore, was often tedious,
uncomfortable, and dangerous compared with the service
offered by river steamers.[15] A passenger steamboat service on
the Seine between Le Havre, on the English Channel, and
Rouen began in 1821, and it extended from Rouen to Paris in
1836. In his novel *Sentimental Education* (1869), Gustave
Flaubert describes the departure of the steamer traveling from
Paris to Le Havre:

People came hurrying up, out of breath; barrels, ropes and baskets
of washing lay about in everybody's way; the sailors ignored all
inquiries; people bumped into one another; the pile of baggage
between the two paddle-wheels grew higher and higher; and the din
merged into the hissing of the steam, which, escaping through some
iron plates, wrapped the whole scene in a whitish mist, while the
bell in the bows went on clanging incessantly. At last the boat moved
off; and the two banks lined with warehouses, yards, and factories,
slipped past like two wide ribbons being unwound. . . . The noise
began to die down. The passengers had all taken their places, and
some of them stood round the engine, warming themselves, while the

funnel spat out its plume of black smoke with a slow, regular breath. Tiny drops of moisture trickled over the brasses, the deck shook with a gentle vibration, and the two paddle-wheels, turning swiftly, beat the water. The river was lined with sand-banks. The boat kept coming across timber rafts which rocked in its wash, or a man sitting fishing in a dinghy. Then the drifting mists melted away, the sun came out, and the hill which followed the course of the Seine on the right gradually grew lower, giving place to another hill, nearer the water, on the opposite bank.[16]

Although steamers and barges could be regarded as modern forms of transport, the length of time the journey took was dictated by the meandering of the river (as in the case of the Seine) or by the number of locks (as in the case of the canals). Therefore, the reputation of the waterways of France rested in part on their picturesque qualities, as recorded most famously in the series of watercolors Turner made for his "Rivers of Europe" project between about 1825 and 1834 (see ill. 11), or as captured in prose by Robert Louis Stevenson in *An Inland Voyage* (1878). Both Turner and Stevenson, like Augustus Hare later, were inspired not only by the landscape itself but also by the historical associations of the places they were passing through.

The real revolution in travel within France was ushered in by the development of the railways, which made a major impact on the aesthetic of the Impressionists. "Canals and roads might be considerable technical achievements; but they had almost always been the extension, through physical effort or technical improvement, of an ancient or naturally occurring resource: a river, a valley, a path, or a pass. . . . Railway tracks reinvented the landscape. They cut through hills, they burrowed under roads and canals, they were carried across valleys, towns, estuaries."[17] The opening of the railway from Paris to Rouen in 1843 and then on to Le Havre in 1847, with numerous branch lines extending like veins into the countryside, created new possibilities for society as a whole. "Trains—or, rather, the tracks on which they ran—represented the conquest of space," which led "inexorably to the reorganization of time."[18] Speed reduced distances, blurred appearances, and intensified pleasure. Tourism quickly flourished on the northern coast of France, and opportunities for leisure activities increased in the suburbs as a result of the creation of the system of railways radiating from Paris.

Located in the center of Paris, the Gare Saint-Lazare was the station from which vacationers departed for the major Channel ports of Le Havre and Dieppe, as well as for the smaller, new resorts of Trouville, Deauville, Étretat, and Fécamp. These resorts were former fishing villages whose ancient customs and folkloric myths soon came to be exploited as tourist attractions. Other services from the Gare Saint-Lazare gave access to the suburbs located to the northwest of Paris—Asnières, Argenteuil, Chatou, Bougival—where Parisians could enjoy weekend excursions.

11. Joseph Mallord William Turner
Between Quillebeuf and Villequier, ca. 1832
Watercolor, bodycolor, and pen on blue paper
5⅜ × 7½ in. (13.8 × 19 cm)
British Museum, London. Department of Prints and Drawings, TB CCLIX-104

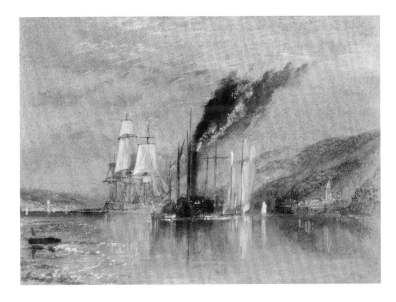

12. Claude Monet

The Beach at Trouville (La plage à Trouville),
1870
Oil on canvas
18⅞ × 29⅛ in. (48 × 74 cm)
Private collection
(DW157)

A whole genre of literature mirrored the increasing popularity of these places—not only the standard guidebooks printed by publishers, such as John Murray and Thomas Cook in London or Karl Baedeker in Leipzig, but also serious studies by writers, such as Adolphe Joanne and Jules Janin.[19]

Artists had known the coastal resorts of northern France since the 1830s, and both Delacroix and Paul Huet had painted there during the 1850s. But it was the Impressionists who undertook the most exhaustive examination of the motifs that these places presented, thereby leading to the artists' close association with certain locales.[20] The young Monet had been brought up near Le Havre, and it is no surprise that some of his earliest paintings made during the late 1860s and early 1870s included seascapes, views of harbors, and beach scenes where the trappings of tourism—hotels, casinos, villas, bathing huts, yachts, steamers, beach equipment, games, entertainments—abounded (see ill. 12). Aimed at the Salon audience or at local collectors, these early pictures by Monet are carefully composed (often underpinned by a strong sense of geometry) and for the most part conscientiously finished, even though there are indications of future preoccupations in the poses of the figures and the handling of the paint. The remarkable feature of these pictures, however, is their self-assurance, and it is clear that should Monet have chosen to do so he could have pursued a successful career as an outstanding marine painter.

A high point in the history of French marine painting occurred during the late eighteenth century, when Claude-Joseph Vernet painted a series on the seaports of France and related subjects for Louis XV (see ill. 13).[21] But rather than follow his countryman's example, Monet chose to model his work on the Dutch seventeenth-century marine painters recommended to him by his mentors Johan Barthold Jongkind and Eugène Louis Boudin, who at the same time were encouraging him to paint in the open air. *Regatta at Sainte-Adresse* of 1867 (ill. 14) is a totally fresh response to a marine subject, and its feeling of spontaneity is striking. In the background is Ingouville, on the outskirts of Le Havre. It is a bright day with a blue sky and high, swiftly moving clouds. Assorted vacationers on the beach watch the progress of the regatta, which might almost have been specially arranged for their benefit. Significantly, perhaps, the local figures, clustered around the boat pulled up on the shore, seem less interested in the view out to sea. The vessels sail offshore in a stately fashion like galleons, and in the foreground Monet bravely leaves an empty expanse of water, which reflects the sky and is beautifully observed in blue, green, and violet. The audacity of the composition, with its shoreline aligned with the yachts and its bright palette, denotes a painter of great daring.

Views of the English Channel also inspired two very different, but highly influential, artists of the day—Gustave Courbet and James Abbot McNeill Whistler—who worked together for a short time at Trouville in 1865. The more established Courbet, who championed realism and was not

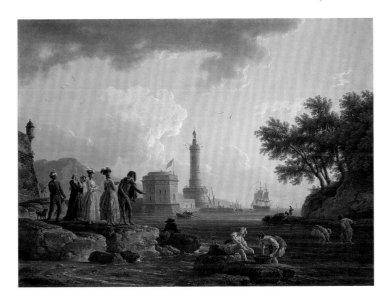

13. Claude-Joseph Vernet
A Sea-Shore (Bords de la mer), 1776
Oil on copper
24½ × 33½ in. (62.2 × 85.1 cm)
National Gallery, London. Bequeathed by
Richard Simmons, 1846–47, NG 201

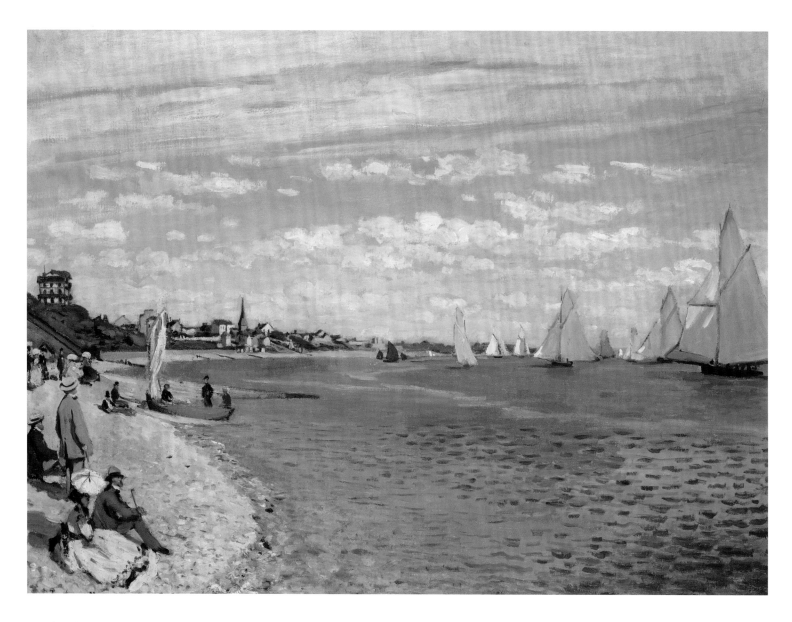

14. Claude Monet

*Regatta at Sainte-Adresse (Les régates à
Sainte-Adresse)*, 1867
Oil on canvas
29 ¾ × 40 in. (75.5 × 101.5 cm)
The Metropolitan Museum of Art, New York.
Bequest of William Church Osborn, 1951,
51.30.4
(DW91)

afraid to use art as a vehicle for political ends, portrays the power of the
sea with rolling waves, scudding clouds, and flying spume (see ill. 15).
On first confronting the Mediterranean a decade earlier, in 1854, Courbet,
who was given to extravagant gestures, had depicted himself saluting the
open sea, but at Trouville, and later at nearby Étretat, he removes himself
from the composition and concentrates on the water, as Monet was to do
increasingly during the 1880s. Where Courbet sees the strength and force of
nature, Whistler discerns pattern and color in a purer, more aesthetic way, in
paintings such as *The Sea* of about 1865 (Montclair Art Museum, Montclair,
New Jersey). What Whistler achieves is akin to a tone poem in music.
The sea has an almost ethereal quality and hardly seems threatening; the
yacht in the lower right corner scuds across the surface and is so diapha-
nously painted that it resembles a butterfly flitting across a garden. During
the mid-1860s these two approaches to painting the sea were far apart, but
later they coalesced in the work of younger generations of artists.

The visitors who frequented the resorts along the coast of the English
Channel were prosperous and cosmopolitan. Trouville and Deauville, which

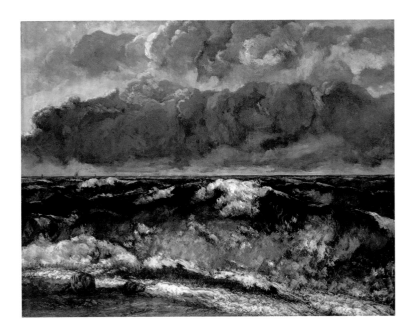

15. Gustave Courbet
The Wave (La vague), 1870
Oil on canvas
44 × 56⅝ in. (112 × 144 cm)
Nationalgalerie, Berlin. Inv. 891, F.V.18
(RF755)

gained the approval of Emperor Napoléon III and Empress Eugénie, attracted rich socialites. It is these people who are so often seen in Boudin's beach scenes (see ill. 16), where the women's crinolines sway and their hat ribbons flutter, the men wear boaters and carry canes, and children and pets play. These crowds are very different from those who traveled out to the suburbs of Paris on the weekends to escape from the unpleasant working conditions, long hours, and pressures of urban life.[22] The suburbs, in truth, witnessed a greater intermingling of the classes that made up French society than the seaside resorts of the English Channel. At the time, many civil servants, businessmen, teachers, soldiers, shopkeepers, and waitstaff were new to the recreational freedoms and experiences on offer along the banks of the Seine. Such people were often satirized by writers and caricatured by artists: they were dismissed as mere day-trippers who behaved improperly in public, shouted a great deal, became drunk and too easily overexcited, left their litter behind, and were prone to sunstroke. The river itself—and particularly the small islands that were such a feature of that part of the Seine—seemed to occasion the breaking down of social barriers. This often resulted in the promotion of sexual indiscretions, deeds of malfeasance, and acts of despair.

Novelists, such as Émile Zola, and short-story writers, such as Guy de Maupassant, found plenty of material at places like Bougival and Argenteuil. In Zola's novel *Thérèse Raquin* (first published in 1867), for example, the murder of Thérèse Raquin's husband, Camille, takes place on the river at Saint-Ouen and is made to look like a boating accident. The author evokes the scene as follows:

> They left the island and walked along the roads, down paths full of groups of people in their Sunday best. Between the hedges, girls were running along in brightly coloured dresses; a team of oarsmen went by, singing; lines of bourgeois couples, old folk and employees with their wives, were strolling, beside the ditches. Every path seemed like a populous, noisy street. . . . Dusk was coming. Great shadows fell from the trees and the water was black at the edge. In the middle of the river, there were wide streaks of pale silver. Soon, the boat was in the middle of the Seine. Here, all the sounds from the banks were muted: the shouts and singing were vague and melancholy as they drifted across, with sad, languid notes. The smells of fried food and dust had gone. There was a chill in the air. It was cold.[23]

Maupassant's short story "Femme Fatale" (originally published in 1881 with the title "La femme de Paul") vividly describes the Restaurant Fournaise at Chatou and the well-known bathing place called La Grenouillère at Bougival. The latter "reeked of vice and corruption and the dregs of Parisian society in

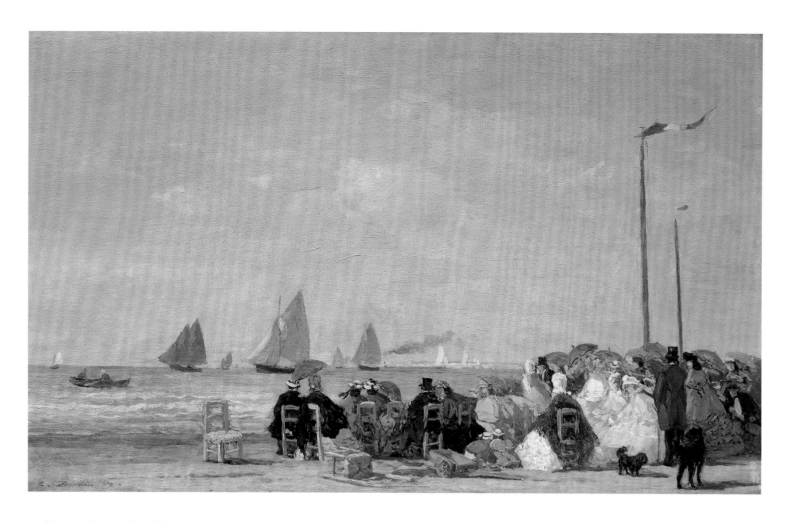

16. Eugène Louis Boudin

The Beach at Trouville (La plage à Trouville),
1863
Oil on canvas
13⅝ × 22⅜ in. (35 × 57 cm)
National Gallery of Art, Washington, DC.
Collection of Mr. and Mrs. Paul Mellon,
1983.1.14

all its rottenness gathered there: cheats, conmen and cheap hacks rubbed shoulders with under-age dandies, old roués and rogues, sleazy underworld types once notorious for things best forgotten mingled with the other small-time crooks and speculators, dabblers in dubious ventures, frauds, pimps, and racketeers. Cheap sex, both male and female, was on offer in this tawdry meat-market of a place where petty rivalries were exploited, and quarrels picked over nothing in an atmosphere of fake gallantry where swords or pistol at dawn settled matters of highly questionable honour in the first place."[24]

The suburbs themselves were in reality a chimera, being neither city nor country but a buffer zone, or intermediary, between the two. Facilities for recreation and leisure, such as restaurants, cafés, entertainments, bathing establishments, and boating stations, were located close to industrial developments, which included factories, tanneries, distilleries, ironworks, and quarries, as well as to pockets of traditional agriculture. The closer the suburb was to Paris the greater the contrast, as at Asnières, where Seurat and Signac worked during the mid-1880s. All of the suburbs, however, serviced the capital, and so there was a constant flow of barge traffic on the river carrying food supplies, provisions, and building materials. In return, the suburbs were less fortunate in being outlets for the capital's sewage system, as was the case at Asnières and Saint-Denis, which had unpleasant repercussions for other places on the river.[25]

The ambiguities that characterized the suburbs were a perfect subject for the Impressionists, just as they were for Zola and Maupassant. The suburbs represented the interstices of an emerging world in which traditional class barriers were breaking down. Here, motifs taken from everyday life could be explored in a changing landscape, giving rise to previously unexplored responses and varied emotions. The relevance of the Impressionists was that their urgent style of painting matched the immediacy of the situation. Impressionism, therefore, was the perfect vehicle for recording the fragmentation of society that triggered the birth of modernism.

Argenteuil was the suburb of Paris that the Impressionists examined in the greatest detail.[26] Manet, Monet, Renoir, Sisley, and Caillebotte all frequented the town during the mid-1870s, and they occasionally overlapped there. Monet actually lived in the town from 1871 to 1878. The supposition must be, however, that these artists associated themselves with the very weekenders and day-trippers from Paris whom they depicted, since the capital remained the principal forum and outlet for their work. Only Monet, by virtue of living at Argenteuil, could claim a sustained local allegiance, which is why so many of his pictures show the town's famous yachts and boats at anchor during the week instead of under sail on the weekend.[27]

The railway line from Paris had arrived in Argenteuil in 1851. The town's population increased during the 1870s, and this expansion was reflected in the amount of new building and the growth of industry. Some surviving picturesque elements of the landscape remained in painters' compositions, such as the hills of Sannois and the windmill at Orgemont, but they had by then receded somewhat farther into the background so that the more modern features of the town could dominate, as in Sisley's *The Bridge at Argenteuil* of 1872 (ill. 118), Monet's *The Road Bridge at Argenteuil* of 1874 (ill. 17), and Caillebotte's *The Highway Bridge at Argenteuil* of about 1885 (ill. 18). Two bridges spanned the Seine at Argenteuil—the Highway Bridge (originally built 1831–1832) and the newer Railway Bridge (originally built 1863), the latter constructed with poured concrete and prefabricated iron. Both bridges were destroyed during the Franco-Prussian War of 1870–1871, but they were immediately rebuilt in order to restore communications and rekindle national pride. Monet frequently made these bridges the principal motifs in his Argenteuil paintings, particularly the Railway Bridge, which serves as a symbol of modernity that figures standing on the riverbank admire with gestures of supplication.

A vitally important feature of the Seine at Argenteuil was its width (682 feet) and depth (78 feet), which created a basin that was perfect for sailing. The sport added to Argenteuil's popularity

17. Claude Monet

The Road Bridge at Argenteuil (Le pont routier d'Argenteuil), 1874
Oil on canvas
23⅝ × 31½ in. (60 × 80 cm)
National Gallery of Art, Washington, DC.
Collection of Mr. and Mrs. Paul Mellon,
1983.1.24
(DW312)

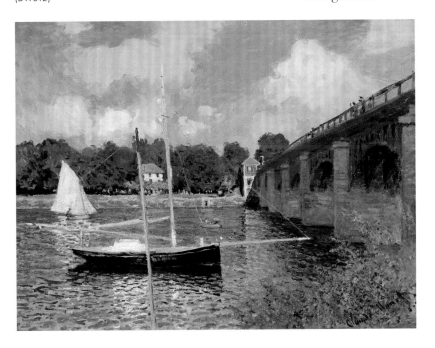

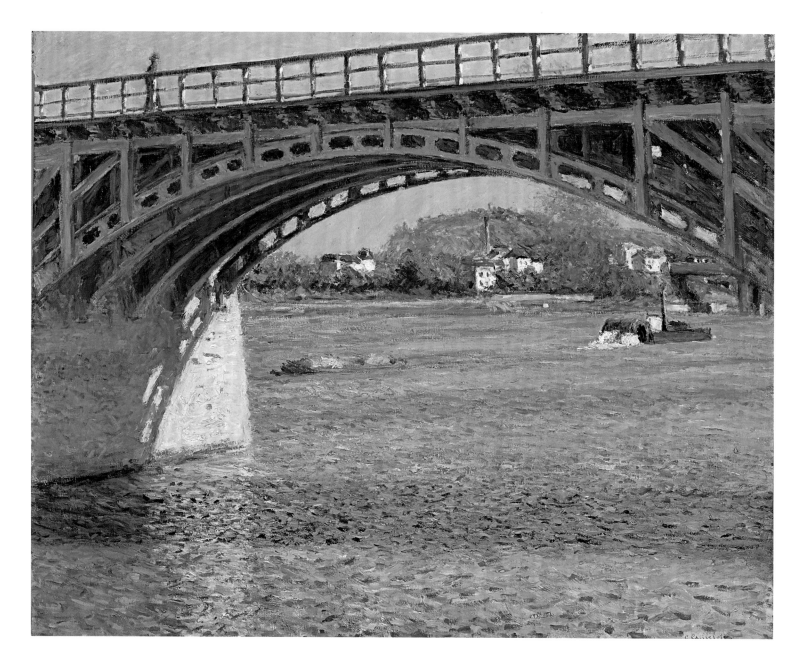

18. Gustave Caillebotte
The Highway Bridge at Argenteuil (Le pont d'Argenteuil et la Seine), ca. 1885
Oil on canvas
25¾ × 32¼ in. (65.5 × 81.6 cm)
Private collection
(MB334)

to such an extent that the town became the center of sailing for the whole of France.[28] Of the different types of boating on the Seine, yacht sailing was predominantly enjoyed by gentleman amateurs with sufficient wealth to buy and equip their own craft and with sufficient leisure to indulge in the sport at their own convenience. As the century progressed, however, sailing became less privileged and exclusive, as yachts could be hired or rented from companies operating along the riverbanks. Official regattas, organized since 1858 by the Cercle de Voile (the sailing club of the Société des Régates Parisiennes), were held twice a month between April and November, and there were less formal races on Sundays. Spectators watched these events, which were widely reported in the press, from the promenades extending along both banks of the river. As it happens, the Impressionists who worked at Argenteuil all had, to varying degrees, a genuine interest in and often firsthand experience of sailing.

Manet spent the summer of 1874 at his parents' house at Petit-Gennevilliers, on the opposite bank from Argenteuil, where he embarked on a small group of paintings intended for the Salon. With characteristic pungency he captured the essence of Argenteuil. The picture titled simply *Argenteuil* of 1874 (ill. 119) was exhibited at the Salon in the following year. Even though it is surprisingly skimpily painted in areas (for example, in the landscape on the right), the surface reads like a patterned mosaic of detail whose parts are carefully fitted together. The positioning of the two figures seated on the pontoon in the immediate foreground, pressed closely against the picture plane, is provocative both visually and socially. The yachtsman seems to be propositioning the young woman, as suggested by the floral bouquet in her lap, and she appears to be deciding whether or not to accept his invitation to go out on his boat. Behind them in the middle distance is the boat basin, beyond which is a view of the town, including the smoking chimneys of the factories. The implied movement of the boats on the intensely blue water perhaps suggests the mental perturbations of the figures in the same way that the linear patterns created by the masts, rigging, and striped clothes activate the composition. Cleverly, though, Manet does not indicate the outcome of this assignation.[29]

Boating (ill. 19), also of 1874 but not shown at the Salon until 1879, presents an interesting counterpoint to *Argenteuil*. The equally shallow composition is remarkable for its economy, evident particularly in the way that the river stretches across the whole of the background, and amounts to "an ideographic condensation of boating."[30] The viewer is admitted onto

19. **Édouard Manet**
Boating (En bateau), 1874
Oil on canvas
38¼ × 51⅛ in. (97 × 130 cm)
The Metropolitan Museum of Art, New York.
H. O. Havemeyer Collection, Bequest of
Mrs. H. O. Havemeyer, 1929, 29.100.115
(R&W223)

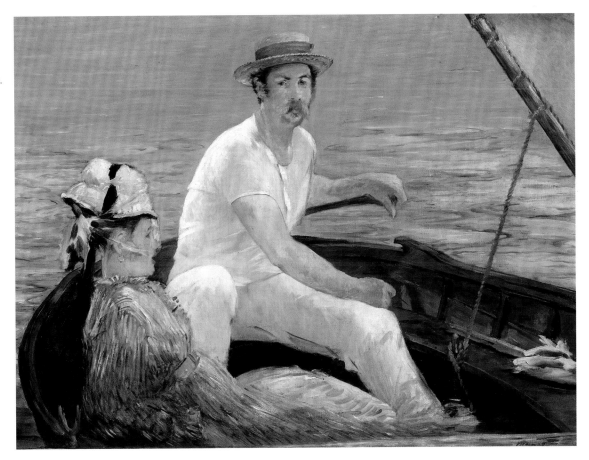

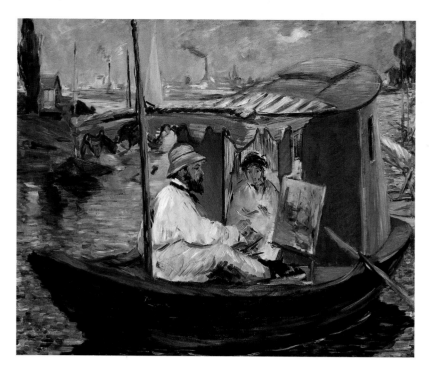

20. Édouard Manet
Claude Monet Painting on His Studio Boat (Claude Monet peignant dans son atelier), 1874
Oil on canvas
32½ × 39½ in. (80 × 98 cm)
Neue Pinakothek, Bayerische Staatsgemäldesammlungen, Munich.
Inv. no. 8759; 1913/14 Tschudi contribution (R&W219)

the boat, as if invading the private space of the two figures. Both are preoccupied with their own thoughts: the man attends to sailing the boat while the finely dressed woman sits back and enjoys the fresh air and warm breeze.

Manet was often in contact with Monet during his time at Argenteuil in the summer of 1874, and his depiction of Monet at work (ill. 20) not only emphasizes the industrial context of the town but also demonstrates the advantage that Monet had in using his floating studio, which he may have adopted in emulation of Daubigny.[31] Manet shows Monet in the act of painting a motif inspired by the town's boat basin. Dressed in the manner of a yachtsman, the artist sits under the boat's striped awning while his wife, Camille, looks on from inside the cabin.

By virtue of being a resident there for seven years, Monet approached Argenteuil in a far more comprehensive manner than did Manet or any of his other colleagues. He painted some 175 views of the town altogether, of which approximately seventy-five are devoted to the main part of the river.[32] The latter paintings can be divided into three groups.[33] The first includes calm and peaceful views of the river in the area known as Le Petit Bras, slightly downstream from Argenteuil, around the Île Marante, where the deep water allowed for mooring larger craft (see ill. 110). The second group depicts the boat rental area on the south bank, close to the Highway Bridge, which was used as an anchorage and at the height of the season could accommodate as many as two hundred craft, some of which were privately owned (see ill. 109). The third group features the boat basin itself, which was the chief attraction for many of the visitors to Argenteuil (see ill. 106). Using his floating studio to advantage, Monet moved in and out of these areas, sometimes going in quite close to the boats.[34] He often incorporated in his compositions partial views of one or sometimes both of the bridges, using them as a signature for the town. The juxtaposition of the yachts, the bridges, and the Argenteuil setting is not accidental. Monet was composing a hymn to modernity: the town is industrialized, the bridges are rebuilt in the most advanced materials, and the yachts are designed according to the latest technology. Thus the artist produced a detailed visual analysis of the process of social transformation, based not only on a specific place but also on a particular recreational activity. The variety that Monet found in his surroundings at Argenteuil allowed him to demonstrate his analytical powers—an aspect of his art that he brought fully to fruition when painting his series toward the end of the decade and afterward.

Monet's productivity at Argenteuil may have been affected by the presence there of Renoir, with whom he had painted at Bougival in 1869. The subject on that occasion had been the popular bathing place called La Grenouillère on the Île Croissy. The paintings made of La Grenouillère

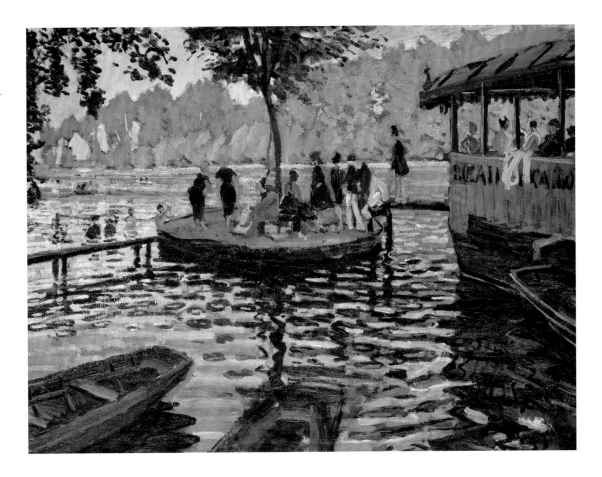

21. Claude Monet

La Grenouillère, 1869
Oil on canvas
29⅜ × 39¼ in. (74.6 × 99.7 cm)
The Metropolitan Museum of Art, New York.
H. O. Havemeyer Collection, Bequest of
Mrs. H. O. Havemeyer, 1929, 29.100.112
(DW134)

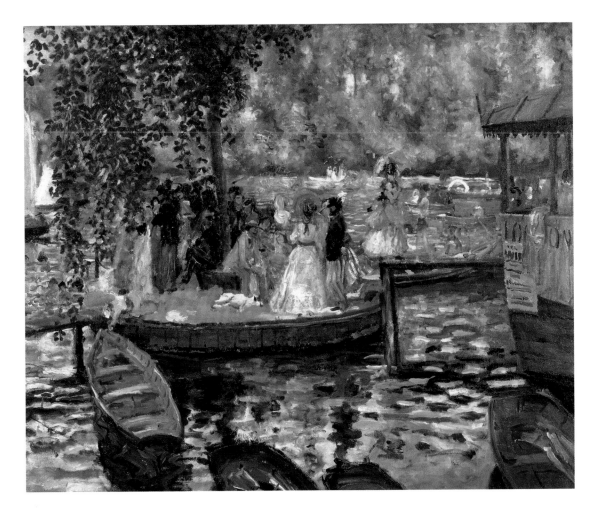

22. Pierre-Auguste Renoir

La Grenouillère, 1869
Oil on canvas
26⅛ × 31⅞ in. (66.5 × 81 cm)
Nationalmuseum, Stockholm. Inv. NM 2425
(G-P&MD114)

by Monet (see ill. 21) and Renoir (see ill. 22) have become defining works in the canon of Impressionism.[35] The reciprocity established in 1869 was therefore easily repeated at Argenteuil between 1873 and 1875. For their paintings of sailboats at Argenteuil (ills. 120, 121), of 1873–1874 and 1874, respectively, the artists took similar positions on the Petit-Gennevilliers bank of the boat basin. The yacht alongside the jetty is the dominant feature in both paintings, but Monet's composition is reductive and carefully structured, whereas Renoir's is more expansive, having a greater sense of activity and considerably more detail. There is a similar contrast in style, which is particularly evident in the handling of the reflections. Monet's brushwork is heavily textured and insistent, as opposed to Renoir's rendition of rippling water and shimmering light.

Both artists seem to have been reluctant to portray an actual regatta, but they did do so on one single occasion in 1874 (ills. 126, 127).[36] These paintings again reveal the essential differences between the two artists. Monet positions himself further away from the action and precisely demarcates the placement of the boats, as in a seventeenth-century Dutch marine painting (see ill. 23). In contrast, Renoir's more agile and fluent brushwork gives a far greater sense of the flurried activity on board a yacht—the straining sails, taut ropes, swinging booms, and rushing water. The lighter palette also contributes to this impression, as the bows of the yachts cut swathes through the water in a lemon-colored haze.

Renoir's interest in boating extended beyond Argenteuil, farther downstream to Chatou, opposite Reuil, where there are a number of islands in the Seine. Equally accessible by train from Paris, Chatou attracted oarsmen in particular, who after their exertions relaxed at the Restaurant Fournaise, immortalized by Renoir in one of his most famous pictures (ill. 25). Unlike Monet, who stressed the anonymity of boating at Argenteuil, Renoir was full of conviviality and acted in a wholly gremial way. Chatou was more open and verdant than Argenteuil, with a more bucolic atmosphere, and the artist reveled in the bright light and the strong contrasts in color presented by the river at that point. Just as the suburbs to the west of Paris were impregnated with the history of the ancien régime, as focused on Versailles, so Chatou for Renoir evoked an earlier time. Thus he laced his modernity with a sense of the past. For example, the young people in *Lunch at the Restaurant Fournaise* of about 1879 (ill. 24) relax in a shaded arbor bounded by a trellis that he treats, in effect, as a religious *hortus conclusus* of suburban leisure, overlooking the sunlit river. The sparkling brushwork, silvery tone, and silky textures are wholly characteristic of Renoir yet ultimately derived from the work of Jean-Antoine Watteau (see ill. 26). Although Maurice de Vlaminck's paintings produce a very different effect and an altogether more modern impact (see ill. 173), the young Fauve artist, who was born in Chatou, could not have painted the river there in the way he did without being aware of the precedent set by Renoir.

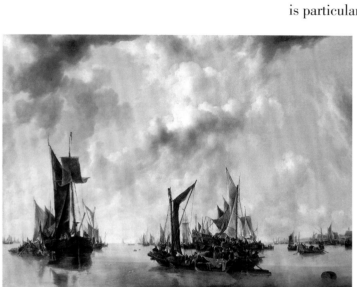

23. Jan van de Capelle
A Calm, 1654
Oil on canvas
43¼ × 58½ in. (110 × 148.2 cm)
National Museum of Wales, Cardiff.
Purchased with the assistance of the
National Heritage Memorial Fund,
the Art Fund, the John Paul Getty Jnr.
Charitable Trust and an anonymous
donor, NMW A 2754

24. Pierre-Auguste Renoir

Lunch at the Restaurant Fournaise (The Rowers' Lunch) (Déjeuner chez Fournaise [Les canotiers]), ca. 1879
Oil on canvas
21⅝ × 26 in. (55 × 66 cm)
Art Institute of Chicago. Potter Palmer Collection, 1922.437
(G-P&MD218)

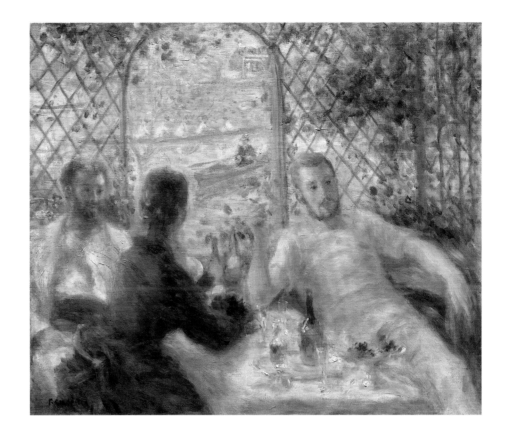

25. Pierre-Auguste Renoir

Luncheon of the Boating Party (Le déjeuner des canotiers), 1880–1881
Oil on canvas
51 × 68 in. (129.5 × 173 cm)
The Phillips Collection, Washington, DC
(G-P&MD224)

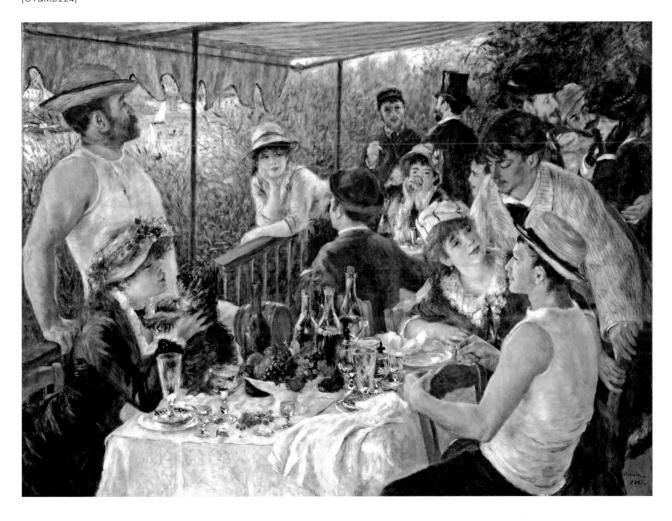

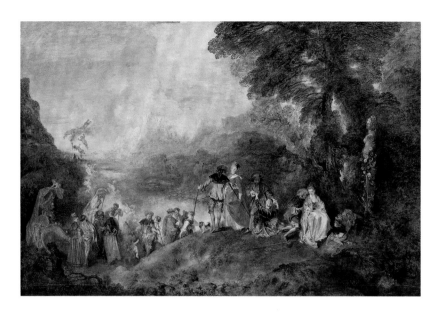

26. Jean-Antoine Watteau
Pilgrimage to the Island of Cythère
(Pèlerinage à l'Île de Cythère), 1717
Oil on canvas
50¾ × 74¾ in. (129 × 190 cm)
Musée du Louvre, Paris. 8525

The one Impressionist artist who took greatest advantage of the boating facilities on the Seine was a late arrival at Argenteuil. Previously the painter and collector Caillebotte had lived close to the Seine at Yerres, to the south of Paris, and had visited Argenteuil only occasionally during the 1870s. His fellow painters were amateurs on the water, but Caillebotte's enthusiasm extended well beyond competitive performance to boat design and building.[37] All types of craft are represented in his paintings: canoes (see ill. 27), rowing boats (see ill. 129), and yachts (see ill. 132). Very often these were craft that he himself had designed or else owned. Caillebotte paid lip service to the iconography of Argenteuil by painting several views of the bridges and boating facilities (see ill. 113), but overall his depictions of yachts amount to the most comprehensive and accurate survey of the sport in the history of art. He combines an enthusiast's firsthand knowledge of boating with a radical approach to painting. In his compositions the steep perspective, oblique viewpoints, and tantalizing visual leaps from the far distance to stark close-ups replicate the dynamics of actually being in a boat. Caillebotte shows that combating the elements in boating requires considerable technical skills. He depicts sailing as a sport of the utmost sophistication, thereby implying that the efforts of the uninitiated could result in tired muscles, blistered hands, and bruised bodies, which city dwellers on a day trip from Paris, for example, might be unprepared for and clearly regret on returning to the metropolis at the end of the day.

Signac was as enthusiastic about sailing as Caillebotte; but, more than that, sailing gave a greater sense of direction to his career as an artist than was the case with Caillebotte. During the 1880s and 1890s Signac worked along the banks of the Seine and often on the coasts of Brittany and Normandy, but in 1892 he discovered Saint-Tropez in the south of France. For the rest of his life he divided his time between Paris and the Mediterranean coast. This was a turning point in the history of French art, and Signac became a persuasive advocate for the advantages of painting in the south. On arriving in Saint-Tropez he declared, "There is enough material to work on for the rest of my days. Happiness — that is what I have just discovered."[38]

Signac's independence announced itself early, and he had no formal training as an artist. He said, "My family wanted me to be an architect but I preferred to draw on the banks of the Seine rather than in a studio at the École des Beaux-Arts."[39] And that is exactly what he did at Asnières, the industrialized suburb close to Paris where his family had a house. Proximity to the Seine encouraged his interest in boating, which was reinforced by Caillebotte's enthusiasm. His first craft was a *périssoire*, provocatively named *Manet-Zola-Wagner*, and there followed in quick succession another thirty or so boats, the most glamorous of which were the cutters named *Olympia*,

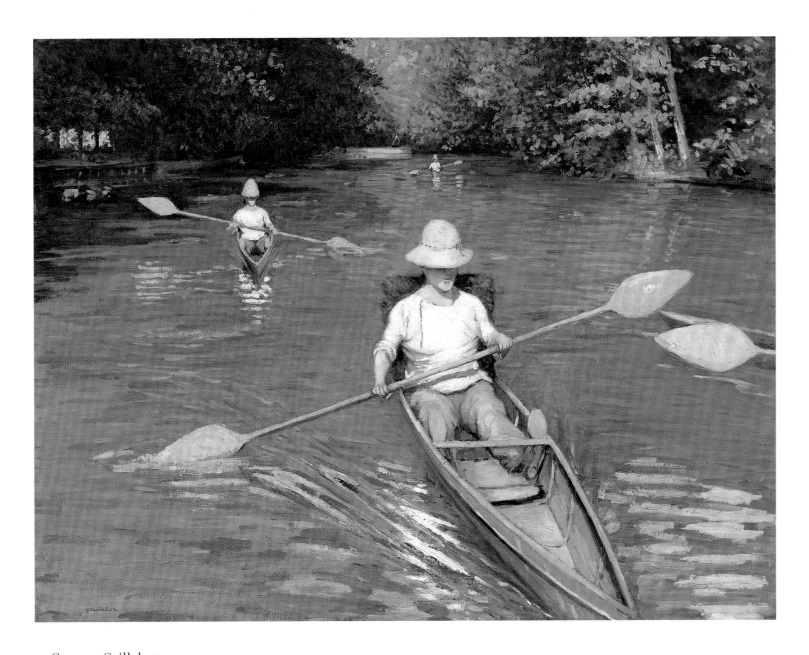

27. Gustave Caillebotte
Skiffs (Périssoires sur l'Yerres), 1877
Oil on canvas
35 × 45¼ in. (89 × 115 cm)
National Gallery of Art, Washington, DC.
Collection of Mr. and Mrs. Paul Mellon,
1985.64.6
(MB87)

Sinbad, and *Henriette I* and *II*.[40] Signac tackled the Asnières landscape head-on, incorporating all its modern motifs such as the two bridges, gasholders, factories, and cranes. Some of his paintings done at Asnières anticipate future stylistic developments. *The Stern of the Tub* (ill. 28) and *The Bow of the Tub* (private collection, Switzerland), both of 1888, reflect Signac's interests in presenting contrasting views of the river at Asnières from his own boat named *The Tub*. Signac used this same boat elsewhere on the Seine. He painted in 1888 at Les Andelys (the birthplace of Poussin) and in 1889 at Herblay (see ill. 29), where *The Tub* sank, unfortunately, in dramatic circumstances.[41]

The development of Signac's style was determined by the relationships he formed with other artists. He attended many of the Impressionist exhibitions from the time of the third, held in 1879, and began by painting in a loose Impressionist style. But within a few years he met Seurat, with whom he sought to devise a new technique, known as pointillism, which became synonymous with Neo-Impressionism. Seurat's early masterpieces

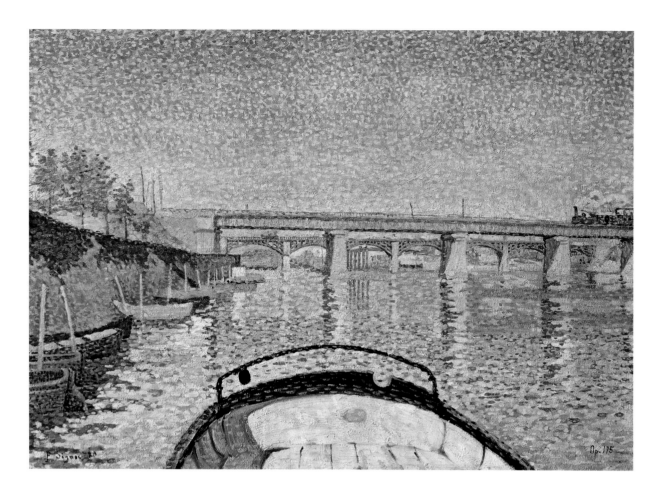

28. Paul Signac

*The Stern of the Tub (Arrière du Tub opus
175)*, 1888
Oil on canvas
18⅛ × 25⅝ in. (46 × 65 cm)
Private collection
(FC161)

29. Paul Signac

*Fog. Herblay Opus 208 (Herblay.
Brouillard opus 208)*, 1889
Oil on canvas
13 × 21⅝ in. (33 × 55 cm)
Musée d'Orsay, Paris. Inv. RF 1958-1
(FC196)

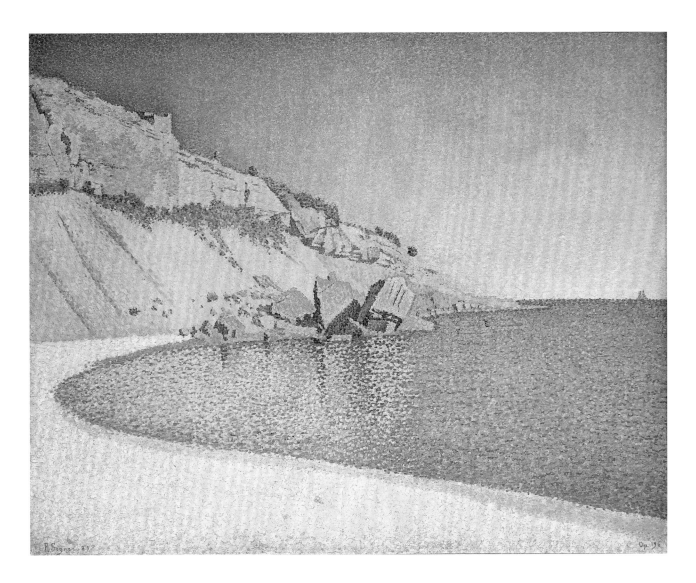

30. Paul Signac

Cap Lombard, Cassis, Opus 196
(Cassis. Cap Lombard opus 196), 1889
Oil on canvas
26 × 31⅞ in. (66 × 81 cm)
Gemeentemuseum Den Haag, The Hague.
Inv. SCH-1956-0054
(FC182)

Bathers at Asnières of 1883–1884 (National Gallery, London) and *A Sunday Afternoon on the Island of Grande Jatte* (ill. 2) testify to a shared passion for the motifs found in Asnières, but they are also indicative of the need that younger artists felt to move beyond pure Impressionism. The immediacy and fluidity of the Impressionist style were replaced by compositions that are carefully planned and deliberately executed in a technique that denies the artist's individual personality. Light and color are also highly contrived, being based on the scientific theories of Michel-Eugène Chevreul and Charles Henry, who wrote about the properties of complementary colors.

The compositions of Neo-Impressionist paintings at their best are luminous and harmonious, but the flattening of the forms, the simplification of the design, and the regularity of the technique incline toward the decorative. The canvases painted by Signac in 1889 at Cassis, on the Côte d'Azur near Marseilles, are outstanding examples of how forms dissolve in the intense light of the south of France (see ill. 30). The critic Félix Fénéon recognized the supreme quality of these works, in which the artist is "able to create exemplary specimens of an art of great decorative development, which sacrifices anecdote to arabesque, analysis to synthesis, fugitive to permanent."[42] These features of Signac's art, so brilliantly assessed by

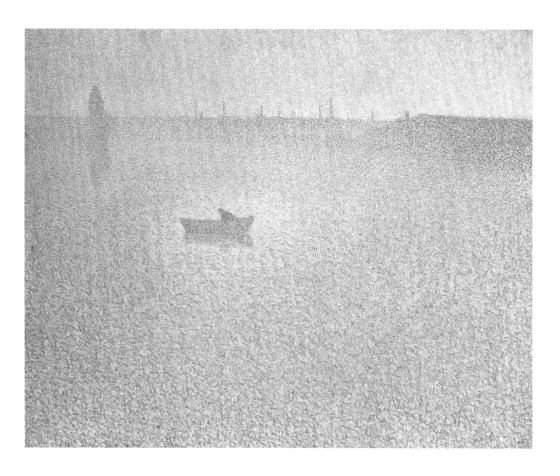

31. Charles Angrand

The Seine at Dawn (Mist) (La Seine à l'aurore [La brume]), 1889
Oil on canvas
24⅝ × 31⅞ in. (65 × 81 cm)
Musée du Petit Palais, Geneva.
Association des Amis du Petit Palais

Fénéon, were perfected in the south of France over a number of years and had major consequences.

The early death of Seurat in 1891 at the age of thirty-five left Signac as the chief proponent of Neo-Impressionism, which is the style he adhered to personally for the rest of his life, although with a growing freedom of execution. Being gregarious, it was not difficult for Signac to attract a group of younger artists to the style, among them Maximilien Luce, Charles Angrand (see ill. 31), Théo van Rysselberghe (see ill. 32), and Henri-Edmond Cross (see ill. 33).

In Seurat's marine paintings, made at various points along the coast of Normandy (see ill. 34), there is a sense of the artist moving beyond direct transcriptions of reality toward compositions that are more concerned with evoking a mood, usually one of melancholy. These pictures have an anonymity and an emptiness that suggest a gradual withdrawal from strictly representational imagery and in many ways anticipate abstraction. The paintings made by Signac and his colleagues in the south of France after Seurat's death share this shift in aesthetic outlook from naturalism to symbolism. The yachts may well be literal transcriptions of what the artists saw, but at the same time they are vested with a deeper significance emanating from the artists' inner states of the mind and anxieties arising from an awareness of transience. The vastness of the sea and the limitless horizon need to be balanced against the fickleness of the elements and the frailty of the craft. These pictures, therefore, are not simply celebrations of the beauty of the Mediterranean but, more disturbingly, a way of registering the

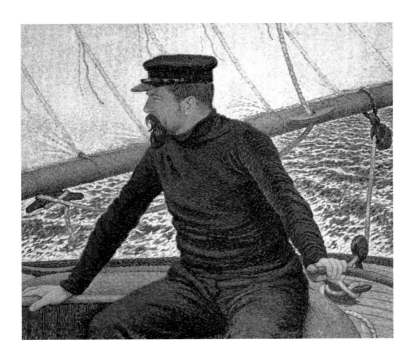

32. Théo (Théophile)
van Rysselberghe
Signac on His Boat (Olympia) (Signac
à bord son bateau [Olympia]), 1897
Oil on canvas
36¼ × 44¾ in. (92.2 × 113.5 cm)
Private collection

33. Henri-Edmond Cross
Pointe de la Galère, 1891–1892
Oil on canvas
25⅝ × 36¼ in. (63 × 91 cm)
Galerie Schmit, Paris

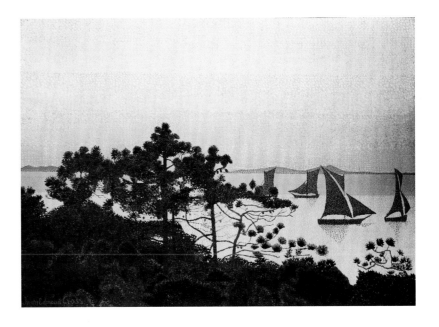

34. Georges Seurat
The Channel at Gravelines, Evening
(Le chenal de Gravelines, un soir), 1890
Oil on canvas
25¾ × 32¼ in. (65.4 × 81.9 cm)
Museum of Modern Art, New York.
785.1963
(D&R210)

uncertainties of the world as a whole and the fragility of human existence in particular. Significantly, Symbolist poets such as Stéphane Mallarmé, Henri de Régnier, and Jacques Madeleine shared these premonitions and frequently used marine imagery to express them in their poetry.[43]

The most explicit visual representation of the boat as a symbol in French art at the turn of the twentieth century occurs in the work of Odilon Redon (see ill. 35). He drew upon personal experience, literary sources, religious texts, and local mythology to devise a defining image indicative of the plight of mankind. The boat in Redon's art becomes a metaphor for man's struggle with fate—an ordeal only to be endured at the mercy of natural elements or superior forces, and only occasionally relieved by the intervention of a supreme being or by the overwhelming power of beauty. Redon's images of boats under sail on perilous seas are often ambiguous: rainbow skies suggest salvation, but, more ominously, darkness implies doom.[44] By contrast, the yachts seen in the pictures of the Mediterranean by Signac and his colleagues inhabit a different world—one of hope and release.

When Signac went to Saint-Tropez for the first time in 1892, he did so by boat. (Saint-Tropez was difficult to reach on land until the 1950s, when the development of tourism and the use of the private motorcar led to easier access.) His voyage on the *Olympia* began on March 24 at Bénodet, in Brittany, from which he sailed down to Bordeaux. Just south of Bordeaux he used the Canal Lateral à la Garonne as far as Toulouse before entering the Canal du Midi and finally reaching the Mediterranean near Sète on April 14.[45] He bought a cottage, "La Ramade" (the Arbor), in the old quarter of Saint-Tropez, but three years later moved into a large villa overlooking the beach, which he called "La Hune" (the Crow's Nest) and gradually enlarged with the addition of a studio. For anyone born in the north of France the Mediterranean was a revelation; just to catch sight of it was to have a glimpse of paradise. The climate, the vegetation, the pine woods, the brilliant light of the midday sun, the warmth, the night sky with its dome of stars—all suggested a whole new range of aesthetic possibilities governed by the wish to escape from the mounting stresses and strains of modern life and to return to a golden age. For Maupassant the principal means of escape was his yacht, the *Bel-Ami*, which he sailed along the coast of southern France in 1887:

> Calm reigns everywhere, the warm, gentle calm of the Midi and it seems weeks and months and years since I've had anything to do with people who dash around and never stop talking. I can enjoy the thrill of being alone, the quiet thrill of being able to rest and never be disturbed by a letter or a telegram, the sound of a doorbell, or even the barking of my dog. Nobody can call on me, invite me out, depress me with smiles, harass me with flattery. I'm alone, really alone, and I'm free. The train may be dashing along the coast but I'm in my floating home which has wings, swaying to and fro like a pretty little nest, more comfortable than a hammock and which is

35. Odilon Redon
The Yellow Sail (La voile jaune), ca. 1905
Pastel on paper
22⅞ × 18½ in. (58 × 47 cm)
Indianapolis Museum of Art. The Lockton
Collection, 70.78
(AW1956)

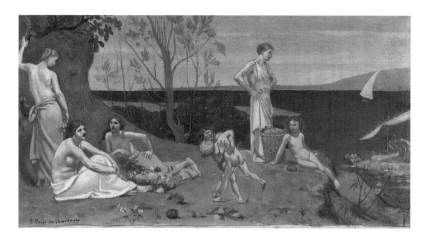

36. Pierre Puvis de Chavannes
Pleasant Land (Doux pays), 1882
Oil on canvas
10⅛ × 18⅝ in. (25.8 × 47.3 cm)
Yale University Art Gallery, New Haven.
The Mary Gertrude Abbey Fund, 1958.64
(AP277)

drifting here and there on the water, following the whims of the wind, going wherever it chooses.[46]

There was also the rich cultural legacy of the Mediterranean so succinctly summarized by Dr. Samuel Johnson in 1776: "On those shores were the four great Empires of the world; the Assyrian, the Persian, the Grecian, and the Roman. All our religion, almost all our law, almost all our arts, almost all that sets us above savages, has come to us from the shores of the Mediterranean."[47] The south of France, therefore, could easily be mistaken for Arcadia, which is exactly what Pierre Puvis de Chavannes depicts in his painting *Pleasant Land* (ill. 36), which was exhibited at the Salon of 1882.[48]

Signac, too, on arriving in Saint-Tropez started to paint subjects that were far removed from anything he had attempted along the banks of the Seine. *Women at the Well* of 1892 (Musée d'Orsay, Paris) and *In the Era of Harmony* of 1893–1895 (Mairie de Montreuil, Paris), like Cross's contemporaneous work *The Evening Air* (ill. 37), are visions of an ideal society based on the theories of the philosophical anarchists in whose work these artists were well versed.[49] Such pictures lead directly to Henri Matisse's famous Neo-Impressionist depiction of the golden age in *Luxe, calme et volupté* of 1904 (ill. 38) and Maurice Denis's *Eurydice* of about 1903–1904 (ill. 39). The sensual reverberations that for so many years were axiomatic of the Côte d'Azur also inspired Maupassant:

> Seeing water caressing sandy shores or granite crags touches my heart and the overpowering joy of feeling myself urged on by the wind and gliding over the waves springs from the sensation of surrendering to the brute forces of the natural world, of returning to a primitive life. When, as today, the weather is fine, I feel the blood of the fauns of old, those lascivious, roving fauns, coursing through my veins, I no longer look on men as brothers, my brothers are all creatures and all things![50]

Even before he moved to Saint-Tropez Signac had already been exposed to the beauties of Mediterranean. His first visit was to the fishing port of Collioure in the High Pyrenees, close to the French border with Spain, during the summer of 1887. He arrived by boat. The combination of arid hills, sparkling water, and distinctive Moorish architecture made an immediate impact on him. At that time Collioure was still operating as a major fishing port, but it was very cut off and still slightly exotic. And unlike such places on the Côte d'Azur as Cannes, Nice, and Menton that were already associated with tourism, Collioure was not yet modernized. This soon changed when Signac recommended the port to the younger generation of artists whom he had already introduced to Saint-Tropez. As a result, Matisse and André Derain arrived in Collioure and began working in a style

37. Henri-Edmond Cross

The Evening Air (L'air du soir), ca. 1893
Oil on canvas
45⅝ × 65⅜ in. (116 × 166 cm)
Musée d'Orsay, Paris. Donation of Mme.
Ginette Signac, RF 1976 81

38. Henri Matisse

Luxe, calme et volupté, 1904
Oil on canvas
33⅞ × 45⅝ in. (86 × 116 cm)
Musée d'Orsay, Paris. Inv. DO 1985-1

39. Maurice Denis

Eurydice, ca. 1903–1904
Oil on canvas
29¾ × 46 in. (75.5 × 116.8 cm)
Nationalgalerie, Berlin. On permanent
loan from the Siemens Foundation,
inv. F.V. 181

that evolved into Fauvism. The Fauves, a group that included Henri Charles Manguin, Albert Marquet, and Charles Camoin in addition to Matisse and Derain, placed emphasis on creating harmonies of pure colors applied with a variety of brushstrokes that made no attempt to conceal the flat surface of the picture.

The impact of Collioure on Matisse, who like the other Fauves had been born under the more changeable light of northern France, is most clearly seen in *Open Window, Collioure* of 1905 (ill. 40), which shows the artist's view from a window overlooking the harbor at Collioure. Views through windows often occur in the iconography of Romanticism, and they fascinated Matisse.[51] There is a contrast in *Open Window, Collioure* between the internal and the external worlds, or enclosed space and open space, symbolizing the difference between reality and imagination, or the passive life and the active life. This picture has been well described as perhaps "the richest and most radiant expression of Matisse's sense that painting gave access to another world: a mystery, glimpsed through an open door or window."[52] Such an image accords with Matisse's aim to create "an art of balance, of purity and serenity, devoid of troubling or depressing subject matter, an art that could be for every mental worker, for the businessman as well as the man of letters, for example, a soothing, calming influence on the mind, something like a good armchair that provides relaxation from physical fatigue."[53] The yachts, or their masts so tantalizingly seen in *Open Window, Collioure*, of course existed in the real world that Matisse experienced, but in the act of being painted they have been transfigured into "such stuff as dreams,"[54] which may, or may not, be within the viewer's grasp. It is ultimately an image of longing and of escape. Over only a few decades the yacht passed from being a symbol of technological advance to one representing the condition of man.

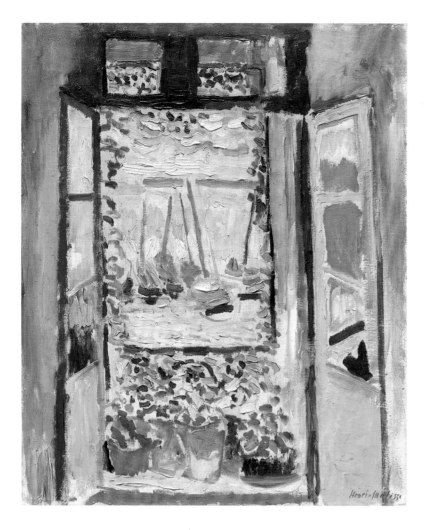

40. Henri Matisse
Open Window, Collioure (La fenêtre ouverte, Collioure), 1905
Oil on canvas
21¾ × 18⅛ in. (55.3 × 46 cm)
National Gallery of Art, Washington, DC.
Collection of Mr. and Mrs. John Hay Whitney, 1998.74.7

NOTES

1. The most important general surveys of Impressionism are Rewald 1946 [1973]; Herbert 1988; Smith 1995; Schapiro 1997; Thomson (B.) 2000; and House 2004, all with detailed bibliographies. For other movements mentioned in this essay such as Post-Impressionism and Neo-Impressionism, see Thomson (B.) 1983, and for Fauvism, see Whitfield 1991, also with further bibliographies.
2. Full discussion of the content and background of the eight Impressionist exhibitions can be found in Washington/San Francisco 1986, which was followed

by the definitive publication Berson 1996, which, where possible, identifies and illustrates the exhibited works and reprints contemporary criticism in full.
3. On the Salon in the second half of the nineteenth century, see Mainardi 1989 and Mainardi 1994. Ward 1991 supplies information about independent exhibitions. Precedents for the eight Impressionist exhibitions were created by the special pavilions set up by Gustave Courbet for the display of his own work at the Expositions Universelles of 1855 and 1867, and by the Salon des Réfusés established by Napoléon

III in 1863, where Manet showed three paintings, including *Déjeuner sur l'herbe* (Musée d'Orsay, Paris).
4. The term was coined on the basis of disparaging remarks made in a review by Louis Leroy of the first Impressionist exhibition of 1874, published in *Le Charivari*, under circumstances explained in Thomson (B.) 2000, 125–28; the complete text of the review is reprinted in Berson 1996, vol. 1, 25–26. Monet's painting *Impression. Sunrise* (ill. 1), which includes the word in its title, is in fact a view of the port of Le Havre.
5. This issue was the subject of an exhibition;

see London/Amsterdam/Williamstown 2000.
6. On collectors of Impressionist art in general, see Distel 1990. Since that publication several detailed studies involving European and American collectors have appeared: see Atlanta/Seattle/Denver 1999, Atlanta/Minneapolis 2000, and Edinburgh 2008. Further contributions have been made by Weitzenhoffer 1986, Rewald 1989, and Fowle 2010.
7. This subject is dealt with comprehensively in Atlanta/Denver/Seattle 2007, with further bibliography.
8. In a letter of January 23, 1905, to Roger

Marx (Cézanne 1976, 313). Cézanne is echoed by Damien Hirst in an interview with Sir Nicholas Serota, the director of the Tate, London: "You've got to devour the history of art in order to be able to do anything, to get to a point where you want to do something that's yourself" (London 2012, 97).

9. The *Voyages pittoresques* is discussed in the very important exhibition catalogue Washington/Worcester/Chapel Hill 1982, 15–26.

10. The significance of landscape painting during the second half of the nineteenth century in France is a much-studied topic that has been explored in several important exhibitions: see Los Angeles/Chicago/Paris 1984; Edinburgh 1986; Edinburgh 1994; Paris/New York 1994, with reference to the three essays by Gary Tinterow on 55–93, 125–47, and 233–63; London/Boston 1995; London 1997, with reference to the essay "The 'Modern' Landscape" on 106–19. Conference papers relating to the exhibition held in Edinburgh in 1994 were collected in Thomson (R.) 1998.

11. For the significance of Millet, see particularly Paris/London 1975 and Boston 1984.

12. The travel literature is impressively analyzed in Richard Brettell, "The Impressionist Landscape and the Image of France" and "The Cradle of Impressionism," in Los Angeles/Chicago/Paris 1984, 27–49 and 79–87, respectively. Photography is the subject of Françoise Heilbrun, "Appendix: The Landscape in French Nineteenth-Century Photography," in the same catalogue, 349–62. It is worth noting that Émile de La Bédollière's *Le Tour de Marne* (1865) was illustrated by photographs taken by Ildefonse Rousset, who, like Daubigny (see pp. 78–83), worked from a specially built floating studio. His images of the River Marne are redolent of Pissarro's painting illustrated here; see Washington/Worcester/Chapel Hill 1982, 153–57.

13. Several examples of these specific landscape motifs were included in a Sisley exhibition (see London/Paris/Baltimore 1992) and two Monet exhibitions (see Boston/Chicago/London 1989 and Boston/London 1998). This tradition was carried on during the 1880s when a colony of artists (among them Sir John Lavery and William Stott of Oldham) established themselves at Grez-sur-Loing, just to the south of the Forest of Fontainebleau, which is where the composer Frederick Delius also came to live in the 1890s.

14. "The web of roads, railroads, and rivers that ran throughout France during the nineteenth century was without doubt the most formidable system of transport and communication in the world" is how Scott Schaefer opens "Rivers, Roads and Trains," in Los Angeles/Chicago/Paris 1984, 137–45. For more recent historical research see Robb 2007, chap. 12, 231–49. The Seine itself is the subject of an illuminating essay by Richard Brettell, "The River Seine: Subject and Symbol in Nineteenth-Century

French Art and Literature," in Washington 1996, 87–129.

15. On the roads, see most recently Robb 2007, chap. 11, 215–30.

16. Flaubert 1975, 15–16. It took a steamer about thirteen hours to travel from Paris to Rouen and then another ten hours from Rouen to Le Havre.

17. Judt 2010, 60.

18. Ibid.

19. The most relevant guidebook published by Joanne is *Les Environs de Paris illustrés*, first published in 1856 and revised and reissued on numerous occasions subsequently. "If there was one book that proposed to systemize French tourism in the period of Impressionism, it was Joanne's guide" (Brettell, in Los Angeles/Chicago/Paris 1984, 44). Jules Janin's *La Normandie* was published in 1844 with illustrations that have a "striking relevance for Impressionist art, so much so that many of the river scenes painted by Monet and Pissarro surely bear a certain relationship to this last glimmering of the romantic topographical tradition, whether it be Monet's trains shooting across the bridge at Argenteuil, or Pissarro's steamers chugging up river" (Lloyd 1986, 80 and plates 38–40).

20. For the Impressionists and the coastal resorts on the English Channel, see Sylvie Gache-Patin and Scott Schaefer, "Impressionism and the Sea," in Los Angeles/Chicago/Paris 1984, 273–78; Herbert 1988, 265–302; Herbert 1994; and Michigan/Dallas 2009.

21. Interestingly, in the nineteenth century Boudin and Signac carried on the tradition of depicting the harbors and ports of France.

22. "Suburban Leisure" is the subject of one of the finest sections in Herbert 1988, chap. 6, 195–263. Clark 1985, chap. 3, 147–204, assesses the political implications of the invasion of the suburbs. The social tensions are wonderfully revealed in Maupassant's short story "A Day in the Country," first published in *La Vie Moderne* in 1881 (Maupassant 2009, 67–79).

23. Zola 2004, 55–64.

24. Maupassant 2004, 78–79.

25. On the sewage system of Paris and its impact on the suburbs, see Tucker 1982, 149–52; Herbert 1988, 202; and Washington/Hartford 2000, 38–40.

26. For detailed studies of Argenteuil see Tucker 1982; Herbert 1988, 229–46; Tucker 1995, chap. 5 "Monet at Argenteuil: 1871–1878," 53–100; and Washington/Hartford 2000.

27. This point is made by Herbert 1988, 242–43.

28. Tucker 1982, chap. 4 "Boating at Argenteuil," 89–120; Katherine Rothkopf, "From Argenteuil to Bougival: Life and Leisure on the Seine, 1868–1882," in Washington 1996, 57–85; and Washington/Hartford 2000 deal with the subject of sailing at Argenteuil at length.

29. Close analysis of this painting is undertaken by Clark 1985, 163–67; and Herbert 1988, 236. Such unresolved

implorations are found in the work of Jean-Antoine Watteau, as indeed on the right of his famous *Pilgrimage on the Island of Cythère* of 1717 (ill. 26) that was often used as a point of reference (usually satirically) by French avant-garde artists in the early 1880s (Smith 1997, 56–58). *Argenteuil* might conceivably be interpreted as Manet's modern take on Watteau's picture.

30. This phrase comes from Herbert 1988, 236.

31. On Daubigny's floating studio, see pp. 78–83 of this publication.

32. This breakdown follows Herbert 1988, 229–30.

33. As posited by Tucker 1982, 92–96.

34. There is an element of stealth in the use that Monet made of his floating studio, and the pictures he painted from that vantage point tend to be in a looser and more spontaneous style. Often the floating studio is surreptitiously hidden among other craft in general views of the boat rental area (see ill. 108).

35. On these paintings, see Ronald Pickvance, "La Grenouillère," in Rewald and Weitzenhoffer 1984, 38–51; and Herbert 1988, 210–19.

36. Hesitantly identified by Tucker 1982, 102, with a regatta held on June 7, 1874.

37. See Daniel Charles, "Caillebotte et la navigation à voile," in MB, 23–28.

38. As given in Paris/Amsterdam/New York 2001, 304.

39. As given in Paris/Amsterdam/New York 2001, 298.

40. For more on Signac's boats and illustrations of them, see FC, 71–73.

41. Recounted by the artist's friend Georges Lecomte, as given in Paris/Amsterdam/New York 2001, cat. 37.

42. Quoted in Paris/Amsterdam/New York 2001, cat. 34.

43. Thomson (R.) 1985, 177–81.

44. On Redon's marine imagery, see Fred Leeman, "Redon's Spiritualism and the Rise of Mysticism," in Chicago/Amsterdam/London 1994, 215–36, especially 233–34; and Paris/Montpellier 2011, cat. 116. Leeman kindly discussed the point further with the author in March 2012. For the iconography of the storm-tossed boat, see Eitner 1955, 287–89.

45. Signac subsequently published an account of the voyage in two parts, "D'Océan en Mediterranée par les canaux," *Le Yacht*, September 17 and September 24, 1892, 343–44 and 351–52, respectively.

46. Maupassant 2008, 8–9.

47. Boswell 1960, vol. 2, 25–26.

48. Price 2010, vol. 2, cats. 276 and 277. On the theme of the Mediterranean in European art generally, see Paris 2000.

49. Signac's two paintings are FC, cats. 234 and 253, respectively. His political views are summarized in Anne Distel, "Portrait of Paul Signac: Yachtsman, Writer, Indépendant, and Revolutionary," in Paris/Amsterdam/New York 2001, 46–47, and also under cats. 75 and 88B. Signac became a

member of the Anarchist-Communist Party in 1888. On Signac's politics, see also Herbert 2001, which is a carefully considered review of the exhibition held in Paris, Amsterdam, and New York in 2001.

50. Maupassant 2008, 37.

51. For the iconography of the open window, see Eitner 1955, 281–90; and New York 2011. Blum 2010 gives a detailed study of this motif in the whole of Matisse's work, with a different interpretation of the artist's intentions in *Open Window, Collioure* (see no. 20, 34–37).

52. Spurling 1998, 305. The finest description of this painting, however, remains Flam 1986, 132–34, which is so good that it ought to be committed to memory.

53. Flam 1995, 42.

54. Shakespeare, *The Tempest*, Act 4, scene 1, lines 156–57.

The Making of Impressionism

BOATING, TECHNOLOGY, AND UTOPIA IN NINETEENTH-CENTURY FRENCH ART

Daniel Charles

A Circle of Sailors

Young Oscar Monet detested going to school "when the sun was inviting, the sea beautiful, and when it felt so good running along the cliffs . . . or paddling in water."[1] He lived on the shores of the great harbor of Le Havre, France, where his father and his uncle were ship suppliers. Later, when Oscar became famous under his chosen name of Claude, commentators defined his father as a grocer, which he was; but he did not simply sell two slices of ham to the neighbor with a yellow dog—he sold twenty hams and more to officers with ships sailing far beyond the horizon.

Monet's first avowed master Eugène Louis Boudin ("he took over my education with unfailing goodness"[2]) also had familial connections to the water. Boudin was the son of a shipwright and fisherman; his grandfather and great-grandfather, also fishermen, had both died at sea. In his early twenties Monet met the Dutch artist Johan Barthold Jongkind, who had painted marine pictures in Holland (see ill. 41) before studying under Eugène Isabey, one of France's leading marine painters.

Monet's peers also had bonds to the water. By the early 1860s Édouard Manet had tried and failed two times to become a naval officer; he had also crossed the Atlantic twice as an apprentice seaman. Camille Pissarro, born in the Virgin Islands, where his father was a ship chandler, had sailed across the Atlantic four times. The promising artist Frédéric Bazille, who died young in 1870 during the Franco-Prussian War, was as much a champion rower as a painter.

41. Johan Barthold Jongkind
*Frigates, Port of Harfleur (Frégates,
port de Harfleur)* ca. 1852–1853
Oil on canvas
21½ × 31¾ in. (54.6 × 80.6 cm)
Sterling and Francine Clark Art Institute,
Williamstown, Massachusetts. Acquired
by the Clark in memory of Eugene W.
Goodwillie (Institute Trustee 1959–74),
1974: 1974.4

Pierre-Auguste Renoir, who also loved boating and its delights, wrote to Bazille in 1865: "We are leaving on a long-haul voyage in a sailboat. . . . We're going to see the Le Havre regattas. . . . I believe it could be charming. Nothing to prevent you from leaving a place which displeases you and nothing either to prevent you to stay at an amusing place."[3] This was a ten-day trip in a boat without comforts, down the tortuous Seine against dominant winds—a difficult assignment even for experienced and assiduous sailors.

Another experienced boater was Alfred Sisley. He taught sailing to a keen canoeist named Gustave Caillebotte. The pupil, apart from a brief career as an artist (1876–1881), became France's leading yachtsman and yacht designer (see pages 70–74 and 212–215). In his turn, he taught sailing to a budding painter by the name of Georges Seurat. Henry Rouart— who participated in all of the Impressionist exhibitions but that of 1882— was involved in testing the first motorboat in history (see page 55). Later he launched the first commercial petrol-engine ferryboat in France—built in Caillebotte's boatyard.

Of all the major pre-Impressionist and Impressionist artists, only Cézanne and Degas lacked boating connections.[4] It is indeed incredible that

most of the major artists—roughly 85 percent—in one of the most celebrated art movements in history had nautical roots. They came from diverse origins—from rich (Bazille, Caillebotte, Degas, Manet, and Sisley), middle-class (Cézanne, Jongkind, Monet, Pissarro, and Seurat), and poor (Boudin and Renoir) families; from the disparate geographical regions of the seashore, Paris, the South, and the center of France—and, apart from their artistic inclinations, they shared two important attributes: all had urban backgrounds and most had some direct connection with boating.

This common nautical foundation has, nonetheless, been generally overlooked. One of the causes of this oversight is the misunderstanding that surrounds marine painting. Today it is considered anecdotal, of purely picturesque interest, but in the eighteenth and nineteenth centuries it was a major genre on par with the subjects of landscape, portraiture, and history. Indeed, the renown of marine artists such as Claude-Joseph Vernet, Théodore Gudin, and Isabey was on equal footing with that of the most famous landscape artists of their time. In 1866 it was as a *peintre de marine* that Monet first introduced himself at the Salon. Why in France, a country where the average town is about six times as far away from the sea than in Britain, did marine painting generate such interest and respect?

French taste for marine painting was deep-rooted. It had been the will of Louis XIV to put the seas under French domination, and he multiplied by eight the size of the French Navy from 1660 to 1683. France's hegemony passed with the Wars of Spanish Succession (1701–1714), followed by the French defeat in the Seven Years' War (1756–1763), after which Britannia ruled the waves. Still, the once-powerful navy left its equipage and machinery along French shores in whole purpose-built cities such as Rochefort, Le Havre, and Lorient, and in immense, fortified harbors such as Brest and Toulon (and soon Cherbourg). Spectacular establishments were also constructed, such as the Hôtel de la Marine, one of the two gilded cornerstones of Paris's Place de la Concorde. During the lean years under Louis XV, the French Navy banked upon innovation, inventing longer, faster, and more maneuverable ships whose performance compensated for Britain's numerical superiority. The formula of the seventy-four-gun ship, designed in France beginning in 1740, was even adopted by the British and became the mainstay of all navies. Later, Gaspard Monge's invention of descriptive geometry (geometry used for practical purposes in plans or mechanisms) allowed for such better and more efficient plans (see ill. 42) that it remained a state secret from 1765 to 1795.[5] Throughout this period the French Navy employed sixty to ninety thousand people—how were so many naval workers to be instructed in these innovations and emerging concepts? To teach this new technology, one needed didactic tools. At that time there were no affordable books, no videos, no websites. There was nothing but models—and, of course, paintings.

Marine paintings were not just realistic depictions: they also had to teach. Some had to describe more than others in what one may call "didactical realism." One would think that these colorful, two-dimensional "schoolbooks" would only have held interest for marine scholars, but instead their

attraction went far beyond those directly concerned with the nautical world, reaching unexpected locales. Such pictures could be found in mountain-bound châteaux, in city mansions—in some of the most un-maritime-like settings imaginable. Why? What made them appeal to non-mariners, to those people who had never even seen a ship? The reason was that these marine pictures were much more than evocations of boats, travel, adventure, survival, or commerce: they represented the proud imprint of mankind's technological superiority over nature.

In fact, marine painting held a de facto monopoly on the representation of technology. Of course, one would find a cannon here and there in pictures of battles, but these depictions were foremost about action—smoke and dust, and great dashes of people and horses. Likewise, one could find a bridge crossing a landscape in many paintings, but until the late 1700s the means by which to build a bridge were widely understood and needed no technical explanation, not least of all in a painting. Ships were different. Their ways and means changed with time in a society where technology had not yet evolved. There was no larger-sized technology than marine technology, and its maximization also required the most minute objects. For example, on a seventy-four-gun ship[6] there was such an enormous number of

42. Ship drawing, eighteenth century, collected by Frederik Henrik Chapman and published in *Architectura Navalis Mercatoria*, 1768. This drawing, made by Chapman, was engraved by his nephew, Lars Gobman.

43. Claude-Joseph Vernet
The Port of Marseille (L'intérieur du port de Marseille), 1754
Oil on canvas
65 × 103½ in. (165 × 263 cm)
Musée national de la Marine, Paris.
Inv. 8294

blocks (or pulleys) needed — 1,400 — that this quantity constituted a great incentive to mechanize production. Thereafter, the block-making machinery (designed in 1799 by the Frenchman Marc Brunel using Monge's descriptive geometry) "represented what was perhaps the first example of fully mechanized production in the world."[7] Thus the marine world was the spearhead of advanced technology.

However, correctly representing technology did not mean that the overall picture was always truthful. Indeed, some of Vernet's spectacular *vues de ports* may be ranged among the most misleading, *unrealistic* realist pictures ever brushed (see ill. 43). To fill the harbor of Marseilles with the number of ships Vernet painted would probably have required the entire Mediterranean fleet and then some. Of course there were excesses and distortions of truth: this has been the rule of all narratives since Homer, and marine painting was not immune. Hyperbole, as much as the sea, interwove the many genres of marine painting. And yet these exaggerations were enslaved to the dictates of causality: the shrouds had to stay the mast, the rudders had to be correctly placed, and the sails had to be properly

oriented, all to respect the cause-and-effect relationships that made the narrative work.

Nowhere more than at sea was causality so dominant. Of course one found superstitions and legends offshore as much as in any province; however, at sea there was no delayed reaction to let superstition linger. At sea, results were instantaneous — if one did not slacken the jib, the boat would not tack — and it was the same for any representation of technology. Exactitude was crucial to understanding a chain of events. On the contrary, in the countryside one had to wait a whole season to see whether the "Spirit of Fertility" had made the grain grow, and this time lapse blunted the impact of causality. In a landscape one could paint a waterfall going nowhere — as long as it was satisfyingly rural, who cared?

Well, somebody cared. The scientific conquests in the eighteenth century were skeptic quests for explanations, for proofs that causality chains (not deities) were the motors of events, and that by respecting them human-kind could master its own fate. Landscape painting, in this cultural environment, was not shielded from the scientific approach that already benefited marine paintings. "Painting," professed John Constable, "is a science and should be pursued as an inquiry into the laws of nature."[8] For example, Constable transposed into his pictures the scientific observations about clouds made by his contemporary Luke Howard.[9] Before revolutionizing landscape painting, Constable had been extensively exposed to the sea's rules and culture. His father owned a sailing ship to carry his corn flour to London; the artist himself sailed the southern shores of England, lived in coastal Brighton, and produced some notable marine paintings. He shared the marine artists' rejection of any artistic license with causality. This denunciation he transposed onto his landscapes, claiming: "Let the form of an object be what it may, — light, shade, and perspective will always make it beautiful."[10]

At such time the Industrial Revolution anchored technology to the ground. Progress was then able to transform the landscape like it had transformed the sea. When Constable painted *Chain Pier, Brighton* (ill. 44) in 1826–1827 this seaside structure, stayed like a ship's rig, was only three years old and the most modern architectural artifact in Britain. Such man-made landscapes demanded a realistic representation, a nonjudgmental exactness that the marine painters had championed.

Constable's refusal of the Neoclassicists' and Romantics' abandon and his habit of painting outside the atelier created a stir in Paris, where some of his landscapes were shown at the 1824 and 1827 Salons; in the latter he received from the French monarch a gold medal for *The Hay Wain*, which hung beside the offering of a promising newcomer, Jean-Baptiste-Camille Corot. Constable's impact was long-lasting: two decades later, as the French Revolution of 1848 thrilled many into stating what they stood for, the informal Barbizon School of painters claimed Constable's precepts as their credo.[11]

"Make a habit of truth,"[12] repeated Thomas Couture to the young Manet during the six years that Manet worked in his atelier. Couture (who

44. John Constable

Chain Pier, Brighton, 1826–1827
Oil on canvas
50 × 72 in. (127 × 182.9 cm)
Tate Britain, London. Purchased 1950,
N05957

would become an adversary of Impressionism) was not exactly part of the Barbizon School, but Jean-François Millet was one of its leading lights, following in Constable's footsteps; together Couture and Millet encouraged the young Boudin. And so, the son of the Honfleur shipwright (Boudin) motivated the son of the ship supplier (Monet), who then met the failed naval officer (Manet) and the son of the ship chandler (Pissarro), and so forth. The circle was created, and soon it spread like ripples on water.

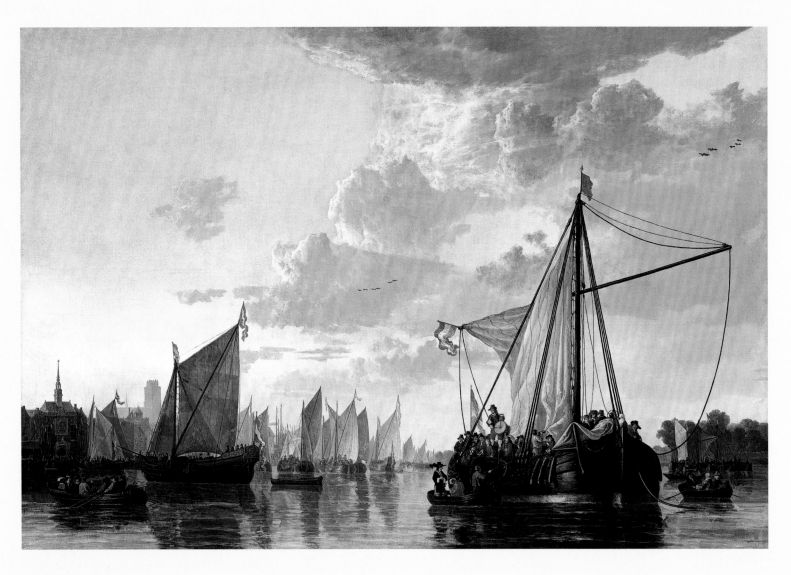

45. Aelbert Cuyp
The Maas at Dordrecht, ca. 1650
Oil on canvas
45¼ × 67 in. (114.9 × 170.2 cm)
National Gallery of Art, Washington, DC.
Andrew W. Mellon Collection, 1940.2.1

THE DUTCH PIONEERS

The rules of didactical realism were pioneered by many of the
Dutch painters of the seventeenth century. Holland was the
first modern country to reach domination through technology—
from polders and windmills to fore-and-aft rigs and leeboards.
In 1670 the Dutch merchant fleet was two and a half times larger
than the combined fleets of Britain and France. This prosperity
built a demand for paintings that would represent its very techni-
cal sources. The influence of the Dutch painters extended inter-
nationally, beyond the Dutch Golden Age. However, the Dutch
realists did not pursue, as Constable did later, "an inquiry into the
laws of nature." In Aelbert Cuyp's picture *The Maas at Dordrecht*
(ca. 1650) (ill. 45) some of the sails are in a perfect calm
(especially those of the crowded center boat) while others are
not, and the flags gyrate as if powered by their own private
breeze. Note the ornate sea *jacht* at middle left. It was such a
jacht that transported Charles II back to England, giving birth to
British yachting.

46. Joseph Mallord
William Turner
The Chain Pier, Brighton, ca. 1828
Oil on canvas
28 × 5⅜ in. (71.1 × 13.65 cm)
Tate Britain, London. Accepted by the
nation as part of the Turner Bequest
1856, N02064

Toward a New Golden Age

John Constable was not the only artist to consider the Chain Pier in Brighton
worthy of representation: less than two years after he brushed his composi-
tion, Joseph Mallord William Turner painted the identical subject (ill. 46).
However, whereas the first views the subject from the shore as an example
of maritime architecture, the second shows it from the sea along with a
retrospective portrait of the three successive phases of naval transportation:
a rowing boat in the foreground; just behind it, two intertwined sailing
vessels; and behind those, closest to the Chain Pier, the (then) paragon of
modernity—the steamship. From there the spectator's eyes glide toward this
most progressive of structures, the pier itself. Fifteen years earlier neither
the pier nor the steamship existed: this was a picture of a changing—
a progressing—world.

 This nascent progress was already orphaned of its oracular leader,
who had passed away in 1825—Claude-Henri de Rouvroy, Comte de
Saint-Simon (1760–1825), who became the posthumous flag bearer of the
new times. His fame was paradoxical: he was buried without a Christian
service, but a church was created in his honor; he influenced Karl Marx, but
others among his followers created major capitalist institutions.[13] Although
Saint-Simon is now best remembered as the prophet of industrialism, he
actually published his first work on the role of the artist in society: "Learned
artist . . . use part of your forces to the progress of the enlightened, you
are the portion of humanity who has the most cerebral energy. . . . It falls
upon you to vanquish the force of inertia."[14]

The artist in Saint-Simon's writings stood on the same pedestal as the scientist: both explored knowledge. Such a quest would bring innovation, which would bring change, and in the early nineteenth century, change was still an alien thought. The laborer's way of life had not been dramatically altered for at least twelve centuries—why change then what had been good for the forefathers? For ages society had evolved at a glacial pace, if at all. Despite the theories and philosophies of Aristotle, Galileo, Newton, Descartes, Pascal, and so many others, science had been powerless to change the actual lives and well-being of the populace—why would it succeed now? "Because of industry," predicted Saint-Simon. Industry—this rarest of activities in agrarian France—would transform the world.

This concept sounded farfetched in the 1820s. Illiteracy in France then stood at forty percent; the words *modernité* (modernity) and *progressiste* (supporter of progress) only debuted in 1823 and 1841, respectively; the first French train did not run until 1830; and applied science was babbling in its infancy.[15] The technological horizon was, to the modern eye, incredibly narrow, but Saint-Simon looked past it to a future far away. His vision promised to "take the golden age away from the past to enrich future generations."[16] How enthralling such a messianic prophecy must have been—how thrilling it would have sounded to rise with "the artists, the imaginative men [who] will set the pace."[17]

Saint-Simon's progressive creed became the anthem of the Industrial Revolution in France, at the time Europe's second-largest economy.[18] "To initiate the masses to all the benefits of civilization, it is to dry up the sources of ignorance, of vice, of misery,"[19] wrote Louis-Napoléon Bonaparte, the future French emperor, in 1844, six years before forcefully transforming the Second Republic into the Second Empire, with himself on the throne under the name of Napoléon III. Like the emperor, any progressive Frenchman became *saint-simonien* by definition. Furthermore, anything implying social (see ill. 47) or technological change would be wrapped in the saint-simonien flag. Under the late aristocrat's banner, his secretary Auguste Comte launched sociology. Some followers built industries and, since they were the avowed "imaginative men setting the pace," they treated their workers paternalistically, "enlightening" them with salaries.[20] Others exported their concepts of civilization into the depths of Africa and Asia, launching France's colonialism. Disciples started banks that permanently

47. An anonymous engraving from the book *Solutions sociales*, authored by J. B. A. Gudin and published in 1871. The artwork is a depiction of Jean-Baptiste Godin's "ideal commune," Familistère, which was created in 1858–1883 and still stands today.

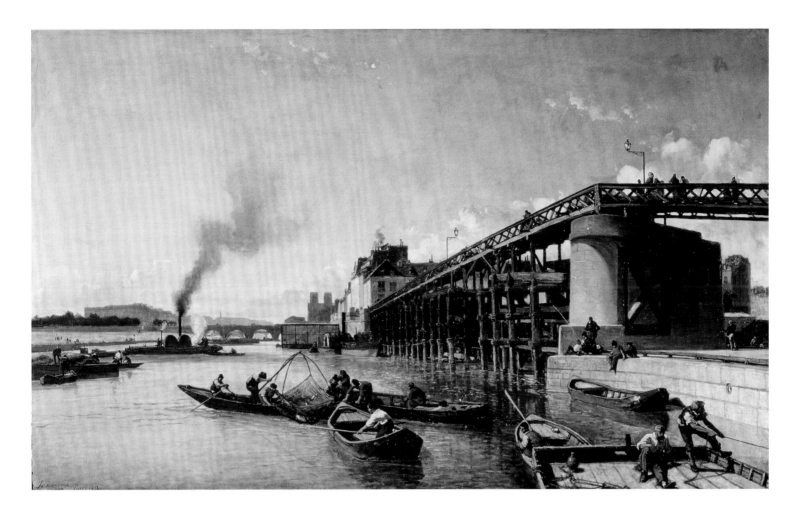

48. Johan Barthold Jongkind

The Estacade Bridge, Paris, 1853
Oil on canvas
41⅜ × 66⅞ in. (105 × 170 cm)
Musée des Beaux Arts, Angers, France
(AS107)

anchored French capitalism.[21] Another, Ferdinand de Lesseps, brought to fruition the old saint-simonien dream of linking the Mediterranean to the Indian Ocean, and built the Suez Canal. Then there were the artists, whom Saint-Simon believed to be the very avant-garde (such an appropriate saint-simonien word!) of his progressive ideology.

It would be a mistake to believe that art insulated painters from the urgent dreams of their time. If that were the case, why would Gustave Courbet portray in *Proudhon and His Children* (1865) Pierre-Joseph Proudhon, the founder of anarchism, who had stated, "Property is theft"?[22] Why would Manet twice paint the radical socialist politician Henri Rochefort, first in a portrait, then as he escaped from a prison colony in New Caledonia? Indeed, avant-garde artists were an active part of this modernization that metamorphosed France. Modernity was beautiful; industry was modernity; therefore, industry was beautiful. The most vital subject of the time could not be any other than this world transformed by Progress.

The Romantics portrayed wilderness in landscapes replete with unpredictable irregularities, but the saint-simonien painters disdained this view of "Nature-the-untouched." They would, on the contrary, focus on "Nature-the-improved-by-Progress" and "Nature-the-conquered"— a disciplined "Nature-bejewelled-by-Mankind-and-Industry." Armed with the didactical realism inherited from the marine painters, having learned from Constable to pursue "an inquiry into the laws of nature,"[23] these artists

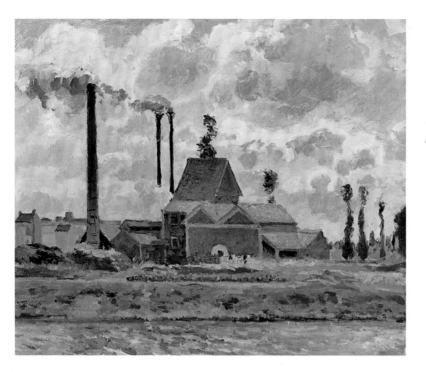

49. Camille Pissarro
Factory at Saint-Ouen-l'Aumône (Usine à Saint-Ouen-l'Aumône), 1873
Oil on canvas
18 × 21½ in. (45.7 × 54.6 cm)
Michele and Donald D'Amour Museum of Fine Arts, Springfield, Massachusetts.
James Philip Gray Collection, 37.03

did the same for the laws of technology. Jongkind was the first to accomplish this synthesis. He had studied with Isabey, the famous *peintre de la marine*. Since he was Dutch, to paint Nature-the-improved-by-Progress was easy in his land of man-made polders, canals, and dikes, where one proudly proclaimed, "God has created the world, but Holland was created by Hollanders."[24]

In Jongkind's *The Estacade Bridge, Paris* (ill. 48), painted in 1853, a quarter of century after Constable's *Chain Pier, Brighton*, nature itself is wiped away. Ancient, classical Paris is made interesting by a modern iron pier and by all the nautical activity surrounding it, including the very modern steam dredgers and tugs. The work boats are represented in amazing minutiae—they are so meticulously documented that one could rebuild them from this painting. Today this large canvas is one of Jongkind's less popular works, perhaps seen as lacking in poetry and focusing only on quaint subjects: man-made steam clouds, workers on their workboats, and a rickety pier. But this is not how the eyes of 1853 saw it. Then, this was not picturesque—it was exciting. All of it was new—it was the future.[25] It showed a world on the move. In the tableau human industry obliterates the ancient monuments—Notre-Dame fades into the misty background. It exemplifies Saint-Simon's motto: "Everything for and by industry."

Monet recognized Jongkind as "my true teacher and it is to him that I owe the final education of my eye."[26] The pupil followed in his master's footsteps. From his 1870 trip to Holland, Jongkind's native country, Monet brought back a series of paintings that look picturesque and charming to today's eyes, but at the time these works described and documented the spread of modern undertakings: man-made canals, windmills, roads, and fishing boats. Upon his return to France Monet forged ahead artistically. He and his like-minded friends depicted a modern world, an ideal place without the squalor of the old. When he, Pissarro (see ill. 49), and Cézanne painted factories with belching smoke that would today fill with revulsion the most tepid of conservationists, it was not out of loathing but rather to emphasize what orderly beauty the saint-simonien Progress brought to the landscape. That this optimistic faith was naïve and not nuanced, there is no doubt—and an awakening would soon come. Meanwhile, the Impressionists, city dwellers as they were, established themselves with a militant saint-simonien conviction shared by the middle class, which had gained so much from France's modernization.

However, the Impressionists' progressive inclinations had more basis than those of most artists: did they not host in their very midst an archetype of saint-simonien success? One artist who participated in most of the movement's exhibitions,[27] not content to be solely a gifted painter, also became a brilliant engineer. Henri Rouart was a *polytechnicien* who produced the first

commercially successful combustion engine, designed by his associate Étienne Lenoir.[28] About 1861 they tested the first powerboat—a radical breakthrough in centuries of nautical history—and then built a second one in 1865 (see ill. 50).[29] Rouart also founded a factory to make hollow iron tubing and pipes, creating work for five hundred people; he adapted the pneumatic mail tube to Paris;[30] and he went into partnership with Ferdinand Carré to produce his revolutionary absorption refrigerator, an ancestor of the modern appliance.

Above all, Rouart became the first Frenchman to produce explosion engines on a mass scale. He first built hundreds of de Bisshop gas engines (ca. 1871–ca. 1882), for which he invented the pressure regulator (still in use today in gas bottles). Then he produced a new Lenoir engine (ca. 1882), installing one on the first power ferryboat in history (1887). When challenged in the courts in 1883–1887 by Nikolaus Otto, who pretended to have been the first to make a four-stroke engine, Rouart won—another example of his successful enterprises. He was a man of the future, the perfect saint-simonien—a scientist and an artist who spent his fortune collecting paintings and helping his artist friends as the first Maecenas of the group.

The Impressionists, with typical Gallic Cartesianism,[31] buttressed their method by evoking the avant-garde literary movement of the time, Émile Zola's "naturalism"—they considered themselves "naturalist" painters. Indeed, the term *Impressionist* was first a soubriquet thrown at them by a traumatized detractor.[32] Of course they were criticized—did they not attempt to "vanquish the force of inertia"?[33] None other than Saint-Simon had warned: "With what relentlessness did the academies persecute men of genius when they fought their opinions! . . . Go over the history of mankind's spirit, you will see that nearly all its masterpieces were owed to isolated men, often harassed."[34] Their rejection certified pictorial naturalism as the mode of the avant-garde. Beyond showing things as they were ("realism"), naturalism demonstrated the impact of environment upon human behavior. Therefore, the Impressionists chronicled the impact of Progress: its cities, its bridges, its railways, its ships, and more.

However, their collective choice of soft-hued subjects appears perplexing. Peaceful rivers lazily spreading among the trees, stately bridges, quiet houses, and enchanting scenes of joie de vivre: all are in utter contradiction with the conflicts that unsettled France during those years. Since 1851 Emperor Napoléon III, a die-hard saint-simonien, had changed from an authoritarian dynamo to a progressive but ailing man. In 1870 the unprepared, undermanned, and mismanaged French armies lost against Prussia. The Empire fell, and France was occupied by German armies.[35] A reborn Republic signed a peace treaty that caused the uprising of the Paris Commune; in retrospect, the gory repression of this first proletarian revolution was incredibly gory (even by

50. A diagram of the four-stroke engine designed and built by Henri Rouart, hull by Gustave Caillebotte's yard. The engine was fitted vertically; its two cylinders, with pushrod-activated exhaust valves, were cooled by air and water. Twice a week the "Lenoir" brought passengers from Le Havre to Tancarville (14 miles) at 7.5 knots.

today's terrible standards).[36] France remained violently divided into monarchists and republicans.[37]

The conflicts did not spare the artists. Bazille was killed during the war;[38] Caillebotte, Degas,[39] Manet, Renoir, and Rouart were volunteers; Pissarro's large store of paintings was destroyed;[40] Monet fled to Holland and England; and Courbet's participation in the Commune exiled him to Switzerland, where he died. So what mark did such extraordinary strife leave on the production of the emerging Impressionist school? Apart from a few lithographs of the Commune by Manet, absolutely nothing. It was as if the Impressionists had rubbed into oblivion not only the sinister memories of the war and the Commune but also the drab conditions that still afflicted most French people.

These naturalist painters appeared unconcerned with the reality of human condition, and their idyllic stance would later be reprimanded by Émile Zola. Indeed, the writer's own novel *Germinal*, which is a story of a coal miners' strike, stood as a denunciation of plebeian distress; but once read, the outspoken book could lie silently on a shelf, as unobtrusive as any catechism or cookbook. Conversely, a painting on a wall remained enduringly visible, and who wanted to live with a dreary reminder of destitution? Happy paintings have always made commercial sense, but still one cannot suspect the Impressionists of such base commercialism. Why would they seek such enterprise when the radical nature of their art made it noncommercial by its essence? The group's cohesion was fueled by their critics; their disdain for the crowd's plaudits was organic. What then was the reason for their idyllism?

For the saint-simonien Impressionists, the painful aftermath of the Second Empire's collapse was paced by unimaginative men—the very opposite of Saint-Simon's "imaginative men setting the pace." Theirs was the time to represent the wonderful promises of the saint-simonien utopia. It was urgent to show with renewed conviction how people could be content in a life of idyllic leisure. Such promised bliss needed a symbol, and it had one—an archetype of a well-meaning, benevolent, lyrical Progress. It was a Janus-like icon, rooted in ancient tradition as well as in modern technical advances,[41] mixing continuity with metamorphosis in both reassuring and exciting ways. It was natural *and* mechanical. It was poetry *and* engineering. It was elitist *and*, in the Paris of the 1870s, surprisingly popular. This symbol was the pleasure sailboat, a dream everybody—rich and poor, intellectual and drudge—then understood and shared.

"The Parisian Is Essentially Nautical"

French sailing, alone in yachting history, was river born and (for a long time) river centered. Even though France's first emblematic yachting events, the Le Havre regattas that Renoir sailed to, occurred along the seashore, two major causes deeply rooted French yachting to fresh water.

The first reason was one of geographic necessity: all of the major historical towns (except Marseilles) were inland, far away from the sea. Even traditional seaports such as Bordeaux, Nantes, or Rouen were nested some sixty miles away from the waves.[42] All the large cities were established on rivers, arteries through which the blood of interregional commerce flowed. Indeed, most French *départements* (the state geographical subdivisions) owe their names to rivers. Waterways also transported people, as described in a memoir of 1824 that seems to evoke a *fête galante* akin to Jean-Antoine Watteau's *Pilgrimage to the Island of Cythère* of 1717 (ill. 26): "I went with a few friends, on a beautiful day of Sunday, to Choisy-le-Roi [from Paris]. The influence of spring marshalled the spirits to a vivacious hilarity. We boarded one of these water coaches where one travels cheaply, and where the company is ordinarily rather mixed. The benches soon filled up. . . . The vision of one of the young women had upon me a singular effect."[43] And even if in this case the flirtation went nowhere, aboard this crowded public waterbus of 1824, peacefully inching upstream while towed by a sedate horse, there already appeared all the future traits of French boating, of this *canotage* where urban dwellers of all stations in life would mix, laugh, flirt, et cetera.

The fondness of the French for their rivers had another (rather oblique) cause: until 1860 wine was cheaper outside the city limits.[44] This encouraged the inhabitants of cities to spend their free time on the outskirts, which were accessible by boat, in the absence of any other cheap public transportation. On the riverbanks stood *guinguettes*, or pleasure gardens, where the wine was cheap and one could eat and drink, sing and dance, kiss and even make love, and otherwise forget about the daily grind of life (see ill. 51).

Guinguettes (the word derives from *guinguet*, a cheap popular white wine produced in Île-de-France) were an invention of Paris, the old Seine harbor that was founded in pre-Roman times by a tribe of watermen. Paris's emblem was a ship, and its motto, *Fluctuat nec mergitur* ("It floats and won't sink"). And what was good for Paris was good for France, at that time the only centralized country of Europe.[45] Parisian river tastes would also pollinate the other urban centers whose problem was identical to that of the capital city: how to entertain the emerging class of workers. *Guinguettes* quickly spread at the water edges of most towns.

51. Illustration of a *guinguette* from the *Manuel universel et raisonné du canotier*, published in 1845

52. Illustration of a rowing regatta from the *Manuel universel et raisonné du canotier*, published in 1845

Le Canotier.

53. Frontispiece depicting a canotier from the *Manuel universel et raisonné du canotier*, published in 1845

MANUEL

UNIVERSEL ET RAISONNÉ

DU CANOTIER

OUVRAGE ILLUSTRÉ DE CINQUANTE GRAVURES SUR BOIS ET
RENFERMANT DES RECHERCHES HISTORIQUES

Sur l'origine et le développement du CANOTAGE

PAR UN LOUP D'EAU DOUCE

PARIS
DAUVIN ET FONTAINE
Passage des Panoramas

POISSY
OLIVIER-FULGENCE
Rue des Dames

1845

One of the most famous *guinguettes*, immortalized in Renoir's *Luncheon of the Boating Party* (ill. 25), the Maison Fournaise, was created by the wife of a boatbuilder who had established his workshop on the island of Chatou. The merrymaking was described by Abbé Jules Jacquin in his *Manuel universel et raisonné du canotier* of 1845, the first French book of boating (see ill. 53): "Only the river and its furies hold attraction for these misunderstood braggarts who feel sailors' hearts beating in their clerks' breasts, and are indignant at being condemned to their peaceful labors all week long. As soon as the morning of a Sunday or a holiday arises, the [clerk's] tailcoat is hooked up, his jersey pulled on; . . . and with beard bristling and a stub pipe in mouth, one steps aboard to cruise from Bercy Bridge to Charenton's, or to show off at the Asnières Bridge regattas."[46] This was the true leisure life.

Actually, this was the *only* leisure life. For the populace and the lower middle classes, no other alternative existed. There was, of course, no radio, TV, cinema, videos. Theater and revues were too expensive for most, and horse racing was the preserve of the upper classes.[47] Not enough readymade goods (nor riches) existed to make shopping worthwhile. As a result, "the Parisian is essentially nautical; he makes a point of justifying, against wind and tides, the symbol of this vessel on the ancient coat of arms of the city."[48] For the growing masses of petty workers and employees, male and female, the only leisure outlets for their unspent physical energies were drinking, singing, dancing, flirting—and boating. Other sports, such as soccer, rugby, tennis, and basketball, were not organized until the 1870s. The only exception was swimming in the Seine—and swimming mostly remained an informal pastime in the wild, unless one was fortunate enough to partake of the upper-class pool that a lifeguard named Deligny opened in 1801[49] in front of the Place de la Concorde.

It is on this quay, near the Bains Deligny, where one can pinpoint the sad birthplace of *canotage*. A nobleman, Edmond de Brivasac, kept there the Seine's first pleasure sailboat, which was apparently a rather makeshift affair. She capsized in March 1823, drowning M. de Brivasac and one of his crew, Louis Gudin. The latter's brother, Théodore, was saved and revived by Deligny, and he became one of the major French marine artists.

At its start *canotage* was not a sport. It could not have been, as the word *sport* only first appeared in French in 1828. The essence of early *canotage* was role-playing. As one observer noted in 1844: "The boater of the Seine performs aboard his freshwater Navy like Don Quixote performed being an errant knight. On everything else he is very reasonable; during the week he puts aside his sea customs, his piracy, his [tobacco] quid, his deep

voice, his gruffness, and all the paraphernalia he gets himself up on Sunday; he is only a rascal, a buccaneer, and a filibuster one day every seven."[50] On the water, those mostly first-generation urban dwellers returned to their rural roots. Jacquin's account hints at the passion of the weekend *canotiers*: "Never the lover who for the first time holds in his arms his idol, . . . never the drinker who uncaps an old bottle experienced such vivacious emotions as the ones felt by the Boatman who rushes downwind, sheet in hand, tiller under his arm, and taming with pride the wind and the water."[51] To go on the water and spite conformity was the Sunday revenge upon the etiquette honored on workdays. *Canotage* was, in essence, a safety valve, a theater of freedom. It was a carnival-like—and even carnal—display of festivity and immoderation.

Early *canotage* was a freemasonry of once-a-week rogues, with group "lodges" that each owned its own boat. One "belonged" to *La Rafale* (The Gust), *L'Écrevisse* (The Crayfish), *Le Crapaud* (The Toad), or *La Grenouille* (The Frog). And since one belonged to a lodge and defended one's own turf, competition was inevitable. Until the 1840s the most popular competition on rivers was the water tournament, a joust where each player would try to throw his opponent "into the drink," generally with a blunted lance. Such playful beginnings were not uniquely French; all over yachting history pomp, pageantry,[52] and improved mastery preceded speed races. From the 1830s onward rowing regattas became popular. The winners were feted to great fanfare: a tribune was dressed up with flags, speeches were made, and there was food, wine, song, and dance—and maybe a fight or two—all in accordance with the rowdy traditions of *canotage*.

However, competitive ambitions soon changed all that. Some wanted better-built boats with refined shapes and proportions. By the mid-1840s construction methods were already quite sophisticated, producing a lighter boat that was faster and easier to maneuver. The communal sailboat *Le Rôdeur* (The Prowler), of which a meticulous model still exists (ill. 54), shows in 1845 a mixture of the rowing boat's refined construction with the fat and jowly hull of a fishing sailboat. There was as yet no strong incentive for performance on the French rivers, no need to be inventive. Elsewhere, however, it was to the contrary. On the high seas during the eighteenth century superior performance was an obligation of the French Navy to compensate for its numerical inferiority against the British. Half a century later the oyster smacks of Britain's southeast coast—where British racing yachts originated—had reasons to be fast: their perishable cargo had to be delivered quickly, and many smacks engaged in smuggling, which meant that they had to escape the customs cutters. In New York Bay commercial competition encouraged technical inventiveness among the water-taxis that aimed to be first to collect and drop off their customers. Competition, more than function, is perhaps the true mother of invention—and competition would split the *canotage* world. It would attract a new sort of person, who strove to excel not just to compensate for the blandness of weekday life, but because each naturally strove to excel every day of the week. The arrival of these up-and-coming achievers ousted the boisterous pioneers of *canotage*.

54. Model of *Le Rôdeur* (1845), the oldest yachting model in France (the yawl rig is missing), from the Musée de la Batellerie, Conflans-Sainte-Honorine

But the rowdy frolics did not by any means disappear; they would in fact last until the 1960s, producing along the way the Java dance and the festive musette.

Despite the divorce between the *canotiers* and the racing yachtsmen, *canotage*'s risqué humor continued to color the new competitive French sailing. Years later—in 1880—the rich Caillebotte (whose half-brother, ironically, was curate of one of Paris's most select churches) built the ultimate Seine racing yacht, the refined culmination of thirty years of architectural evolution, and she dominated the Seine at once. This expensive and ultralight sporting tool had one half of her hull painted in trompe l'oeil bricks, and fake grindstones decorated the other half. The new champion was christened *Condor* (see ill. 56), but the evocation of an Andean predatory bird was as spurious a cover as the mock bricks. In truth, the name was a pun on a coveted part of female anatomy; and lest anybody doubt this below-the-belt meaning, Caillebotte had a large heraldic cat painted on the silk sail. Three years later, while still owning *Condor*, he named his next racer *Cul-Blanc* (White Bottom), thus completing the geography of the nether regions. And in the 1920s and 1930s one of the most competitive French types was the *Chat* (Cat) keelboat, whose class rules obliged every owner to give their boat a name beginning with "cha": *Charivari*, *Charlemagne*, *Chat-rade*, and so forth.

Returning to the late 1840s, competition could not exist without some rules and order. "A few teams . . . were exclusively made of badly mannered people . . . [and] *canotage* was surrounded by general reprobation. The name *canotier* became a diploma of bad conduct. One wouldn't dare anymore to admit in the world that one went on the water: it was at the least

55. A clipper at the time of the Impressionists, ca. 1874. These racers were approximately 55 feet long, and the river was only 500 feet wide; the huge sail was balanced by the weight of the crew and bags of sand or lead shot.

56. An anonymous drawing of Gustave Caillebotte's *Condor*, built in 1880. This clipper was the last and fastest of the pure clippers. The length on deck was only 27 feet, but she was 57 feet overall, with 1040 square feet of silk sails.

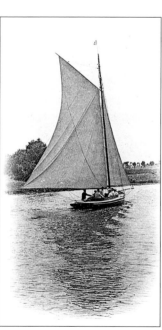

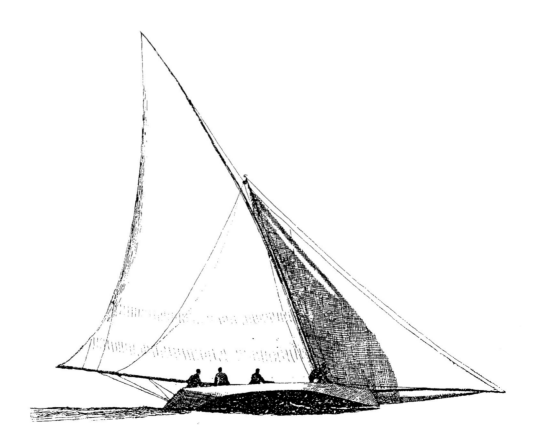

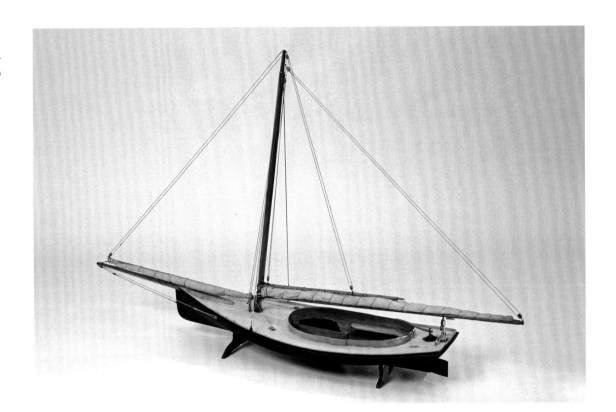

57. This model of an unnamed clipper was built in 1876 at the Musée national de la Marine. At the time, clippers were, for their size, probably the fastest wind machines in the world. Musée national de la Marine, Paris, inv. 3PL3

abandoning oneself to the most condemnable of eccentricities."[53] The response was to create ad-hoc organizational structures. From 1850 to 1860 seventeen yacht clubs were created in France; by 1875 they numbered thirty-seven. Their members shunned the communal ownership that had been the rule of the old *canotage* (and that still rules most rowing clubs today). The new sailors also preferred the foreign word *yachting* to the home-grown term *canotage*. With anglophile pretense,[54] the sailing bourgeoisie also called their racing boats "clippers" (see ills. 55, 56, 57). There was an excellent reason for this, as these racers did not originate in France—but they did not originate in Britain either.

Since 1827 the fleet of the Royal Yacht Squadron had made a habit of crossing the Channel for foreign excursions in Le Havre. The town's inhabitants, inspired by the English example, created in 1839 the first French yacht club, the Société des Régates du Havre. It organized a week-long regatta every July, which was a relaxed and somewhat parochial event: fishing and rowing regattas, demonstrations from the navy, and the usual pomp and circumstance. Pleasure boating was hardly represented; indeed the administration would not grant it a legal existence until 1850. However, something happened in 1848 to change all of this. Two cosmopolitan ship owners, one from Le Havre and one from Bordeaux, imported from New York Bay two local racing sailboats. Each was open-decked with a centerboard and a bow as sharp as a razor, and each had a very wide beam (measuring ten feet by some twenty-six feet in length—enormous by today's standards as well) to hike out ballast bags on the windward side. Each was lightweight but immensely stable to carry an enormous sail area, and each was fast— very, very fast. At the Société des Régates du Havre these new racers, among

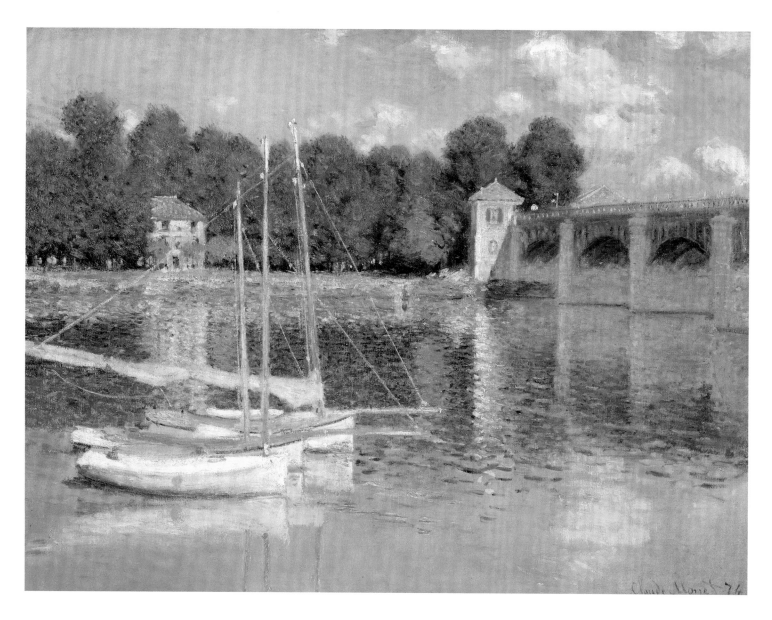

58. Claude Monet

The Bridge at Argenteuil (Le pont d'Argenteuil), 1874

Oil on canvas

23⅝ × 31½ in. (60 × 80 cm)

Musée d'Orsay, Paris. RF 1937.41

(DW311)

the motley workboats of Le Havre, were like tigers at a dog show. Lucien Môre, the founder of the Société, recalled in 1858: "I still remember the stupefaction of all the seamen at the view of these hulls so pointed at the bow, so wide at the stern, and so low on the water, of these 'irons' as they were called from their shape, and the vast stupefaction when they saw them fly and win."[55] These fast, most famous Yankee ships were called "sandbaggers" by the New Yorkers, but the stunned French spectators gave them their new name: "clippers."[56]

Of course, the American boats proved fierce and untamed in the hands of French crews used to more sedate behavior; in fact, one of the champions of Le Havre drowned her crew on her first outing in the Gironde. Still, numerous copies were instantly built in Le Havre, Paris, Nantes, Saint-Malo, and elsewhere. But to own a copy did not mean one mastered the original's operating handbook. According to Môre: "More or less fortunate imitations would not have been enough for Paris to admit the superiority of the centerboard boat if an original specimen of American construction had not been presented to the eyes of Parisian amateurs in 1853."[57]

Its successes owed much to the emergence of regatta-wise crews whose leader, Môre, remained all his life a proselyte of the American way of yachting.[58] While the new clippers spread all over France and beyond,[59] the growing maturity of the crews made them realize how the foreign model could be improved for better sailing in narrow rivers. The Yankee straight keel, so detrimental to maneuverability, became arched. Beyond the transom of the New York design grew an aft overhang whose deck allowed the crew to move their weight aft when running downwind. The remarkable skills of the Parisian boatbuilders, honed by the construction of rowing shells, made the new clippers lighter, more responsive, and better able to sustain larger sail areas hoisted on masts tall enough to trap the wind where it was. Watertight tanks were added to prevent a capsized craft from sinking. In fifteen years the Seine clipper became a formidable wind machine. When it came to tackling the fickle breezes of constricted rivers, it had no peer anywhere in the world.

The shape of the clipper hull influenced the racers of Marseilles; in turn, the rigs from Marseilles, with their gaff extending in line with the mast, influenced the Parisian clippers. This gunter rig[60] was adopted at Argenteuil during the period of 1870–1875 (see ills. 106, 59 [detail]). We know this because we have visual testimonies of this evolution, mainly thanks to *canotiers* who also painted and came to be known as the Impressionists.

From a yachting historian's point of view, the boats painted by the Impressionists are among the best graphic information available on this period. Here were artists who attracted reviews like: "Wallpaper in its embryonic state is more finished!"[61] Such artists, not known for their precision, still applied great care and accuracy to their representations of boats, treating the subject with the same faithfulness usually granted to portraits.

One of the very rare pictures documenting the way yachts of the time set their sails downwind in light air is Monet's *Regatta at Sainte-Adresse* of 1867 (ill. 14). Often, respect for details and practice went unexpectedly deep, as in Monet's *The Bridge at Argenteuil* of 1874 (ill. 58). It shows three clippers[62] yoked upon a common mooring. The one in the foreground has her mainsail and boom stored away; the halyard—the rope used to haul the mainsail up—has been carefully coiled on the deck, pancake-shaped, as is necessary to minimize damage to the ropes and to equalize their tensions. There is a rope fender on the side, in case another boat would want to tie up alongside. Between the second and third boats there is a horizontal sliver of

59. Detail of Claude Monet, *The Port of Argenteuil* (*Le bassin d'Argenteuil*), 1872 (ill. 106), depicting the rigging of the sailboats. This is one of the few paintings that shows the clipper evolution from gaff to gunter.

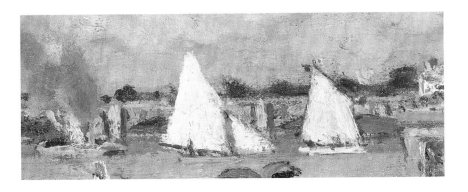

60. **John Singer Sargent**

An Out-of-Doors Study, 1889
Oil on canvas
25¹⁵⁄₁₆ × 31¾ in. (65.9 × 80.7 cm)
Brooklyn Museum, New York. Museum
Collection Fund, 20.640

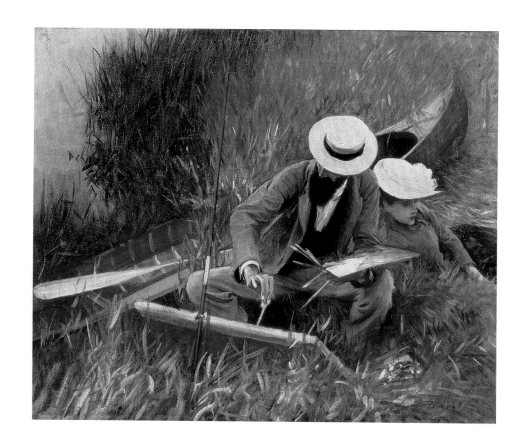

61. **Thomas Eakins**

The Champion Single Sculls (Max Schmitt in a Single Scull), 1871
Oil on canvas
32¼ × 45¼ in. (81.9 × 117.5 cm)
The Metropolitan Museum of Art, New York.
Purchase, The Alfred N. Punnett Endowment
Fund and George D. Pratt Gift, 1934, 34.92

Numéro 228 PRIX : 40 CENTIMES 10 Mai 1884.

A. ROBIDA

La Caricature

JOURNAL

62. Cover of the French journal
La Caricature, May 10, 1884, illustration
by Albert Robida

white that does not make much aesthetic sense. However, from a boating point of view, it must be there. If one yokes up three boats together on a river (say, the Seine) where commercial traffic may produce damaging waves, the boat in the middle must be held between the outer two, which need to remain stable to resist capsizing. Therefore, the two outer boats will have their heavy centerplates lowered, while the middle boat's plate will be raised. The sliver of white on the painting is just the tip of the raised centerboard on the middle boat—a respectful representation in its most minute details. However, there is something else in this painting that does not make much boating sense: a halyard going from the top of the middle mast down to the deck of the outer boat. It is important compositionally because it fills and animates a space that would otherwise be static. Here Monet did take some artistic license, but the boater in him refused to invent a completely fictitious line, so to cross this inert space in the painting he used a rope that already existed on the boat.

To give another example, on June 7, 1874, a Sunday, Monet and Renoir set their easels side by side on the shore of the Seine and sequentially painted a regatta (ills. 126, 127). In the time that passed between the scenes captured in the two paintings, the whole tactical situation changed. There was a luffing match; the leading boat in Monet's picture used her right of way and forced her competitors closer to the wind, allowing her to gain more ground, as shown in Renoir's picture.

This uncanny respect for nautical detail extended beyond the core French Impressionists to Dutch, Scandinavian, and American artists, among others. John Singer Sargent, in painting *An Out-of-Doors Study* (ill. 60),[63] took such care in representing the canoe in the reeds that one can recognize clearly the red mahogany planking, the steamed acacia frames, the floor in clear ash or elm—information precise enough to allow any good craftsman to rebuild precisely the same boat. Soon after his French studies in the same atelier as Caillebotte,[64] Thomas Eakins produced some of the most accurate representations of rowers (see ill. 61).

However, *canotage* remained intrinsically French. Granted its numbers were unimpressive: in 1854, when organized sailing competitions had barely begun, an author counted seven thousand *canotiers* among the million Parisians.[65] In a society still mostly preoccupied with survival, *canotage* was marginal—but it was iconic, a multifaceted image of leisure and excellence, of poetry and technology, and maybe of progress in general (see ill. 62).

To be part of this advance was, to the conservatives, "a diploma of bad conduct." As one such art critic quipped: "In its horror of the conventional [the Impressionist group] goes boating at Asnières or Argenteuil."[66] On the flip side, not to be part of *canotage* was a diploma of conservatism. The same Albert Wolff who described the 1876 Impressionist show as "a cruel exhibition [of] five or six lunatics haphazardly throw[ing] some color,"[67] had before "unsuccessfully looked for a moral function in the Regatta Society."[68] *Canotage* was a divide, the ridge separating the waters of the past from those streaming toward the future.

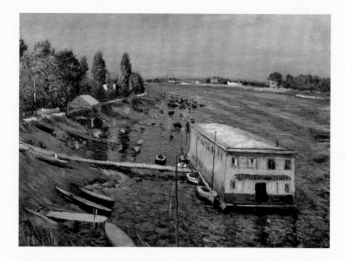

63. Gustave Caillebotte
The Pontoon at Argenteuil (Le ponton d'Argenteuil),
ca. 1886–1887
Oil on canvas
29⅛ × 39⅜ in. (74 × 100 cm)
Private Collection
(MB276)

THE CERCLE DE LA VOILE DE PARIS

The Cercle de la Voile de Paris (CVP) played a crucial role during the Argenteuil period. Created in 1853 as the Société des Régates Parisiennes, its activities initially involved more rowing than sailing. Tensions quickly arose between sailors and rowers, creating dissidences such as the Cercle des Voiliers de Basse-Seine (1858), soon to become the Cercle des Yachts de Paris (the upper-class Yacht Club de France had been independently created in 1860). Meanwhile, the sailing section of the Société des Régates Parisiennes refused to support the debts of the rowing section. After a two-year-long dispute, in 1865–1867, the sailors decided to rally the unwilling Cercle des Yachts, which they had to conquer. This infighting impeded sail racing on the Seine until the Franco-Prussian War in 1870 put a halt to it. Racing in Argenteuil started anew in 1872. On April 28, 1875, the Cercle des Yachts took the name of Cercle de la Voile de Paris. Caillebotte, a member beginning in 1876 and vice president from 1879 until his death in 1894, expanded the CVP's influence over the entire Seine. The Cercle was established on the upper floor of a pontoon (see ill. 63) (there was a boat keeper at the water level), and a clubhouse was created at 11 rue Saint-Lazare in Paris. From the eponymous railway station, trains brought members to Argenteuil in twenty-two minutes. Unhappily, in 1893 it was decided that an additional railway bridge would cut the legendary stretch of water at Argenteuil, and the CVP was forced downriver to Meulan, where Caillebotte bought, just before his death, its present plot of land. This is where the famous One Ton Cup started, and where the first (rather unofficial and discrete) sail races of the Olympic Games were held in 1900, and again (for the smaller classes) in 1924.[69]

THE STRAW BOATER HAT

Pétronille Cantecor (1770–1846) was a peasant in Sept-Fonds, a small village seventeen miles northeast of Toulouse. In the early 1790s she invented a way to make a flat braid of straw that was rigid enough to serve as the basis for a straw hat. The braid could be twisted into a round shape, each edge being sewn to the next. She established her first workshop in 1796 and began to sell her new braids to hatmakers. Soon she made her own hats. Sept-Fonds became the capital of straw hats, where hat factories employed some two thousand workers.

Initially these hats appealed exclusively to women. However, even single braided they had a quality that attracted the growing number of boaters around the cities—they floated. In the twentieth century they were nicknamed *canotier* (boater) hats and became one of the first modern items of unisex apparel.

In 1869 Fortuné Cantecor, Pétronille's grandson, saw in London a flat braid made in Canton (China). It had the same quality as his grandmother's braid but was much cheaper. Soon the weaving was abandoned, and the industry concentrated on buying and sewing the Chinese braids into hats. However, the single-braid construction made for rather soft and supple hats. There are six *canotier* hats illustrated in Renoir's *Luncheon of the Boating Party* of 1880–1881 (ills. 25, 64 [detail]), but none has the rigid rim of modern boaters.

The boater hat acquired its boxy shape in the 1890s. Some said that it was inspired by the hats of Venice's gondoliers, although those hats were then of black velvet; the Venetian straw hat was a later development. A more plausible explanation is that makers of straw boaters, wanting to free their product from its "cheap" image, began to pile up the braids, making the supple hat rigid and boxy. This metamorphosis justified a vast increase in price, and the boater became a high-class product.

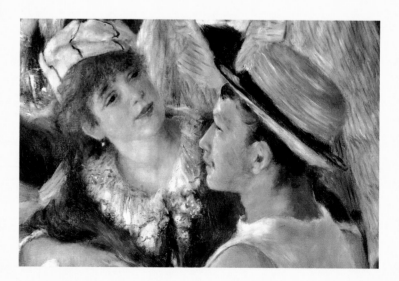

64. Detail of Pierre-Auguste Renoir, *Luncheon of the Boating Party (Le déjeuner des canotiers),* 1880–1881 (ill. 25),
depicting one of the straw boater hats shown in the painting

The End of the Affair

And then it ended. What had inhabited so many paintings, had been omnipresent with its favorite subjects of bridges, trains, and sails—Progress, the "beautifier of landscapes"—deserted art, taking with it all its shiny toys and gleaming boats. By a bizarre coincidence, Impressionism as a movement dissolved at the same time. Of course, Progress would pursue its irresistible expansion with cars, airplanes, atomic bombs, coffee machines, and more; and each Impressionist would continue to paint until each's own passing, although all began to focus their art on changing light, color, shape, and people, abandoning their earlier saint-simonien activism. One is compelled to ask why—why did the Impressionists change their subject matter?

What most likely sparked the Impressionists' 1881 dispersion was Degas's desire to introduce new members to the group.[70] "Degas brought disorganization between us," wrote Caillebotte to Pissarro.[71] Degas considered that the Impressionists' prime quality was their independence from the established authority, while Caillebotte and his entourage believed that the Impressionists stood for more. Perhaps their nautical origins or tastes, which Degas did not share, and their saint-simonien leanings, to which Degas never adhered, were the causes of the controversy. It was this discrepancy in the choice of subject matter that fueled the dispute. In return, it was the choice of subject matter that had always ensured the group's cohesion, which gives much more meaning to the reason why this saint-simonien subject and the *canotage* attached to it were abandoned.

The Impressionists were not alone in their desertion; in truth, they had been saint-simoniens when everybody was, and they stopped being so at the same time as everybody else. The utopia was not buried by a long shot, and it remained influential,[72] but it had lost its popular attraction. The gaping chasm between the ideal and the real had simply become too big to be ignored.

At this time Saint-Simon had been dead for more than fifty years. Back when the philosopher described his utopia, production was in the hands of artisans, industry was rare, and large industrial compounds were nonexistent. However, times had changed. Industry, which, according to Saint-Simon's creed, would free mankind from the dreary tyranny of the soil, actually generated new forms of servitude. Although many industrialists took the well-being of their employees to heart, notably building more or less advanced worker cities,[73] in truth "productivity at all costs" was the real name of the game—progress was not aimed at enlightening the masses, but at making money.

All this seems quite obvious today because we are accustomed to the ways of industry and of capital, but the utopians did not know any better. The biggest unknown concerned how people would react to a vast increase of monetary flow. Liquidity was extraordinarily scarce in preindustrialized times, when barter reigned: in the United States of 1830, for example, the currency circulation per inhabitant was only five dollars and twenty cents.[74] Then industry came and the circulation of goods generated prosperity and

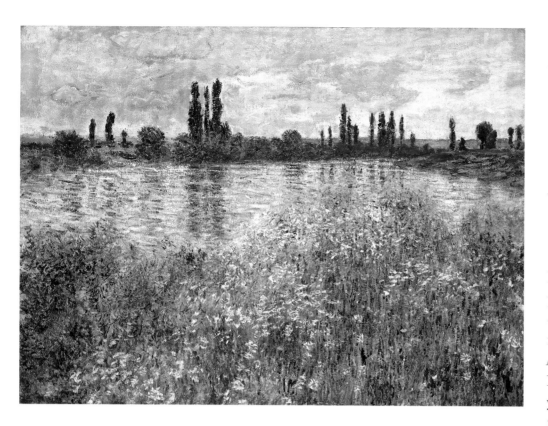

65. Claude Monet

By the Seine near Vétheuil (Au bord de la Seine, près de Vétheuil), 1880
Oil on canvas
28¾ × 39⅜ in. (73.4 × 100 cm)
National Gallery of Art, Washington, DC.
Chester Dale Collection, 1963.10.177
(DW597)

money. France's GDP increased seventy-five percent from 1832 to 1848.[75] How vindicated the saint-simoniens must have felt by this success that established their long-lasting influence. The disciples went on to create banks, industries, and railroads, offering what private savings lacked — a profit-making conduit. Then the speculators came, and the game changed. Money, with speculation, became an end unto itself. The politician François Guizot allegedly chanted: "Make savings instead of children. . . . Get rich!" And this motto became true from 1852 to 1870, during the eighteen years of stability and growth of the Second Empire. The disaster of the 1870 Franco-Prussian War, followed by a Third Republic that seemed only to benefit the speculators, killed this economic prosperity.

Monet, who had been the group's most militant and most consistent admirer of "Progress the beautifier," became the first to suffer from "Money the disfigurer." Around 1875, at the height of his saint-simonien period, Monet met an "ideal man" of the "ideal society": Ernest Hoschedé was a successful cloth magnate, established but open minded, with a charming family and an enchanting property; he was rich and generous, while also eclectic with artistic leanings.[76] This enlightened Maecenas supported the Impressionists (among others) and bought works by Sisley, Manet, and Monet. Alas, Hoschedé, the archetypal saint-simonien, was also a spendthrift, and he declared bankruptcy in 1877. This rudely awakened Monet from his utopian dream. The sale of the Hoschedé collection went poorly and depressed an already dire Impressionist market. The artist, his family, and the Hoschedé family took refuge in a miserable house in Vétheuil, where they spent two dreary years from 1877 to 1879; these difficult times were further exacerbated by the death of Monet's wife in 1879. In his own misery, the artist found solace in the contemplation of nature — Progress and its bridges and its seducing sailboats were suddenly less appealing and less trustworthy than light flickering in foliage (see ill. 65).

At this point the end of the affair was general. Despite nationalistic bragging, France was falling behind. It had been the first economy in Europe in 1700, the second in 1800, and the third in 1880: decline appeared irresistible. The country was split between right and left. The anticlerical republicans imposed secular education while the overly ambitious Catholic and monarchist bank Union Générale collapsed under the assaults of its Protestant and Jewish competitors. (The Impressionists were not immune to

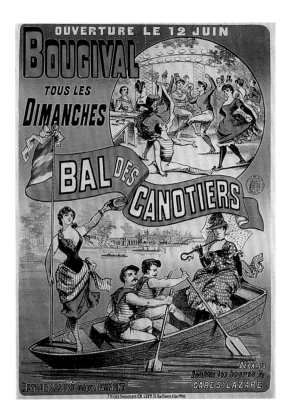

66. Boating Party (Bal des canotiers) poster, late 19th century

this collapse: the director of the Union Générale, Jules Feder, was financing Durand-Ruel, the group's principal buyer, who had to cease his acquisitions.) The eight years from 1879 to 1887 exhausted no less than twelve governments, the shortest lasting twenty days. Anarchism was on the rise[77]: "Many people [are] disgusted by the sad comedy that governments served us for so many years," claimed anarchist Louise Michel. "I am ambitious for mankind, what I would want is that everybody were enough of an artist, enough of a poet, for human conceit to disappear."[78]

A sort of anarchy swept the Impressionist group. Declared Monet as early as 1880: "The small [Impressionist] church has become a commonplace school, which opens its doors to the any first-come dauber."[79] By 1881 the group's cohesion was gone, even though Impressionist exhibitions would continue until 1886. Still, it was a uniquely long ride, considering that the movement had officially begun in 1874. They had been strengthened by many intellectual bonds (outdoor painting, naturalism, saint-simonism, boating) as well as geographical ones (Paris, Argenteuil). Geographical proximity, however, had become unnecessary with the rise of mobility. In the 1880s, in the time it once took Monet to go by train from Paris to Le Havre, one now reached Marseilles, and more comfortably so. The PLM[80] trains made "going south" a formality (see ill. 66): the sun and its colors were only ten hours away from the art merchants of Paris. And so each painter could go his own way, literally or figuratively, and each did.

Art did the same: Impressionism lost its avant-garde position to Pointillism and Symbolism (which would soon lose theirs to other -isms). Each avant-garde was fated to either give up what its artists had fought for or consent to become passé. Of the Impressionists, only Pissarro and Armand Guillaumin briefly tried to adapt their art to the new trends. It was an unwinnable fight because, as its disciples learned, Progress fabricates its own obsolescence. The era of proselytism was over. It was the time to leave behind realism, naturalism, and saint-simonism, and to follow instead one's own way into art for art's sake. To paint for art alone, not for representation, not for documentation, not for telling a story—this was a major turning point in art history.

It had taken only fifteen years for the Impressionists to break the antique chains of realistic representation. The dictatorship of "The Subject" was toppled over, superseded by a kingdom of fleeting colors, ephemeral lights, and instantaneous emotions. Freedom was there for all and it was there to be used—but the unleashed creativity would produce impermanent truths. With unwitting irony, the saint-simonien defectors had successfully built art on the very plan of Progress itself: a Manichean fight between innovation and obsolescence.

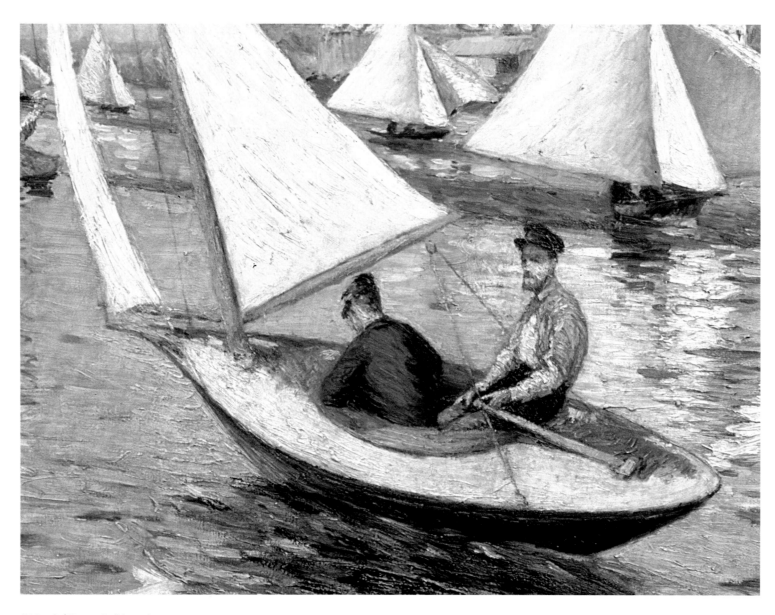

67. Detail of Gustave Caillebotte, *Regatta at Argenteuil* (*Régates à Argenteuil*), 1893 (ill. 132), depicting Caillebotte at the tiller, guiding his boat with just one finger

Caillebotte and the Ultimate Gesamtkunstwerk

The late nineteenth century was a time of perpetual change—in technology, finance, politics, society, and beyond—and most people were too ignorant to follow the new directions, much less understand them. In the face of such instability, narrow-mindedness was an obvious refuge; however, the Impressionists were above the failings of such ignorance. They were more than great painters. When they wrote, they wrote well, some even excellently (Boudin, Degas, and Renoir, for example). They were well traveled at a time when traveling was arduous and expensive. Their political consciousness was well informed and was, for the most part, unmarred by nationalism.[81] And at least two of them—Rouart and Caillebotte—were authentic Renaissance men.

Rouart's engineering achievements have already been detailed (see pages 44, 55). Gustave Caillebotte's were no less various and no less remarkable. Indeed, works by Caillebotte can be seen not only in the most prestigious art museums but also in the British Library, where his (and his brother's) stamp collection is "the foundation of the [British] national philatelic collections."[82] Also Caillebotte was without contest the most influential French yachtsman of his time. He singlehandedly proved that the clipper model was outdated (1883–1885); he codesigned and helmed the first fin-bulb-keel yacht—now the standard keelboat model—ever to win a regatta (1885); he fathered the first French national yacht handicapping system (1886); he established and financed the best small yacht boatyard in France (1886); he gathered the most racing prizes two years in a row (1888–1889); he created the first racing class in the world ruled only by a sail-area restriction (1889); he was instrumental in creating a representative national yachting authority (1892); and he designed and built what is acknowledged as the first French offshore racer (1893—the year before his death). All this while designing twenty-five yachts, propelling the club of which he was vice president to a leading national position, collecting stamps on a monumental magnitude (until 1888), and, of course, painting. (For more about Caillebotte's boating, see Chardeau, this volume.)

As the most eminent boater among the Impressionist artists, Caillebotte had nautical achievements and skills that deserve a special place here despite one detail: he became an eminent boater only after he had broken with the Impressionist group—and, in fact, *because* of this split. It is an important distinction that Caillebotte was not an "Impressionist sailor," but rather a sailor who took up the nautical enterprise fully after leaving the artistic movement.

Caillebotte refused to compromise the quality of the participants in the Impressionist exhibitions; indeed, it was the purist nature of the movement that had attracted him to it. After the bitter 1881 dispute with Degas, he basically

68. Gustave Caillebotte

Oarsman in a Top Hat (Canotier au chapeau haut de forme), 1877
Oil on canvas
35⅜ × 46⅛ in. (90 × 117 cm)
Private collection
(MB122)

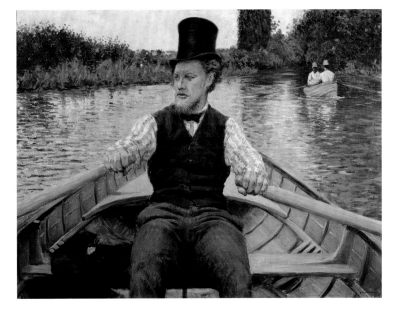

gave up his more idealistic artistic ambitions. At his death in 1894, one obituary stated, "One saw with surprise Mr Caillebotte withdraw from the fight. He eventually renounced painting to give himself exclusively to gardening and boating."[83] Although these conclusions were considered valid until twenty years ago, they are debatable.

First, Caillebotte never stopped painting, and he maintained long-standing relations with some of his ex-colleagues, mainly Pissarro and Renoir. One summer day Renoir painted his wife, Aline, rowing with Caillebotte's companion, Anne-Marie Pagne (a.k.a. Mme Humbert), whose dog observes the scene from Caillebotte's pontoon (ill. 123). In the back-ground is Caillebotte's racer of 1886–1887, the first boat built in his boat-yard, *Mouquette* (ill. 69), clearly recognizable from the peculiarities of her rig. Caillebotte lived in some seclusion in Petit-Gennevilliers, but his gardening was on a professional scale, with an immense glasshouse used to grow his orchids. As for his boating, many today think that he gave up the

69. Engraving of the launch of Gustave Caillebotte's boat *La Mouquette*, by L. Bieneait, 1886

70. Photograph by Martial Caillebotte of Gustave Caillebotte's boatyard with his racer *Roastbeef*, the most eminent boat in the 30m2 class, February 1892. Private collection

71. Photograph by Mr. Le Fèvres of *Roastbeef* moored in front of Caillebotte's dock, 1892. Private collection

prey for the shadow. But in truth he left a very marginal movement with few contemporary followers for an established force that was growing. There were probably fewer real fans of Impressionism than there were members of the Cercle de la Voile de Paris: in 1881, 201 members owned 117 boats. Therefore if, as another obituary stated, "He had dropped the brush for the oar and the spade,"[84] it was a big spade and quite a mighty oar.

Caillebotte's nautical career has been extensively detailed elsewhere,[85] and its technological adventures go beyond the scope of our subject (see bibliography). Until 1885 he painted many boats (mostly his own). However, during his years as France's sailing champion (1887–1893) and as the country's foremost designer of racing yachts (1890–1894), he mostly painted flowers. His late work attests to how far the artist then was from the hubbub of modern life. However, in 1893 he painted one last major work: *Regatta at Argenteuil* (ills. 132, 67 [detail]).

This large canvas stands naturally outside the saint-simonien canon. By the time of its making most of the artists (including Caillebotte) had shied away from the defense of the modern industrial world. Also, this marine subject was not so much painted for the public as it was for

72. Photograph by Martial Caillebotte of Gustave Caillebotte's pontoon in Petit-Gennevilliers; *Roastbeef* is moored on the left, 1892. Private collection

73. Half model of *Roastbeef* sculpted by Gustave Caillebotte. Private collection

Caillebotte himself, as a personal memento of one of his most successful designs. As such, the painter took leave from the radical perspectives of his early works (such as the *périssoires* or city views); instead of the stylistic experiments of his more militant Impressionist days, he adopted an eighteenth-century convention. In the classical *portrait de navire* genre, the same boat is represented three times in the same picture, each depiction showing a different position (one at a mooring, one under sail to windward or on a reach, and one going downwind). However, Caillebotte breathed new life into the old formula by spreading a low-angle shot onto a vertical frame. In terms of marine painting it was certainly as radical as some of his most audacious canvases of past, but few paid much attention, as by that time marine painting had become a marginalized, second-rate genre.

The merit of *Regatta at Argenteuil* is elsewhere in the fact that it is an extraordinary and unique case in pictorial history, the ultimate nautical Gesamtkunstwerk. The composer Richard Wagner popularized the concept of a "total work of art" creating a synthesis of many art forms. Such synthesis naturally would imply that the artist was polyvalent enough to master many genres—and as a demonstration of nautical polyvalence, *Regatta at Argenteuil*, with its representation of Caillebotte's other skills, reaches a summit.

Here, Caillebotte represented his own racer, *Roastbeef* (see ills. 70, 71, 72, 73),[86] which he had steered to victory many times in 1892. *Roastbeef* was designed by Caillebotte himself in October 1891 and built in his own boatyard under his own supervision. She belonged to the 30m² (thirty-square-meter) CVP class of the Cercle de la Voile de Paris—in 1899

Caillebotte created this class, the most successful in France at the time and the first racing class in history ruled only by a limitation in sail area. Then, in memory of "his" class that he had to scuttle down for the general sake of French yachting,[87] he painted his own 30m² racer in the permanent motion of *Regatta at Argenteuil*. From drawing table to easel, through building and victory, it was a total work of art involving drawing, sculpting (the original half-model, carved and polished by Caillebotte, still exists [ill. 73]), boat-building, racing, and painting.

This artwork summarizes its creator's yachting experience. "If there is a . . . thing that I believe I can be proud of," wrote Caillebotte, "it is to have contributed with all my strength . . . to the triumph of the ballasted boat over the old [clipper]."[88] Caillebotte represented himself at the helm in *Regatta at Argenteuil* (see fig. 67). In a preparatory drawing, the artist's pencil insisted *heavily* on the single, featherlike finger holding the tiller. It is as if this darkened finger proclaimed: "Look! Look how light is the tiller of this modern boat, compared with the ancient monsters you'd have to steer with both arms!" Caillebotte, who had been so criticized when he attempted to revolutionize painting, painted in his last great picture the one revolution he succeeded in leading.

NOTES

The author expresses his gratitude to the late Marie Berhaut and to Phillip Dennis Cate for their encouragements. Many thanks are also given to those who shared their knowledge: Dr. Martine Acerra, Cristina Baron, Dr. Jean-Yves Bernot, François Casalis, Nicolas Guichet, Jean-Pierre Monhonval, Louis Pillon, and Dr. Laurent Roblin. Special thanks are further given to Christopher Lloyd, Dr. Lynn Federle Orr, Richard Fenn, and Mary Charles.

1. Monet 1900, n.p.
2. Ibid.
3. Pierre-Auguste Renoir, letter to Frédéric Bazille, 1865, cited in Rewald 1946 [1973]. Bazille, more of a rower than a sailor, declined the invitation.
4. The nautical experience of Guillaumin and Morisot is unknown, although both painted many nautical subjects. Morisot in fact painted more nautical subjects than pure landscapes.
5. See Snezana Lawrence, "History of the Descriptive Geometry in England," *Proceedings of the First International Congress on Construction History* (Madrid, January 20–24, 2003), 1270.
6. The hull of this type of ship was about two hundred feet long and their crew numbered some 750 men.
7. L. T. C. Rolt, *Isambard Kingdom Brunel:*

A Biography (New York: Longmans Green, 1957); repr. Penguin Books, 1986), 29.
8. Constable 1970, 69.
9. Luke Howard (1772–1864) devised the typology of clouds: cumulus, stratus, cirrus, and others.
10. Quoted by C. R. Leslie in *Memoirs of the Life of John Constable, Esq. RA* (London: James Carpenter Ed., 1843), 308.
11. The link between Impressionism and the British painters has been observed before: "Claude Monet is doubly indebted to English art. Profoundly moved by Turner, whose works he studied at first hand in England, he also traces an artistic descent through Jongkind and Boudin from Corot, who caught the methods of Constable and Bonington." Wynford Dewhurst, *Impressionist Painting: Its Genesis and Development* (London: G. Newnes, 1904), 7.
12. Thomas Couture, *Méthode et entretiens d'atelier* (Paris, 1867), 38.
13. Including the Crédit Lyonnais and Société Générale, still active today.
14. Saint-Simon 1802, 33.
15. Thermodynamics were developed (by Rudolf Clausius, 1822–1888) in 1850, twelve years after the first Atlantic crossing by a steamship; however, the basis of thermodynamics went back to Sadi-Carnot's pioneering book *Réflexions sur la puissance*

motrice du feu et sur les machines propres à développer cette puissance (Paris: Bachelier, 1824).
16. Saint-Simon, *Opinions littéraires, philosophiques et industrielles*, 1825, cited by Luc Ferry, *Homo Aestheticus, l'invention du goût à l'âge démocratique* (Paris: Grasset, 1990), 275.
17. Ibid.
18. European economic power must be put in perspective. In 1820 China and India produced about half of the world's GDP; the contribution of the United States was less than two percent, only three times more than Holland. See the numerous publications of Angus Maddison, notably *Contours of the World Economy, 1–2003 AD* (New York: Oxford University Press, 2007).
19. Bonaparte 1844.
20. "The patron was both husband and father, taking care of those less fortunate and less capable of caring for themselves." See Elizabeth Sage, "Political Economy and Paternalism in Nineteenth-Century France," *Business & Economic History*, vol. 2, 2004.
21. For example, the Pereire brothers founded Crédit Mobilier and Prosper Enfantin began Crédit Lyonnais. Enfantin had also been one of the founders of the ephemeral saint-simonien church.
22. Pierre-Joseph Proudhon, *La Propriété c'est le vol* (Paris: Gaume Frères, 1848).

Courbet was elected during the Paris Commune of 1870 and then imprisoned during the following repression. Pissarro later embraced some of the anarchist ideas.
23. Constable 1970, op. cit.
24. This phrase appeared on the pediment of the Dutch Pavilion at the Brussels World Expo in 1958. While the average altitude of Holland is some sixty-five feet, its lowest elevation is twenty-four feet below sea level. Over the ages most of the surface of the country has been "terraformed" by human intervention.
25. To imagine the impact of this painting on a contemporary provincial spectator, one can compare it with the impact a view of Cape Canaveral would have had in the early 1960s on a Wisconsin farmer (or, in the personal experience of the author, on a Belgian teenager).
26. Monet 1900, op. cit.
27. Rouart did not participate in the 1882 exhibition. He also presented paintings at the Salon.
28. Some four hundred units are said to have been produced between 1859 and 1863 (the sources differ on the duration of the run, from a few months to a few years, and the number seems vastly inflated, as many claims are regarding this engine). Lenoir (1822–1900) was a Belgian-French inventor. His engine did not compress the

mixture before ignition. In 1883 Lenoir adopted the Beau de Rochas cycle (four-stroke engine). Such an engine equipped the commercial ferry Rouart had built (by Caillebotte's boatyard) in 1887; see page 55.

29. This first boat trip was on the Seine, on an unknown date between 1861 and 1863. The fact that the first steamboat (made by Jouffroy d'Abbans in 1774, although he might have been preceded by another Frenchman, Denis Papin, seventy years earlier) and the first motorboat (Lenoir, ca. 1861) were produced in France testifies to the country's interest in marine technology, and in technology in general. The invention of the first outboard engine, the first motorboat race, and the first car race also occurred in France.

30. A British invention, it sent mail and small parcels in canisters propelled by compressed air through piping.

31. Cartesianism is the philosophical doctrine described by René Descartes in his *Discours de la méthode pour bien conduire sa raison et chercher la vérité dans les sciences* (1637).

32. Inspired by the title of Monet's painting *Impression. Sunrise* of 1872 (ill. 1). See Louis Leroy, "L'exposition des Impressionnistes," in *Le Charivari*, April 25, 1874.

33. Saint-Simon 1802, 33.

34. Ibid.

35. Wilhelm I was proclaimed emperor of the unified Germany at Versailles.

36. In one week between ten and twenty thousand people were killed in Paris alone.

37. Monarchy was eventually voted for in 1875—to no avail, as the future king wanted to abandon the tricolor flag. This was unacceptable, and the Third Republic was created.

38. Bazille was killed on November 28, 1870, nearly two months after Napoléon III's surrender in Sedan. Four of his paintings were posthumously shown in 1874 at the first Impressionist exhibition.

39. Degas's niece attributed his later eye illness to the long watches he kept as a sentry during the 1871 siege of Paris; see Jeanne Fevre, *Mon oncle Degas* (Geneva: P. Cailler Ed., 1949), 138. Degas and Rouart were reacquainted during the war; they had been at school together.

40. Pissarro was said to have lost more than 1,400 paintings and drawings. Guillaumin also lost many works during the war.

41. During the 1870s sailboats adopted lead ballast, cotton sails (instead of linen), and wire rigging with turnbuckles, and they abandoned the yard-rigged downwind sail for the spinnaker. At the same time, the level of the competition increased.

42. Actually, all the towns that were major Atlantic harbors in the Middle Ages were as inland as possible. The reason was that it was much cheaper then to bring cargo upriver by ships than to cart it down to the river mouth. A cart transporting one ton needed two persons, so to transport two hundred tons would require two hundred cart trips and four hundred people; a ship

did that with ten people. The harbors of Le Havre, Brest, and Lorient were developed later, starting in the sixteenth century, directly on the Atlantic.

43. Jacques Lablée, *Mémoires d'un homme de lettres* (published privately, 1824), 86–87.

44. The city limits of Paris were expanded in 1860 beyond its original boundaries, where most of the *guinguettes* had been established.

45. However, the cultural unification of France was not yet complete. The country was split into many local dialects; in 1850 less than half the French population spoke French as their first language.

46. Jacquin 1845, chap. 1.

47. The painter Charles Meissonier was a *canotier* until he became rich enough to exchange the river for the hippodrome.

48. Eugène Chapus, *Le Sport à Paris* (Paris: Hachette, 1854), 189.

49. Barthélemy Turquin established the first swimming pool on a quay of the Seine in 1785. In 1796 it was transferred to a floating swimming pool—the first in Europe. Deligny, Turquin's son-in-law, extended it in 1801. It was rebuilt in 1840 at the phenomenal cost of 250,000 francs, reusing the ship built to bring back Napoléon's ashes from Saint-Helen. There is a picturesque description in Eugène Briffault, *Paris dans l'eau* (Paris: Hetzel, 1844), 70–76.

50. Briffault, op. cit., 27.

51. Jacquin 1845, op. cit.

52. From 1350 to 1785 the Brotherhood of Montuzet organized a water "pilgrimage" on the Gironde, from Bordeaux to Plassac and back, and there is no memory of any organized race. The oldest existing yacht club, Royal Cork (founded in 1704), never mentions races in its original rules, which concern pageantry, floating displays, and the number of hams and bottles each member could bring with him.

53. Vicomte Alfred de Chateauvillard, in Karr 1858, 37.

54. Victor Hugo, a vocal critic of Napoléon III, went into exile in Britain—as did Napoléon III himself, in 1870. Use of English words among the French high society was very fashionable until the 1950s.

55. Lucien Môre, in Charles 1980, 122–124.

56. *Canoa* is a word used in South America for a small craft. It gave us the words *canoe*, *canot* ("to launch" in Spanish), *canotage*, and *canotier*. The French also imported from the United States the concept and the word *sharpie*.

57. Môre, in Charles 1980, 122–124.

58. Lucien Môre (1816–1898) was first a star rower. He founded the Société des Régates Parisiennes (future Cercle de la Voile de Paris) in 1853 and the Yacht Club de France, of which he was the first secretary. As soon-to-be president of the Cercle de la Voile de Paris (1877–1878) he welcomed a new member by the name of Gustave Caillebotte in 1876; the two men later became adversaries.

59. In 1860 a cousin of the painter,

engraver, and *canotier* Félicien Rops had a five-meter hull built on the French-American "clipper" model by a boatbuilder in Liège based on a design by two British expatriates—it was quite an international affair! See Roger Pierard, *Le Royal Club Nautique Sambre et Meuse, cent ans de vie sportive namuroise* (privately published).

60. Actually, the French *houari* rig has a much longer gaff than the British gunter rig. Although both gaffs are rigged the same, the operations are different: the extra length of the French gaff makes it impossible to hoist horizontally.

61. Louis Leroy, op. cit.

62. Actually, the boat in the foreground is a transom version of the clipper, named an *océan*.

63. Paul Helleu was a society and marine painter and a noted yachtsman, one of the very rare French members of the Royal Yacht Squadron, Britain's most exclusive yacht club.

64. Bonnat became one of the most ardent adversaries of Impressionism. If there is any value in this parallel of Caillebotte and Eakins, it takes root not in Bonnat's teachings but in the milieu of the young Parisian artists of the time.

65. Chapus, op. cit., 190. It is unknown how and on what basis Chapus reached this number; at best it must be taken as a ballpark estimate.

66. Charles Ephrussi, in *La Gazette des Beaux-Arts*, date unknown, cited by Sophie Monneret, *L'Impressionnisme et son époque, dictionnaire international*, 2 vols. (Paris: Denoël, 1978–1979; repr. Robert Laffont, 1987), vol. 1, 17. Ephrussi later became a supporter of Impressionism and is alleged to be the man in the top hat turning his back to the viewer in Renoir's 1880–1881 *Luncheon of the Boating Party* (ill. 25).

67. Albert Wolff, "Le Calendrier parisien," in *Le Figaro*, April 3, 1876.

68. Albert Wolff, "Gazette de Paris," in *Le Figaro*, February 19, 1867, 1. In that year the Société des Régates saw the separation of the sailors from the rowers.

69. Savoye 1958.

70. Notably Jean-François Rafaëlli. Degas also wanted to strictly enforce the group's rules (written by Monet), which would have expelled any member participating in the official Salon (including Monet).

71. Letter to Pissarro, January 24, 1881. Cited by MB, op. cit., 245.

72. Indeed, the influential Centre Saint-Simon was created in 1883. In its bosom was born the Alliance Française.

73. Some were influenced by the utopian social theories of Charles Fourier.

74. The money supply in 1830 was only 83 million dollars for 16 million inhabitants. This was the total monetary circulation (paper money and coins). See J. K. Galbraith, *Money, Whence It Came, Where It Went* (New York: Houghton Muffin Co., 1975). The dollar circulation per inhabitant has since been multiplied by more than six hundred.

75. Pierre-Cyrille Hautcoeur and Nadine Levratto, *Bankruptcy Law and Practice in*

Nineteenth-Century France (Paris: Paris School of Economics, 2007), 17.

76. Later he would become a journalist and art critic. See D. Lobstein, *Défence et illustration de l'impressionisme* (Paris: Ernest Hoschedé et son and Brelan de Salons, 1890; repr. Dijon: L'Échelle de Jacob, 2008).

77. The year 1882 marked the first publication of the anarchist newspaper *Le drapeau noir*.

78. Louise Michel, speech for her own defence in front of the High Court (*cour d'assise*) of the Seine, June 22, 1883.

79. Claude Monet, quoted in E. Taboureux, "Un après-midi avec Claude Monet," *La Vie Moderne*, June 12, 1880. Renoir's opinion, which he explained later to the art dealer Ambroise Vollard, was more organic: "Around 1883, there was a break up in my work. I'd run Impressionism to its end, and I reached this conclusion that I knew neither to paint nor to draw. . . . I'd reached a dead end." Cited in J. P. Crespelle, *La vie quotidienne des Impressionnistes, 1863–1883* (Paris: Hachette, 1981), 251.

80. Different companies had built lines from 1842 onward. In 1857 they were amalgamated into Paris-Lyon-Méditerranée (PLM), a creation of the notable saint-simonien Paulin Talabot.

81. Degas, a royalist, became an avowed anti-Semitic, as did Cézanne.

82. Dr. David R. Beech, Curator of Philatelic Collections, the British Library, letter to the author, August 29, 1990. Gustave and Martial Caillebotte created an exhaustive collection (mostly of Mexican and Philippine stamps) that was sold at Martial's marriage (for an extraordinary price—reportedly four hundred thousand francs, which was forty times what a prosperous Parisian medicine doctor made in the same year) to the British philatelist T. K. Tapling, who then willed it to the British Library. The "brothers Caillebotte" were listed in 1921 by the British Philatelic Congress in their "Roll of Distinguished Philatelists."

83. *La Chronique des Arts*, March 3, 1894.

84. *Le Rappel*, February 27, 1894. Cited in MB, 72.

85. See bibliography.

86. Length of hull: 8 meters; length of waterline: 5.28 meters; beam overall: 1.63 meters; draft: 1.4 meters; displacement: 1,370 kg, including 1,000 kg of outside ballast; sail area: about 32 square meters.

87. The success of this class made acceptable a new handicap rule that would at last include the sail area; this new handicap rule was created by a new national authority that Caillebotte helped engineer. Having created a satisfactory national handicap rule (so satisfactory that it became international and was used from St. Petersburg to Lisbon), it was unaccept-able to maintain a class outside this new rule, and the 30m² CVP were abandoned.

88. Gustave Caillebotte, untitled article, *Le Yacht*, January 10, 1891, 15.

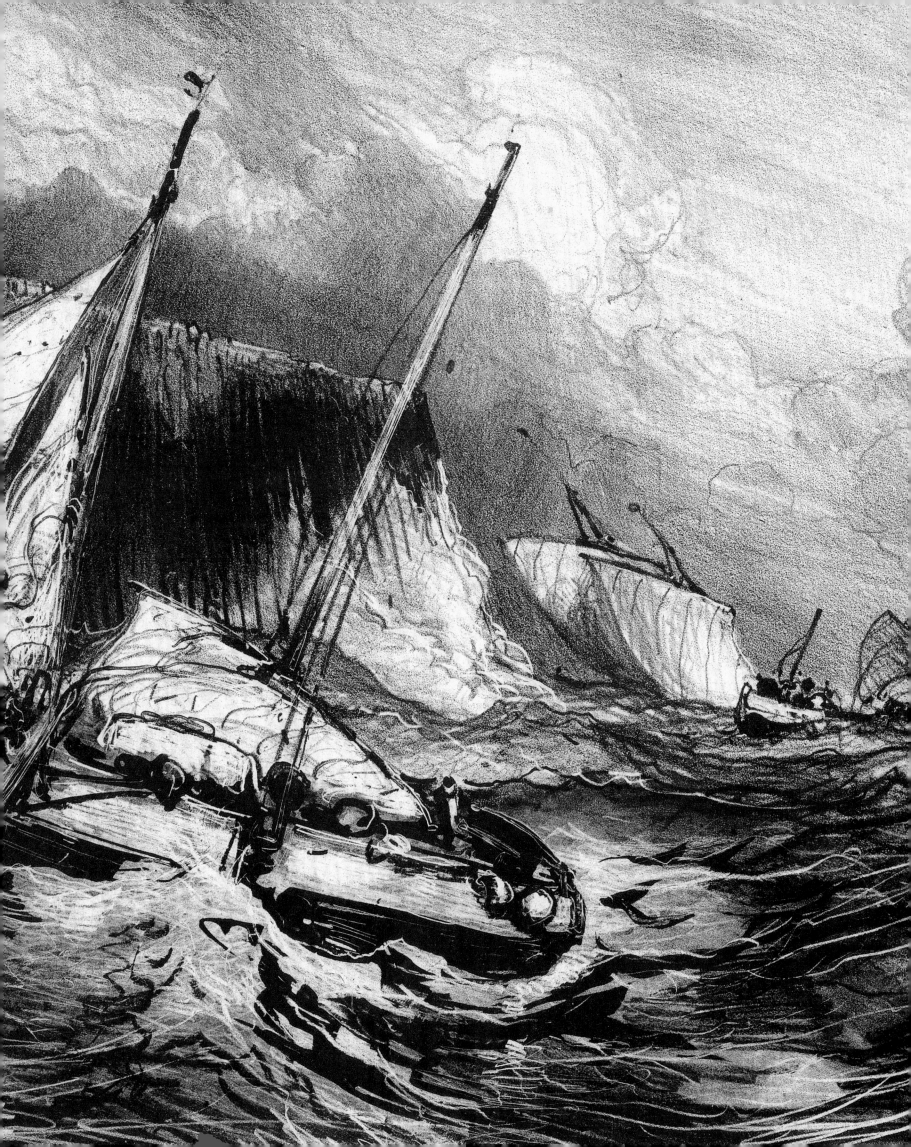

Visions of Boating in French Printmaking

FROM DAUBIGNY TO THE PONT-AVEN SCHOOL

Phillip Dennis Cate

In the spring of 1862 the print dealer Alfred Cadart and the photographer Félix Chevalier, in association with the master printer Auguste Delâtre, founded La Société des Aquafortistes (the Society of Etchers). Their goal was to rejuvenate the art of etching, a printmaking process that had seen its days of glory in the seventeenth and eighteenth centuries with the work of Rembrandt van Rijn, Jacques Callot, Jean-Honoré Fragonard, Giovanni Battista Tiepolo, Giovanni Battista Piranesi, and others. In the first half of the nineteenth century etching lost its appeal to many artists and collectors because of the commercial popularity of engraving, lithography, and photography. These three printing techniques were widely used to reproduce artists' paintings. In fact, a major purpose of La Société des Aquafortistes was to combat the reproductive function of printmaking and to return the medium to its creative and more spontaneous role, with etching as the principal process. The recent invention of photography, with its unprecedented verisimilitude, was the greatest threat: "In a time when photography delights the common people with the mechanical accuracy of its reproductions, a movement in art had to declare itself toward free caprice and picturesque fantasy."[1]

From the 1830s important artists of the Romantic period and the Barbizon School, such as Eugène Delacroix, Paul Huet, Théodore Rousseau, Jean-Baptiste-Camille Corot, Charles Jacque, Jean-François Millet, and Charles-François Daubigny, had to some degree practiced the art of etching. However, by mid-century the overall impression of critics and collectors was that etching—this medium of "caprice and fantasy"—was a lost art. Thus the year 1862 was the official beginning of the so-called etching

74. Eugène Isabey
Fishing Boats in a Stormy Sea
(Bateaux de pêche dans une mer agitée),
no. 66 from *Croquis par divers artistes,*
1830
Lithograph
6½ × 9⅛ in. (16.4 × 23.1 cm)
Fine Arts Museums of San Francisco.
Gift of Harry A. Brooks, 1961.50.3
(CI20 ii/iv)

revival in France, during which each month for five years La Société des Aquafortistes commissioned etchings from five painter-printmakers and sold them to subscribers. Among the many participating artists were Daubigny, Johan Barthold Jongkind, and the future Impressionists Édouard Manet, Ludovic-Napoléon Lepic, and Félix Bracquemond. Artistic etching was suddenly modern.

In that same year Daubigny published his astonishing series of sixteen etchings titled *The Boat Trip* (*Voyage en bateau*), made in the previous year (ill. 75). Although in 1830 Eugène Isabey had created lithographs depicting Romantic seascapes that include ships on the water or beached (see ill. 74), Daubigny was the first artist to record his own voyage, in his own boat, and it was a voyage whose sole purpose was painting *en plein air*. As Robert J. Wickenden discusses in his 1913 article on Daubigny's prints, in 1857 the artist was so overwhelmed with requests for seascape paintings that he decided to create a floating studio that would allow him to work directly on the water. Thus he asked his friend Baillet in Asnières, who had an old, unused ferryboat thirty feet long and six feet wide, to adapt the vessel into a houseboat that provided a sufficient but cramped space for cooking, sleeping, working, and storing art supplies. It functioned with three or six oars and, if desired, with a sail. *Le Botin*, as it was christened by a local resident (a washerwoman, as stated in Frédéric Henriet's preface to the series), took Daubigny, often accompanied by his son Karl, up and down the Seine, the Oise, and the Marne rivers. During winter evenings the artist recorded his travels from memory in forty-seven drawings (now in the collection of the Musée du Louvre, Paris) from which he selected fifteen subjects for his series of etchings.[2] Although Delâtre initially printed the series in a small edition for friends and family, Cadart published it as an album selling for twenty francs. Published again in 1876 with the preface by Henriet, Daubigny's biographer, it sold for sixty francs.[3]

Undoubtedly, the Impressionists — and Monet, in particular — were aware of this extraordinary series of boating images, and especially *The Floating Studio* (ill. 75, image 12), which was published in the May 1874 issue of *Gazette des beaux-arts.* Another version of Daubigny at his easel on *Le Botin* is found in the artist's etching *Le Botin à Conflans,* which is among the illustrations by various artists, including Corot, created for Henriet's book *The Landscape Architect* (*Le paysagiste aux champs*) of 1866. Indeed, both the Barbizon School's lessons in plein-air painting and Daubigny's example of an artist working directly on the water were absorbed by artists prior to the 1870s. As Henriet relates in his preface, *Le Botin* was also a common sight on the Seine in Paris:

A little upriver from Pont Marie, in the midst of the bright squadron of boats and shells endlessly swayed by the slow flow of the Seine, one can see a plain watercraft, topped by a sort of small house and

75. Charles-François Daubigny

The Boat Trip (*Voyage en bateau*), 1861
Sixteen etchings
Fine Arts Museums of San Francisco.
Achenbach Foundation for Graphic Arts
(MD99–115)

1. *Title page–frontispiece*
7⅛ × 5³⁄₁₆ in. (18.1 × 13.2 cm)
1963.30.38616

2. *The Lunch before Going Aboard at Asnières*
(*Le déjeuné du départ à Asnières*)
5 × 7 in. (12.7 × 17.8 cm)
1963.30.32201

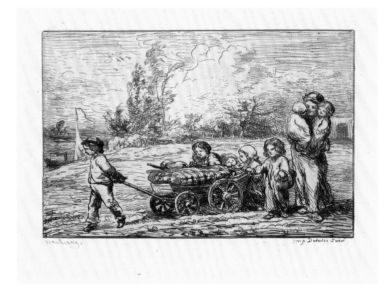

3. *Moving into "Le Botin"* (*The Ship's Furnishings*) (*L'Emménagement au botin*)
5⁷⁄₁₆ × 7⁵⁄₁₆ in. (13.8 × 18.6 cm)
1963.30.32202

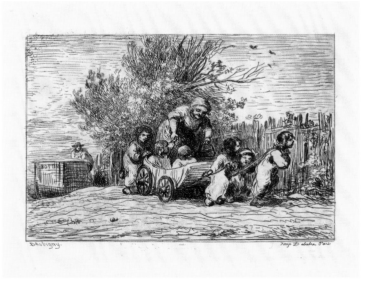

4. *Heritage of the Cart* (*The Children with the Cart*) (*L'héritage de la voiture*)
4¹⁵⁄₁₆ × 7¹⁄₁₆ in. (12.6 × 18 cm)
1963.30.32203

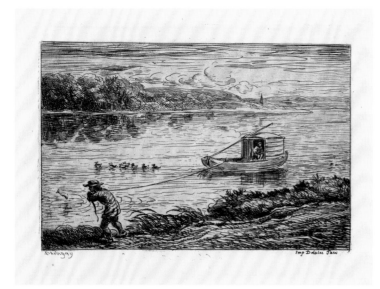

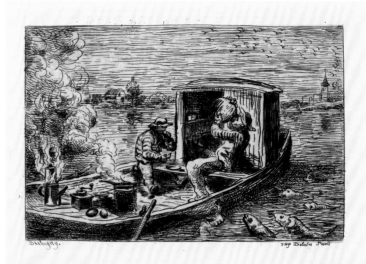

5. *The Cabin Boy Hauling the Tow-Rope*
(Hauling by Rope) (*Le mousse tirant*
au cordeau)
4¹⁵⁄₁₆ × 6¹³⁄₁₆ in. (12.6 × 17.3 cm)
1963.30.32204

6. *Guzzling (Lunch on the Boat)* (*Avallant*)
5 × 7 in. (12.7 × 17.8 cm)
1963.30.32205

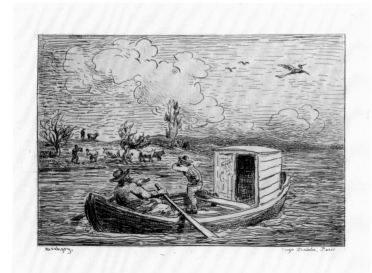

7. *The Slanging Match* (*Le mot de*
cambronne)
5⁷⁄₁₆ × 7⁷⁄₁₆ in. (13.8 × 18.9 cm)
1963.30.32206

8. *The Search for an Inn* (*La recherche*
d'une auberge)
5¹⁄₁₆ × 7¹⁄₁₆ in. (12.8 × 18 cm)
1963.30.32207

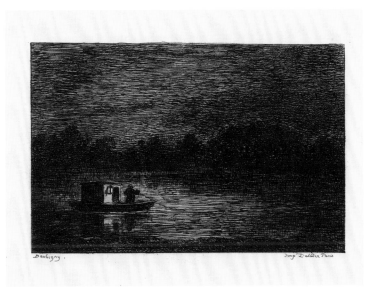

9. *Interior of an Inn (The Corridor of an Inn)*
(*Intérieur d'une auberge*)
4⅝ × 5¹³⁄₁₆ in. (11.7 × 14.8 cm)
1963.30.32208

10. *Night Voyage or Net Fishing (Voyage de nuit ou la pêche au filet)*
5⁹⁄₁₆ × 7⁷⁄₁₆ in. (14.1 × 18.9 cm)
1963.30.32209

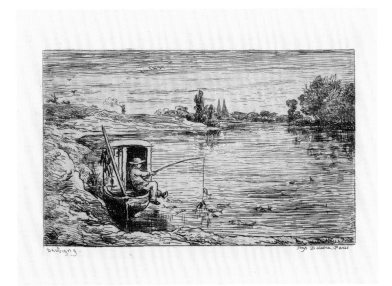

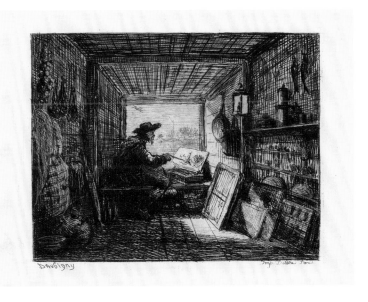

11. *The Cabin Boy Fishing (Line Fishing)*
(*Le mousse à la pêche*)
5⁷⁄₁₆ × 7⅜ in. (13.8 × 18.7 cm)
1963.30.32210

12. *The Floating Studio (Le bateau-atelier)*
5¹⁄₁₆ × 7 in. (12.9 × 17.8 cm)
1963.30.2736

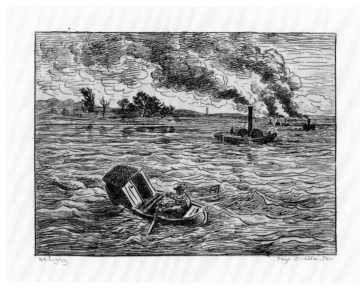

13. *The Steamboats (Watch Out for the Steamers)* *(Les bateaux à vapeurs)*
5⅜ × 7⅜ in. (13.6 × 18.7 cm)
1963.30.32211

14. *Bedding down Aboard the "Bottin"* *(Night on the Boat)* *(Coucher à bord du bottin)*
5¼ × 5½ in. (13.3 × 13.9 cm)
1963.30.32212

15. *Rejoicing of the Fish at the Departure of the Cabin Boy (The Fish)* *(Réjouissance des poissons du départ du mousse)*
5⅜ × 7⅜ in. (13.6 × 18.7 cm)
1963.30.32213

16. *The Departure (The Return)* *(Le départ* *[Le retour])*
5¹/₁₆ × 7 in. (12.9 × 17.8 cm)
1963.30.32200

lined with wide bands of varied colors, which are like the glorious chevron stripes marking its many trips: this is *le Botin*!

Its pretty or ambitious neighbors, *l'Invincible, la Belle-Sylphide*, usually limit their feats to sailing from Pont Marie to Pont de Charenton with a laughing consignment of boatmen and grisettes, amateurs of fish stew and young wine; but

The *Botin* can aim for a higher destiny,

For she carries Caesar and his wealth, — I mean Daubigny and his easel![4]

While it was not Daubigny's concern to document contemporary boating technology in the series *The Boat Trip*, the artist did consider himself a realist as well as a humorist. The former is particularly evident in the Rembrandtesque view of his boat's interior, *The Floating Studio*, in which the artist is hard at work at his easel, painting a sailboat vaguely visible in the distance. Declaring his predilection for realism, Daubigny scribbled *realisme* on the back of the leaning painting at the far right. Throughout the series he demonstrates a sense of humor in his anecdotal accounts of his experiences with jumping fish, mooning farmers, rough waters, and crowded sleeping quarters, and of his relief to finally return home by train — the modern system of transport.

From 1838 to 1877 Daubigny created a total of 150 prints, mostly etchings. True to the Barbizon School, most are landscapes and very few depict water scenes. In contrast, Jongkind, an active member of La Société des Aquafortistes who began his etching career in 1862, created twenty known etchings during his lifetime, of which Cadart published seventeen and more than half depict boats. The Dutch artist arrived in Paris from Holland in 1846, traveling first by steamboat to Antwerp and then by train to Paris. He settled in Montmartre, where he entered the studio of the marine painter Eugène Isabey. In July 1847 Jongkind, along with Isabey, made his first trip to Normandy and Brittany. Steeped in the tradition of seventeenth-century Dutch seascape and landscape painters, and reinforced by Isabey's teachings, Jongkind had marine painting in his blood.

For Jongkind, 1862 was a landmark year. His small album of six etchings depicting views of Holland was published by Cadart and announced in the first album of La Société des Aquafortistes. Three important art critics, two French and one British, remarked on the modernity of these etchings. Charles Baudelaire:

> [Jongkind] has confided the secret of his reveries, singular abbreviations of his painting, sketches that all the amateurs who are used to deciphering the soul of a painter in his fastest *gribouillages* [daubs] will be able to read (*gribouillage* is the term used rather flippantly by the good Diderot to define the etchings of Rembrandt)[5]

Philippe Burty:

> A Dutchman who has become, as we will see, Parisian to the death, M. Jongkind has just etched with a fast and sure needle six views of Holland that we could not better compare than to the likeable drawings of Van Goyen.[6]

Philip Gilbert Hamerton:

> [Jongkind is] also a man of genius, undoubtedly, but of a dangerous sort of genius. What crafty caricaturists do with men and women Jongkind does with landscapes and houses, that is to say, he takes what is useful to render the expression and discards the rest. Each stroke is full of character because of the singular selective faculty that the artist has. No landscape artist that I know of can infallibly take everything he wants and reject as assuredly everything that does not serve his aim. Of all the modern etchers, Jongkind is the most skillful artist on the copperplate. But this kind of talent is balanced by a great sacrifice. The custom of looking at some truths to exaggerate them, of closing one's eyes to other things so that they do not interfere, gives this calm equanimity of observation that is indispensable to the profound study of an unreal nature.[7]

In the summer of 1862 Jongkind traveled to Normandy. He made some studies at Sainte-Adresse before moving on to Trouville, where he encountered Eugène Louis Boudin for the first time, and then to Honfleur, where he met the young Monet. Between 1863 and 1867 Jongkind created four etchings depicting the port of Honfleur, in addition to watercolors and drawings (see ills. 76, 89, 90). While each etching has a quickly sketched, spontaneous quality overall, the sailboats are precisely rendered, prefiguring the Impressionists' concern for exactitude intermingled with simple abstraction. In fact, the boats' measure of nautical precision defies their seemingly casual drawing.

A comparison of the prints by Daubigny and Jongkind with a very finished etching of 1873 by Frédéric Régamey (ill. 77) and a watercolor of about 1876–1878 by Edmond Morin (ill. 78) reveals the great divide between the new realism of the two pre-Impressionists and that of old-guard illustrators. When depicting the modern pastime of boating, anecdotal storytelling is the greatest concern of Régamey and Morin. Régamey's etching *Raising a Sail* was published under the title of *Destitution* in the June 1873 issue of Richard Lesclide's sixteen-page weekly journal *Paris à l'eau-forte*, which was illustrated only with original etchings. Placed in the journal's section "Parisian Studies," this small print depicts young men raising the sail of their dinghy as they prepare to take their Parisian girlfriends, dressed in

76. **Johan Barthold Jongkind**
View of the Port at Honfleur with the Railroad Dock (Vue du port à chemin de fer à Honfleur), 1866
Etching
10¹³⁄₁₆ × 13½ in. (27.4 × 34.3 cm)
Fine Arts Museums of San Francisco. Gift of Theodore M. Lilienthal, 1959.122.20
(MJ13 ii/ii)

77. Frédéric Régamey

Raising a Sail (À la voile), 1873
Etching
3¼ × 3¾ in. (8 × 9.5 cm)
Private collection

78. Edmond Morin

Boating Party (Les canotiers),
ca. 1876–1878
Watercolor
10⅞ × 17½ in. (27.5 × 44.5 cm)
Private collection

countryside attire, on an excursion on the Seine near the Île Seguin, located west of Paris, across from Meudon. While the boat and sail are accurately portrayed, the main purpose of the print is to convey a narrative: the inexperienced sailors are about to overturn the boat as they misunderstand the effect of the wind on the sail. In Morin's watercolor, fashionable young women ready themselves for a leisurely spin on the water in a flat, elongated rowboat designed for stability and safety. Just as numerous traditional depictions of sailboats and ships in French art from the second half of the nineteenth century have nothing to do with pleasure boating, a multitude of illustrations in Parisian journals of the 1870s and 1880s, such as *Le Monde illustré* and *La Vie parisienne*, record the weekend antics and pleasures of Parisians on the water. But although the narrative of Daubigny's *The Boat Trip* series is essential to its purpose—and this is reinforced by the inclusion of captions—the story is rendered in an abbreviated system of drawing that challenges traditional painting and illustration. Both form and subject are the modern interests of Daubigny, Jongkind, and the Impressionists.

Apart from Daubigny's series and journal illustrations, it is rare to find the boat as a topic of humor in French art. However, two notable exceptions employ a comic boating image in order to make statements about art and politics, respectively. Henri Gustave Jossot was a prolific printmaker and illustrator of satirical journals such as *Le Rire* and *L'Assiette au beurre*.[8] His olive-gray lithograph titled *Wave* of 1894 (ill. 165) was published in the avant-garde album of prints *L'estampe originale*.[9] Eight years after the final Impressionist group show, Jossot, in his inimitable curvilinear style, poked fun at the plein-air Impressionist painters whose once influential movement, he suggests, has been dethroned by Japonisme. Literally, within Jossot's image, the Impressionist painter, canvas, and easel are capsized from a boat by the decorative wave found in Katsushika Hokusai's color woodcut *Cresting Wave off the Coast of Kanagawa (The Great Wave)* of about 1830–1832 (ill. 79).

Hokusai's dramatic wave image was also the inspiration for Léon Mendousse's design for a rare lithographic poster of about 1902 that comments humorously on the Franco-Russian Alliance (ill. 80). This large vertical poster was made to fit within the wooden structure that a typical Parisian newsstand used to promote the latest newsworthy events and thus to sell papers. In this case the event is the voyage by the French president Émile Loubet to Russia in May 1902, whose purpose was to reinforce the military pact formed between the two countries ten years earlier and signed into law in 1894. The contract between these two diametrically opposed political entities—the French Republic and imperial Russia—created a partnership against the military threat of the Triple Alliance: Germany, Austro-Hungary, and Italy. In exchange for cheap loans from French banks, Russia's strong military fleet acted as a buffer against France's longtime enemy, Germany. Many in France saw the alliance as needlessly sapping scarce financial resources that could be put to better use by alleviating poverty in the country than by supporting an absolute monarchy.[10] The poster, titled *The Fortuitous Meeting*, depicts Loubet on the verge of being swept away by a

79. Katsushika Hokusai

Cresting Wave off the Coast of Kanagawa
(*The Great Wave*), from the series *Thirty-Six*
Views of Mount Fuji, ca. 1830–1832
Color woodcut
9¹³⁄₁₆ × 14⁷⁄₁₆ in. (25 × 36.6 cm)
Fine Arts Museums of San Francisco.
Museum purchase, Achenbach Foundation
for Graphic Arts Endowment Fund,
1969.32.6

80. Léon Mendousse

The Fortuitous Meeting (*La rencontre*
opportune), ca. 1902
Color lithograph
59½ × 21 in. (150 × 44.5 cm)
Private collection

81. Édouard Riou
Cover illustration for Guy de Maupassant's
Afloat (Sur l'eau), 1888
Photo-relief
7⅜ × 4⅝ in. (18.5 × 11.8 cm)
Private collection

Hokusai-inspired wave; from his small French Republic boat he yells for help from Nicholas II, who, from his large imperial yacht, the *Standart*, extends a hand of assistance. In the distance is the powerful Russian military fleet offering promise to France. Ironically, two years later during the war with Japan, the Russian fleet was decimated in the battle at the Russian naval base of Port Arthur. Nevertheless, the Franco-Russian Alliance continued until 1917.

In his book *Afloat (Sur l'eau)* of 1888 (see ill. 81), Guy de Maupassant recorded his daily thoughts during a weeklong cruise along the Mediterranean coast between Nice and Monaco in April 1887 on his yacht, the *Bel-Ami*.[11]

> This diary does not contain any history or any adventure of interest. Having made a small cruise last summer along the Mediterranean shores, I amused myself with writing every day what I saw and thought.

> In brief, I saw water, sun, clouds, and reefs—I cannot report anything else—and I simply thought, as one thinks when the flow rocks you, numbs you, and leads you about.[12]

He may not have chronicled "adventures of interest," but Maupassant makes numerous observations on contemporary life. Nevertheless, the account reveals his passion for the pleasures of yachting and boating, which parallels that of artists of his generation. While members of the Impressionist group and others not only practiced the sport of boating but also painted images of boating on the Seine and elsewhere, Maupassant wrote stories that included the adventures of *canotiers*, or boating men, such as his short story *A Country Excursion (Une partie de campagne)* of 1881. His work, as a quick sketch of modern life, is the literary equivalent of Impressionist and Post-Impressionist paintings.

One day in 1888, the year that Maupassant published *Sur l'eau*, the young Henri de Toulouse-Lautrec took the helm of the yacht owned by Commodore de Damrémont, the famous yachtsman, and won a regatta in the bay of Arcachon, the popular resort town on the Atlantic just west of Bordeaux and not far from his mother's château at Malromé.[13] The next year Toulouse-Lautrec painted a view of the bay of Arcachon from the bow of his own small yacht, the *Cocorico* (ill. 155). The yacht's rigging and mast, delineated in a quasi-Impressionist style, are accurate by all accounts, while the dramatically foreshortened perspective forecasts the spatial composition found in his posters of the 1890s such as *Le Moulin Rouge* and *Le Divan japonais*. According to Henri Perruchot, in the summer of 1889 Toulouse-Lautrec "swam, fished, sailed his yacht, followed the regattas and baked himself on the beaches of Arcachon and Taussat at hours when they were not too frequented. Or he wandered about the hills, among the pines and gorse. This country of sea, sand and pines delighted him. Sitting in the bows of his boat, he tried to paint seascapes, but above all, as he himself said, he 'soaked and restored his carcass.'"[14]

This future notorious master of Parisian nightlife seems like an unlikely nautical-sport enthusiast, but from his early childhood he spent part of each summer swimming, fishing, and boating in Arcachon and its environs. He continued sporadically to visit the resorts throughout his short life and often took a steamer, rather than a train, from Bordeaux back to Paris via Le Havre. In fact, it was on a steamer voyage from Le Havre to Lisbon in the summer of 1895 that Toulouse-Lautrec encountered a beautiful but married young woman, becoming immediately infatuated with her, and recorded her sophisticated attire and dreamlike demeanor in his lithographic poster *The Passenger from Cabin 54 — On a Cruise* (ill. 156).

With the exception of Manet's 1874 etching *The Sea* (ill. 124), which is in the tradition of seascapes by Isabey, and various prints by Impressionists such as Pissarro, depicting landscapes or seascapes with incidental boats, there are no counterparts in Impressionist prints to the leisure-boating content of their paintings. However, the publication in 1876 of Charles Cros's non-anecdotal poem "The River" ("Le fleuve"), accompanied by eight abbreviated etchings by Manet, is an important precedent for later Symbolist interpretations of the phrase "on the water" — and specifically for the collaboration of Maurice Denis and André Gide in the publication of the latter's *The Voyage of Urien* (*Le voyage d'Urien*) in 1893 (ills. 163, 164). Critics at the time commented on the evocative, Symbolist quality of both Gide's text and Denis's startling anti-academic illustrations. *La Plume* declared in its review: "The *Voyage d'Urien* by André Gide and Maurice Denis is also a very peculiar manifestation of the new art: within a rather obscure but highly literary text of the first, the second has designed lithographic illustrations that will make the traditionalists scream and maybe anger the pure dogmatists."[15] A reviewer for *Mercure de France* stated:

> If I come to speak of the *Voyage d'Urien*, the recent effervescence that M. André Gide has presented to us without prompting, I will not say anything more tender than this, that he depicts in it the path of our painful exile with a quiet intuition of our suffering, and so revealed us to ourselves by calling Urien our domestic spirit. This long voyage through life and toward at long last an authentic exaltation resolves itself according to our own private drama, and flows like a river down the headrace of our sensitivity to the invisible.[16]

The title *Le voyage d'Urien* has a double meaning in French. Urien is the young male protagonist who, with seven fellow passengers, takes a Ulysses-inspired sea voyage to exotic and mysterious lands. But the French word *rien* means "nothing," and when *Voyage d'Urien* is pronounced it takes on its second meaning, "the voyage of nothing." In true Symbolist style, the poem and Denis's lithographs are vague and suggestive rather than direct and explicit.

The emphasis on flat, decorative designs is an essential element in the art of the group of artists called the Nabis — a Hebrew word meaning "the Prophets." The Nabis were founded in 1889 by the painter Paul Sérusier,

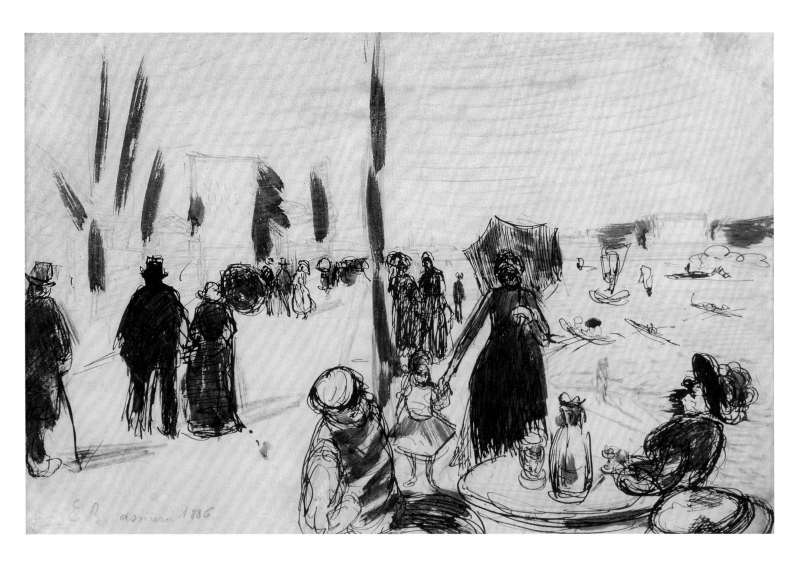

82. Émile Bernard
Along the Seine at Asnières (Le long de la Seine à Asnières), 1886
Ink on paper
10¹⁄₁₆ × 12³⁄₁₆ in. (25.5 × 31 cm)
Private collection

who was inspired by the Symbolist art Paul Gauguin created in Brittany and, especially, in the village of Pont-Aven. The Nabis included, among others, Sérusier, Denis, Pierre Bonnard, Édouard Vuillard, Henri Ibels, Félix Vallotton, József Rippl-Rónai, Ker-Xavier Roussel, Paul Ranson, and Aristide Maillol, and had close associates such as Charles Filiger and Charles Cottet. They all sought an art that, rather than literally representing nature, gave priority to evoking mood and emotion by emphasizing the abstraction of line, color, and form.

The young Émile Bernard—who beginning in 1884 had studied with Toulouse-Lautrec, among others, at the studio of the academic artist Fernand Cormon—met Gauguin in the summer of 1886 during a visit to Pont-Aven. While in Asnières that same summer he drew a lively ink sketch of the wharf along the Seine in which a variety of sporting and pleasure boats—skulls, rowboats, sailboats—dance across the water, confirming the reputation of Asnières as a center for leisure boating (ill. 82). During the following summer Bernard's style changed dramatically as his art took on a flat, decorative quality akin to that of stained-glass windows and Japanese prints. Bernard's transition from Impressionism to so-called Cloisonnism, as he referred to his Synthetist style, would have a great impact on the art of Gauguin and later the Nabis.[17]

The Pont-Aven School, led by Gauguin and Bernard, held its first group show in 1889 at the Café Volpini at the Paris Exposition Universelle.[18] Bernard's *Bretons in a Ferryboat* (ill. 158) is one of seven zincographs (lithographs printed from zinc plates) published in his album *Les Bretonneries* and exhibited for the first time in the Volpini exhibition. Its flat composition and boldly foreshortened sailboat reveal Bernard's dramatic change in style and his debt to Japanese prints. Equally important is the fact that the scene depicts a river near Pont-Aven, rather than the Seine, the Impressionist center of pleasure boating. This shift to Brittany heralds a new vision of scenes "on the water" found in paintings by Georges Seurat (see ill. 146) and Ernest Lucien Bonnotte (see ill. 169), for example, and in prints by Eugène Delâtre (see ill. 157), Théo van Rysselberghe (see ills. 161, 162), Paul Signac (see ills. 151, 152), and especially Henri Rivière (see ills. 167, 168).

In the summer of 1885, a year before Gauguin and Bernard had discovered Brittany, Rivière followed the advice of his childhood friend Signac and took his first of what would be annual pilgrimages to Brittany. In Saint Briac he encountered Pierre-Auguste Renoir, who complimented the young artist on one of his studies. The first results of Rivière's trip were a series of four etchings depicting views of Brittany and illustrations for the book *The Fairies, Breton Tales* (*Les farfadets, conte Breton*), written and published by Achille Melandri in 1886. Beginning in 1890 with two series of color woodcuts inspired by Japanese prints—*Breton Landscapes* (*Les paysages Bretons*) and *Sea: Studies of Waves* (*La mer: Études des vagues*)—Brittany and its coast became a dominant theme in the art of this prolific printmaker. Rivière's prints of Brittany reinforce the role of the river and the sea as a means to present an aesthetic that eschews the festive, progress-oriented viewpoint of the Impressionists in exchange for a contemplative, meditative rendition of life.[19] In a sense, these boating images in turn-of-the-century French art represent the calm before the storm of Fauvism.

NOTES

1. Théophile Gautier, "Un mot sur l'eau-forte," preface to the first album of La Société des Aquafortistes (1863), reprinted in Bailly-Herzberg 1972, vol. 1, 266.
2. Robert J. Wickenden, "Charles-François Daubigny: Painter and Etcher," *Print Collector's Quarterly* (April 1913): 177–206, reprinted in Melot 1978, 279.
3. Bailly-Herzberg 1972, vol. 2, 62.
4. Page 2 of Henriet's preface to the 1876 edition of the etchings.
5. Charles Baudelaire, "L'Eau-forte est à la mode," *La Revue anecdotique* (April 2, 1862), reprinted in Bailly-Herzberg 1972, vol. 2, 121.
6. Burty 1862, 3.
7. Hamerton 1864, 87–88. In 1887 Hamerton published *The Saône: A Summer Voyage* (London: Seeley, 1887) with numerous illustrations by him and Joseph Pennell. This detailed account of his voyage down the Saône in the northeast of France

describes the necessity of using two forms of transport, depending on the region of the river: a sailboat for the lower Saône and a canal boat for the upper. The canal boat was converted like that of Daubigny's *Botin* to serve as a studio and living quarters.
8. Paris 2011.
9. See Amsterdam 1991.
10. In 1897 the French president Félix Faure visited Nicholas II in Saint Petersburg, and the following year the emperor came to Paris to dedicate the construction of the Pont Alexandre III, the bridge named after his father, who had died in 1894. (The bridge was officially inaugurated in 1900 at the time of the Exposition Universelle.) After Faure's death in 1899 Loubet was elected president, and thus in 1902 it was his turn to visit Russia.
11. Maupassant bought his first sailboat, *La Louisette*, in 1883; the next year he replaced it with *Bel-Ami*, which was thirty-five

feet long and weighed nine tons. In 1884 he bought an even larger yacht and named it *Bel-Ami II*. See Lécureur 2009, 95.
12. Guy de Maupassant, *Sur l'eau* (Paris: C. Marpon et E. Flammarion, 1888), v (English translation published as *Afloat*; see Maupassant 2008). *Sur l'eau* first appeared in 1876 as a gruesome short story under the title *En Canot*. In 1881, with the title *Sur l'eau*, it was included in the collection of tales titled *La Maison Tellier*.
13. Frey 1994, 250.
14. Perruchot 1962, 132.
15. Sainte-Claire [Germain de Corydon], review in *La Plume* (August 1, 1893): n.p.
16. Camille Mauclair, review in *Mercure de France*, no. 44 (August 1893): n.p.
17. See Amsterdam 1986; Frèches-Thory and Terrasse 1991.
18. See Cleveland/Amsterdam 2009.
19. See Sueur-Hermel 2009.

GALLERY

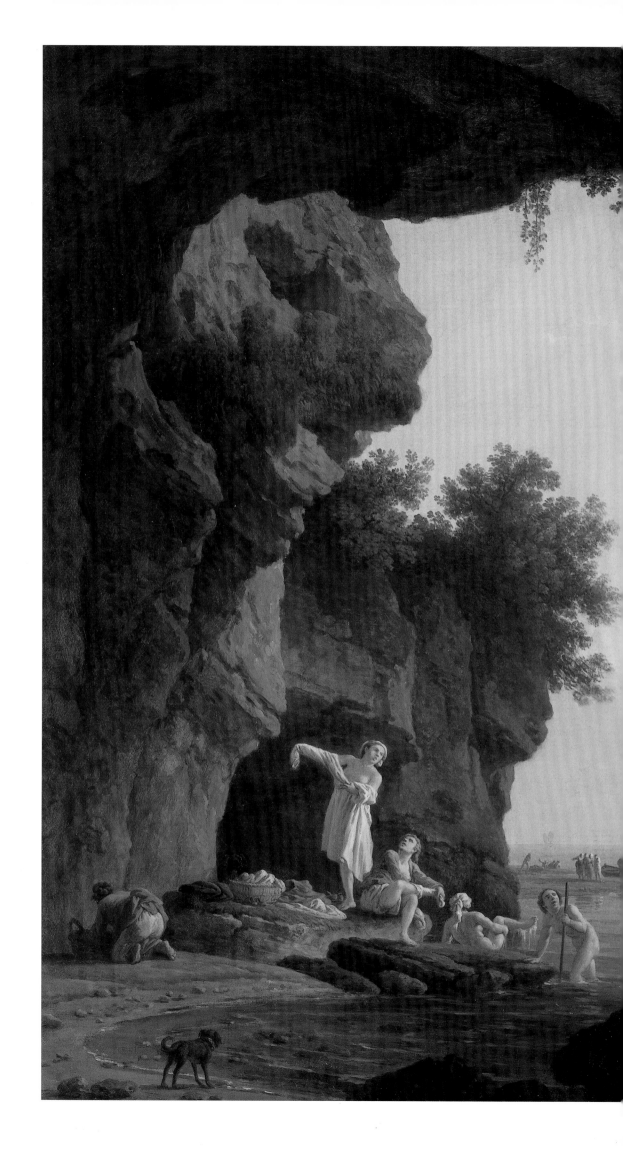

83. Claude-Joseph Vernet

The Bathers (Les baigneuses), 1786
Oil on canvas
22½ × 32½ in. (57.2 × 82.6 cm)
Fine Arts Museums of San Francisco.
Museum purchase, Gift of Mrs. Georgia
Worthington, 76.29

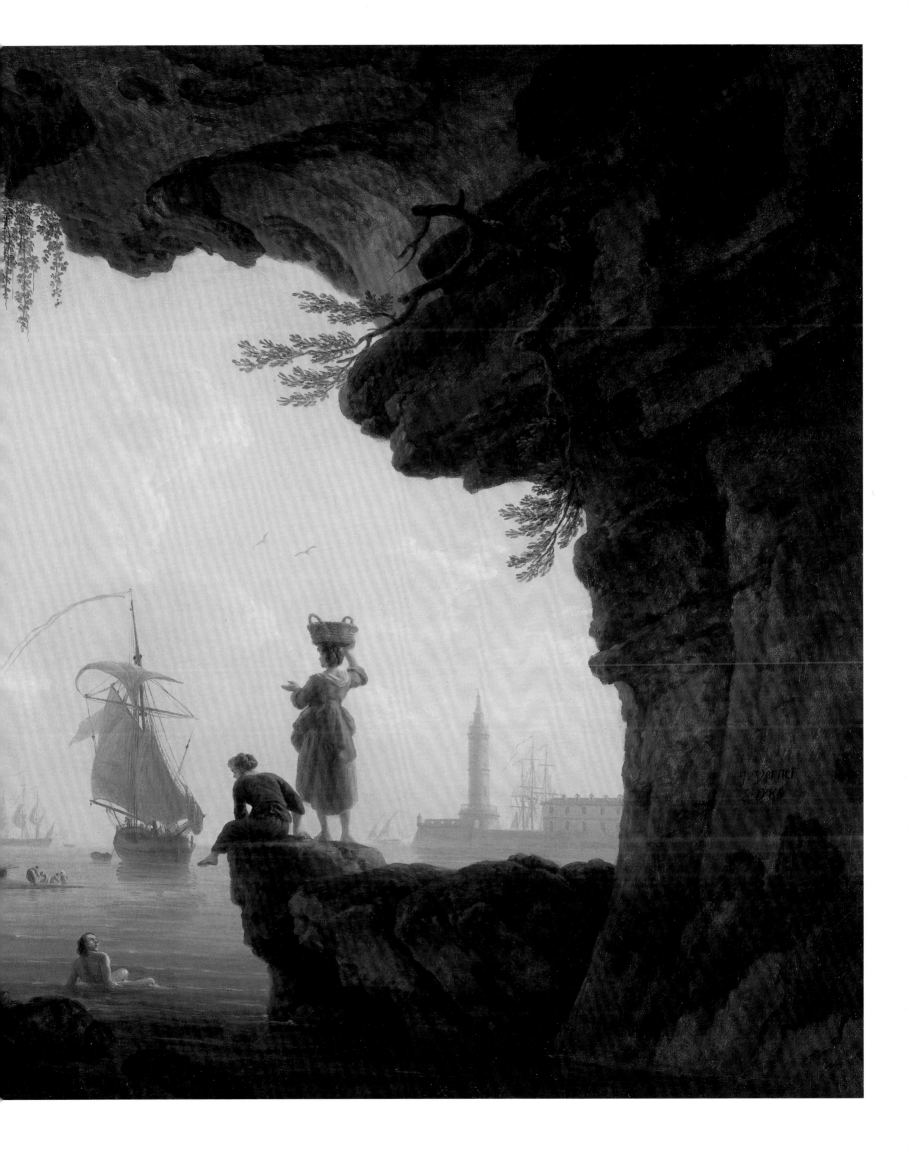

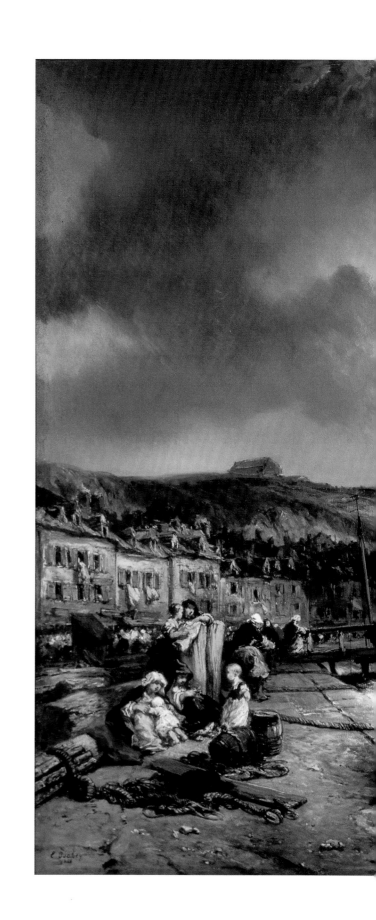

84. Eugène Isabey
Fishing Village (Village de pêche), 1856
Oil on canvas
36¹/₁₆ × 54⁹/₁₆ in. (91.5 × 138.3 cm)
The Art Museum at the University of
Kentucky, Lexington. Transfer from the
Carnahan Conference Center; gift of Mr.
and Mrs. Henry H. Knight, 1958, 2005.1.3

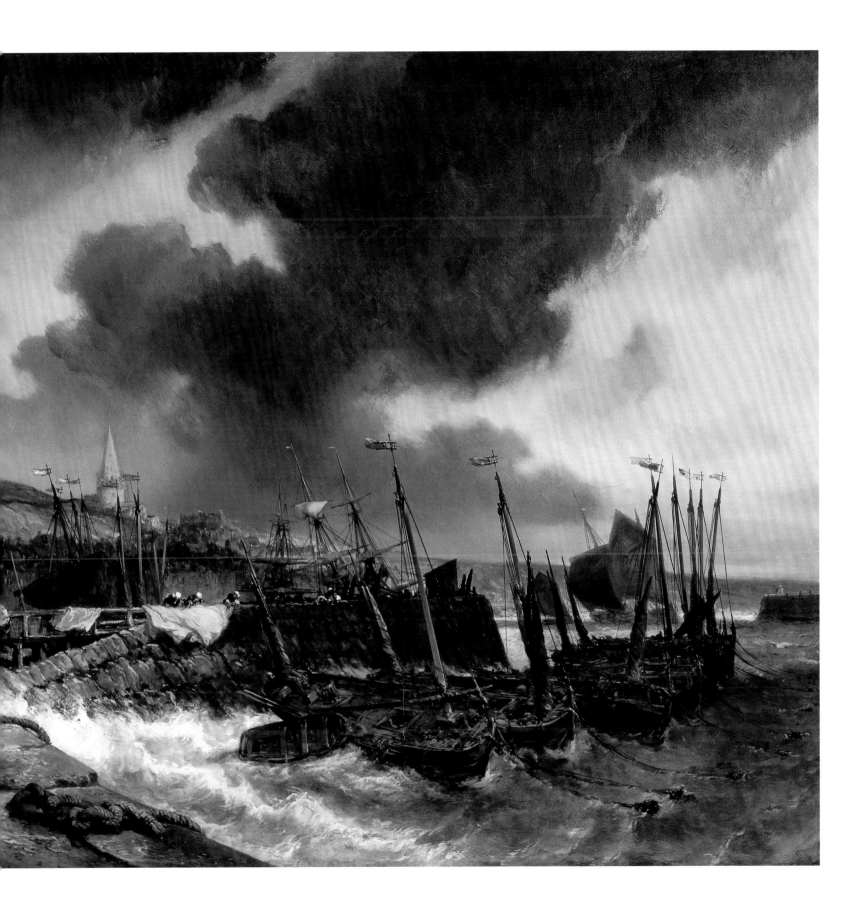

85. Théodore Gudin

On Board "Le Veloce" (À bord du
"Veloce"), 1837
Oil on canvas
15³⁄₁₆ × 25⁷⁄₁₆ in. (38.5 × 65 cm)
Kunsthalle Bremen—Der Kunstverein in
Bremen, Germany. Inv. no. 667-1954/38

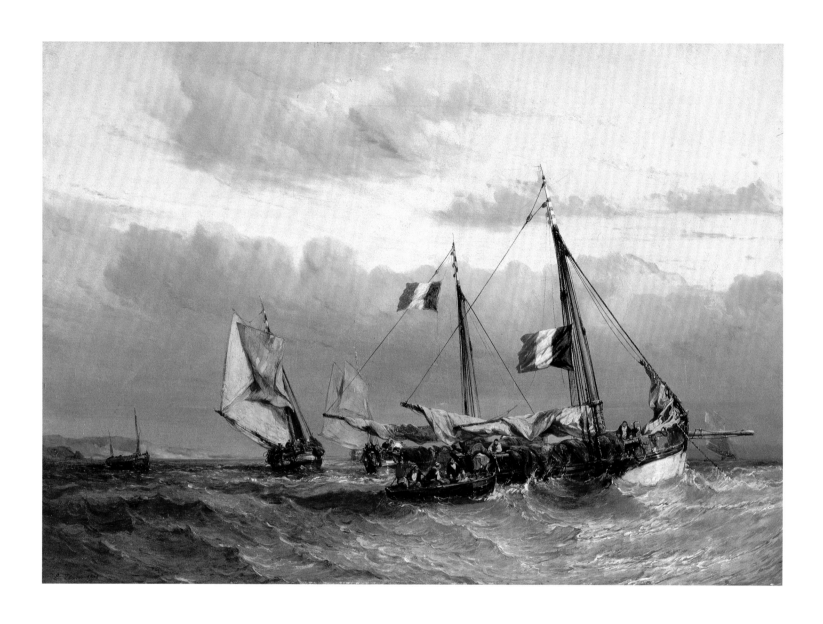

86. Eugène Isabey
Fishing Boats (Barques de pêche), 1840
Oil on canvas
18½ × 26 in. (47 × 66 cm)
Musée national de la Marine, Paris

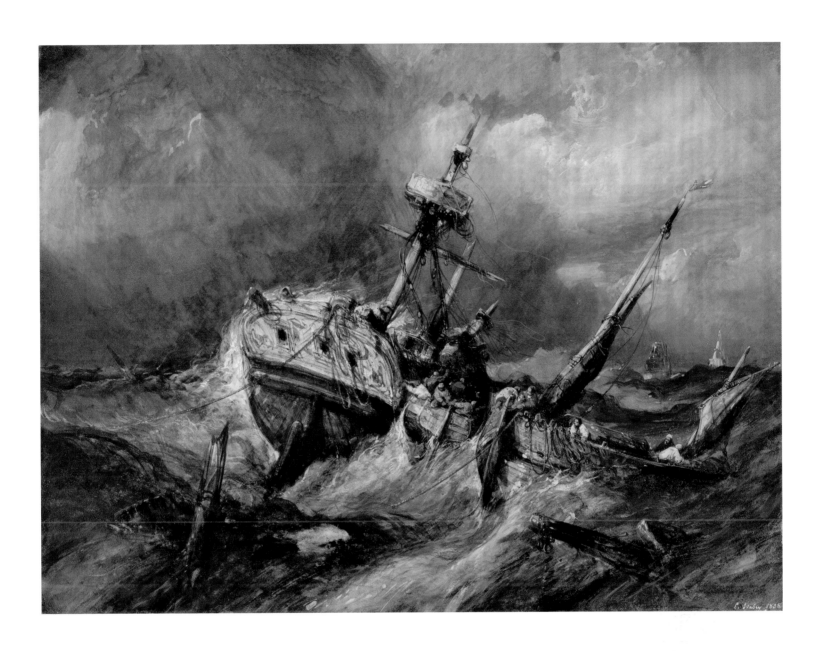

87. Eugène Isabey

The Shipwreck (Le naufrage), 1858
Watercolor and opaque watercolor over
graphite underdrawing on wove paper
affixed to cardboard
13³⁄₁₆ × 17¹¹⁄₁₆ in. (33.5 × 45 cm)
Fine Arts Museums of San Francisco.
Museum purchase, Elizabeth Ebert and
Arthur W. Barney Fund, 1978.2.43

88. Charles-François Daubigny

The Village of Gloton (Gloton), 1857
Oil on panel
11¾ × 21⅛ in. (29.8 × 53.7 cm)
Fine Arts Museums of San Francisco.
Mildred Anna Williams Collection, 1940.4
(RH81)

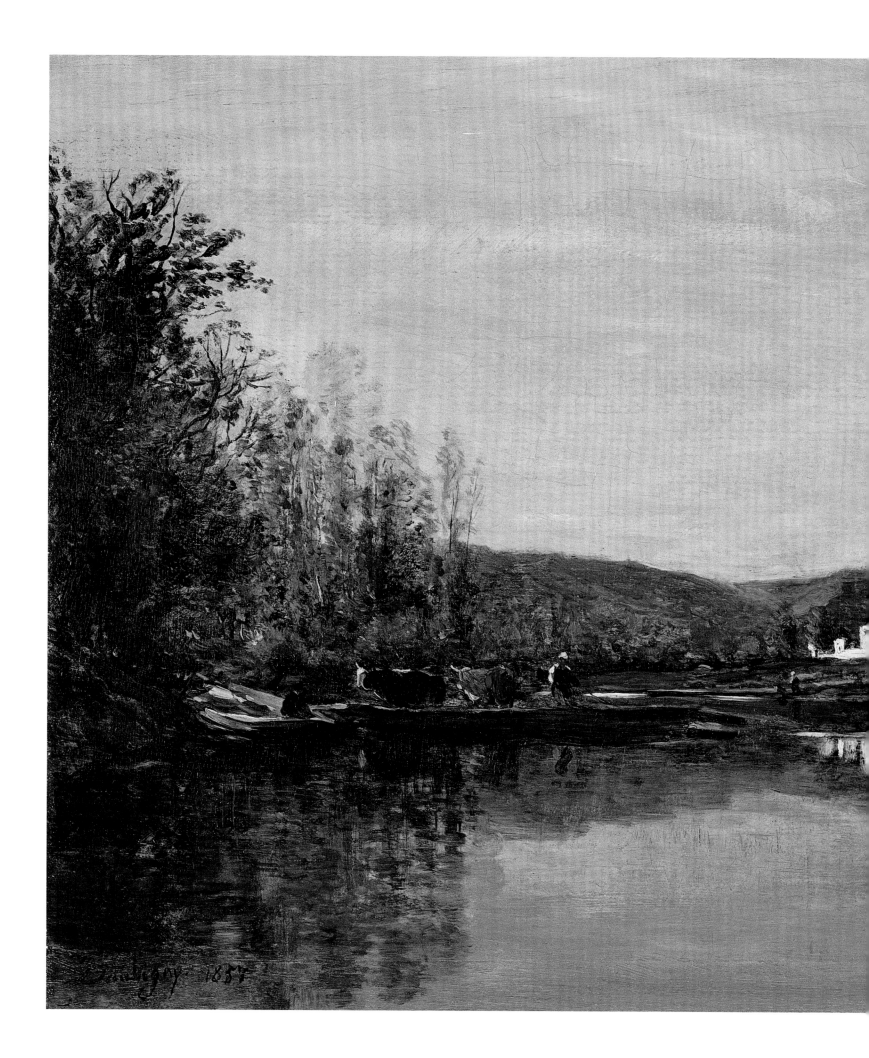

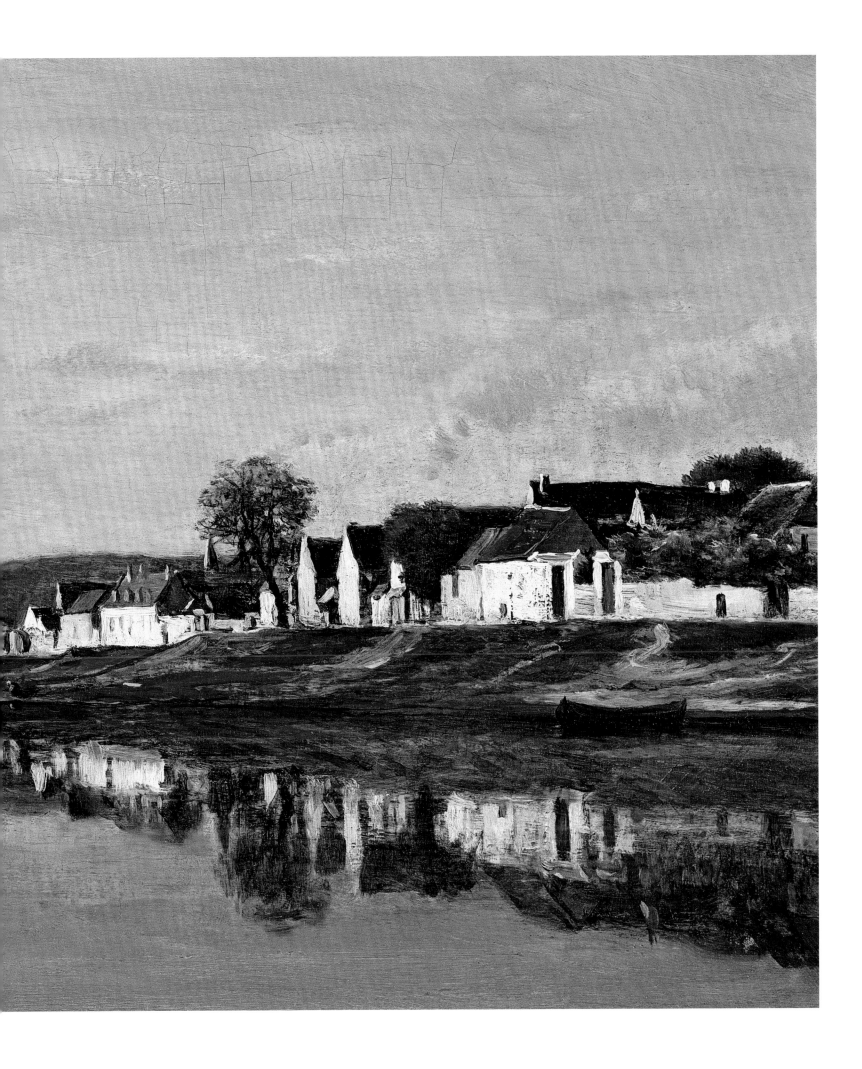

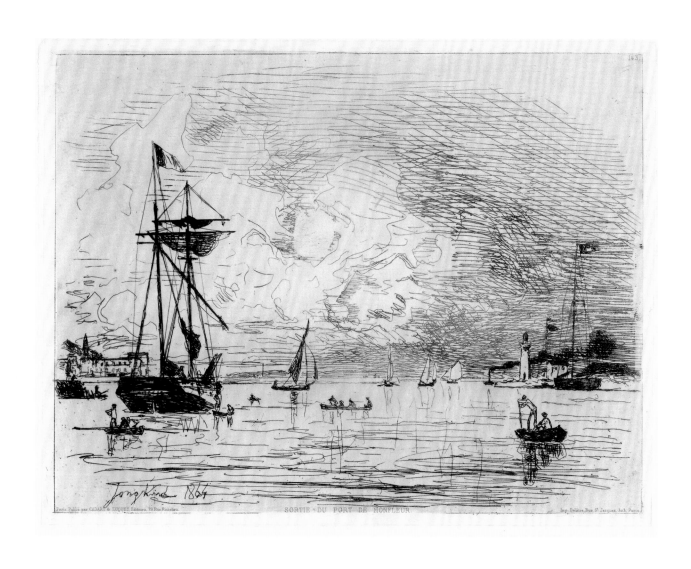

89. Johan Barthold Jongkind
*Outlet of the Port of Honfleur (Sortie du port
de Honfleur)*, 1864
Etching
9⁷⁄₁₆ × 12⅜ in. (24 × 31.4 cm)
Fine Arts Museums of San Francisco. Gift of
Ruth and Morton Macks, 1989.1.282
(MJ11 iii/iv)

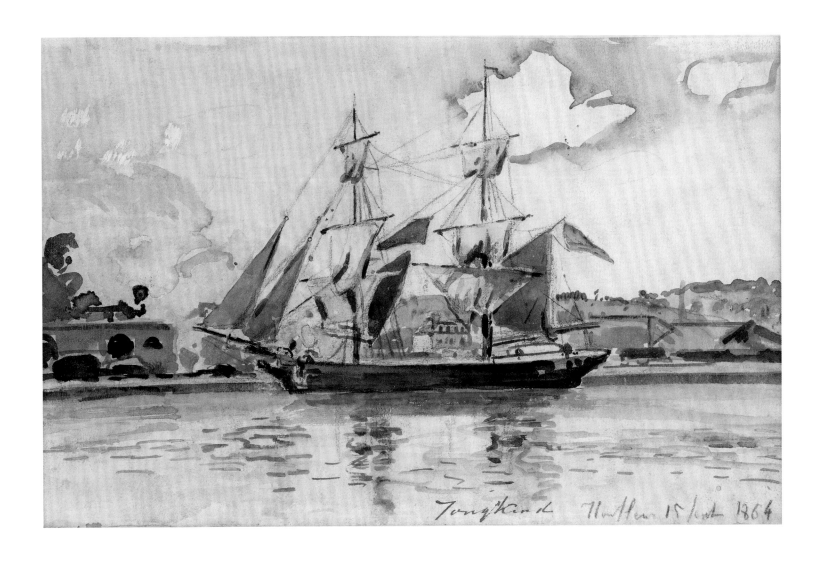

90. Johan Barthold Jongkind

Honfleur, 1864
Pen and ink and watercolor on paper
7 3/16 × 11 5/8 in. (18.2 × 29.5 cm)
Zimmerli Art Museum at Rutgers University,
New Brunswick, New Jersey. Gift of David
A. and Mildred H. Morse, 83.010.006

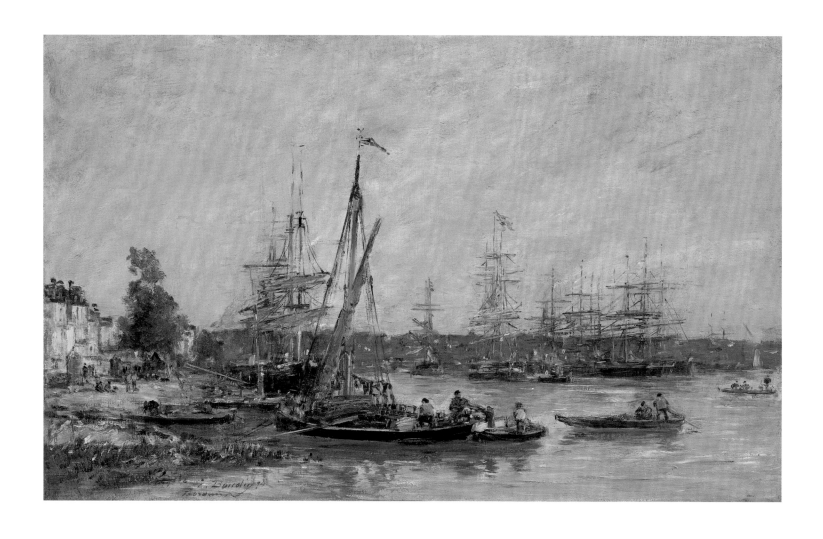

91. Eugène Louis Boudin

Harbor at Bordeaux (Port de Bordeaux),
1874
Oil on light linen
14³⁄₁₆ × 23 in. (36 × 58.4 cm)
Fine Arts Museums of San Francisco. Gift of
Mr. and Mrs. Grover A. Magnin, 64.53

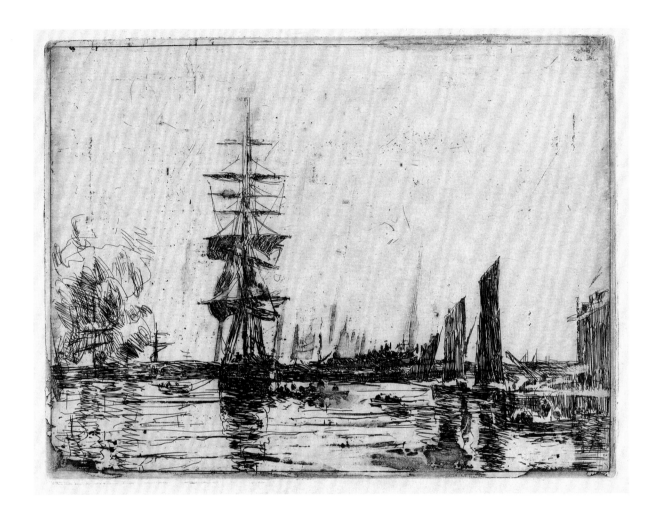

92. Eugène Louis Boudin

Boats (Bateaux), ca. 1898
Etching and spit-bite etching
4⅝ × 6½ in. (11.9 × 16.4 cm)
Fine Arts Museums of San Francisco.
Museum Purchase, Achenbach Foundation
for Graphic Arts Endowment Fund,
1966.80.46

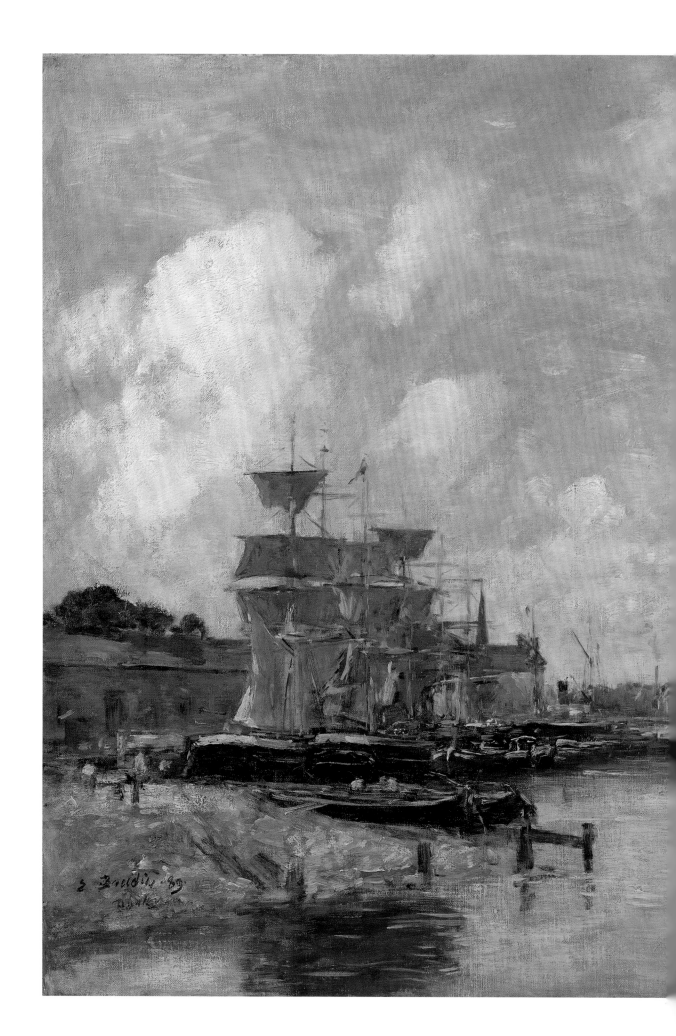

93. Eugène Louis Boudin

Dunkirk, 1889
Oil on canvas
18⅛ × 26 in. (46 × 66 cm)
Fine Arts Museums of San Francisco.
Gift of Osgood Hooker, 1963.17

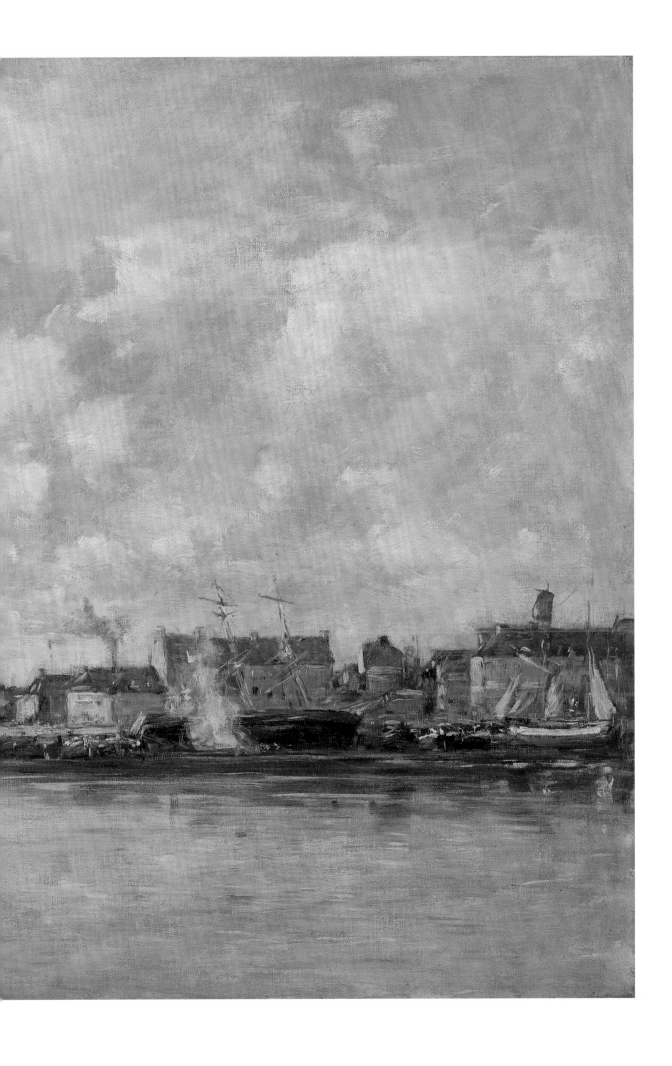

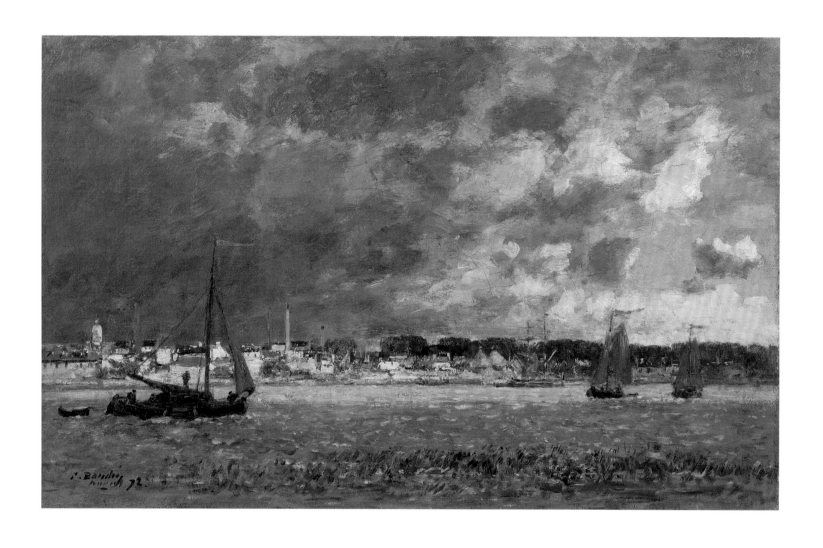

94. Eugène Louis Boudin

Storm over Antwerp (Tempête sur Anvers), 1872
Oil on canvas
16 × 25⅝ in. (40.6 × 65.1 cm)
Fine Arts Museums of San Francisco.
Gift of Osgood Hooker, 1963.16

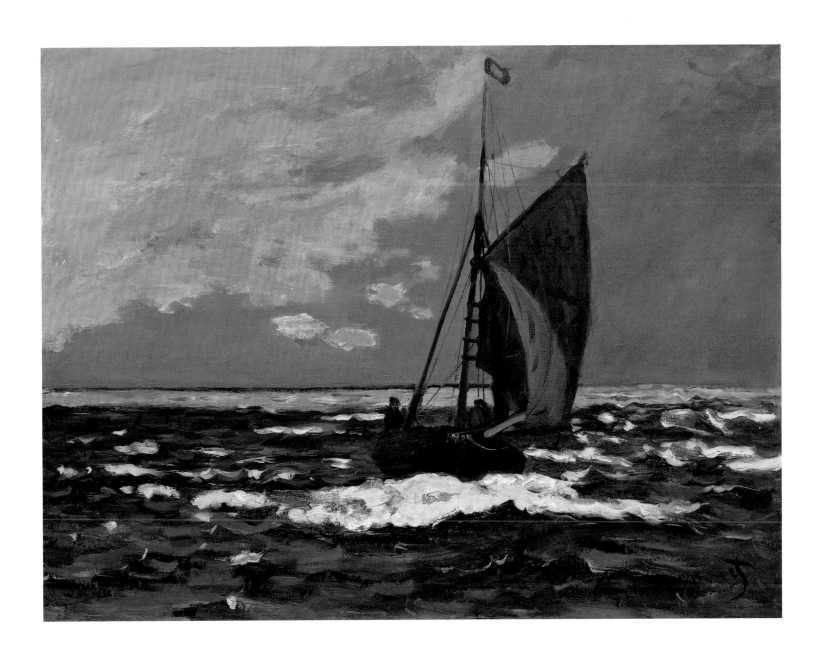

95. Claude Monet

Stormy Seascape (Marine, orage), 1866
Oil on canvas
19¼ × 25¼ in. (49 × 64 cm)
Sterling and Francine Clark Art Institute,
Williamstown, Massachusetts. 1955:561
(DW86)

96. Claude Monet

*The Seashore at Sainte-Adresse (Bord de la
mer à Sainte-Adresse)*, 1864
Oil on canvas
15¾ × 28¾ in. (40 × 73 cm)
Minneapolis Institute of Arts. Gift of Mr. and
Mrs. Theodore Bennett, 53.13
(DW22)

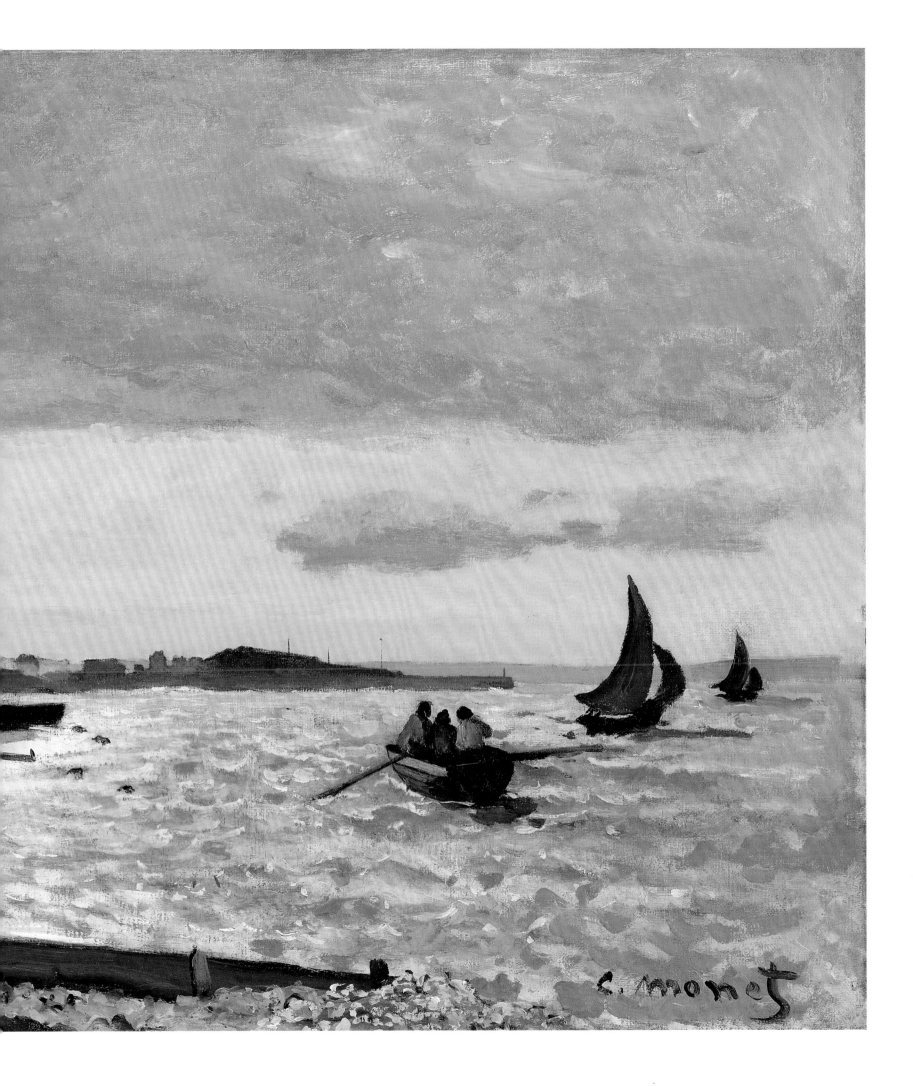

97. Claude Monet

The Sea at Sainte-Adresse (*La mer
à Sainte-Adresse*), 1868
Oil on canvas
23⅝ × 32⅛ in. (60 × 82 cm)
Carnegie Museum of Art, Pittsburgh,
Pennsylvania. Purchase, 53.22
(DW112)

98. Gustave Le Gray

The Brig (Brick) (Brick au clair de lune), 1856
Albumen silver print
12⅝ × 16⅟₁₆ in. (32.1 × 40.8 cm)
The J. Paul Getty Museum, Los Angeles.
84.XM.637.2

99. Gustave Le Gray

The Breaking Wave (La vague brisée. Mer
Méditerranée no. 15), 1857
Albumen silver print
16⁵⁄₁₆ × 13³⁄₁₆ in. (41.4 × 33.5 cm)
The J. Paul Getty Museum, Los Angeles.
84.XM.347.11

100. Claude Monet

View from Voorzan (Vue de Voorzan), 1871
Oil on canvas
13⅜ × 28¹¹⁄₁₆ in. (34 × 73 cm)
Nationalmuseum, Stockholm. NM 2513
(DW179)

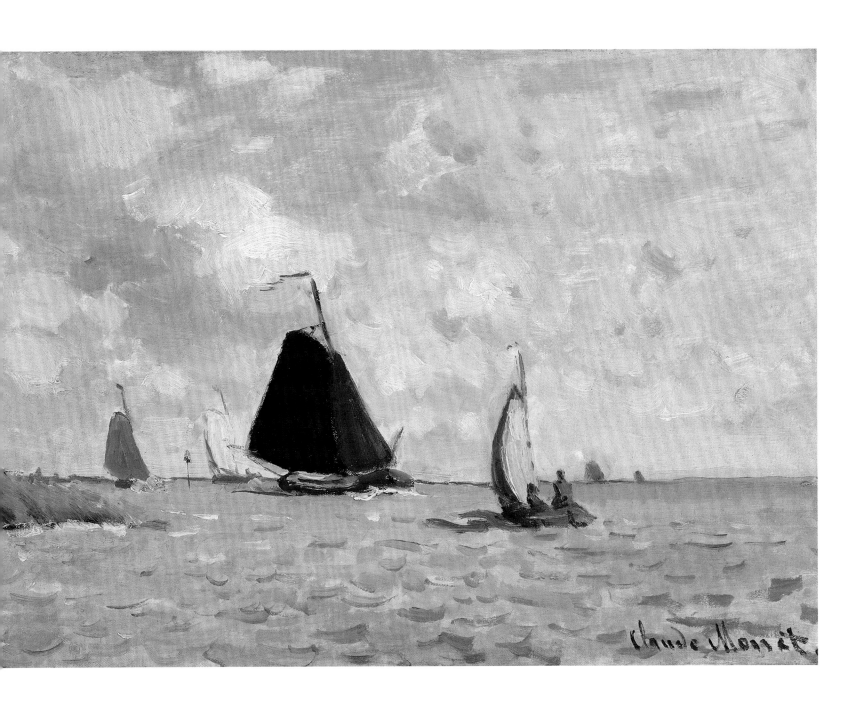

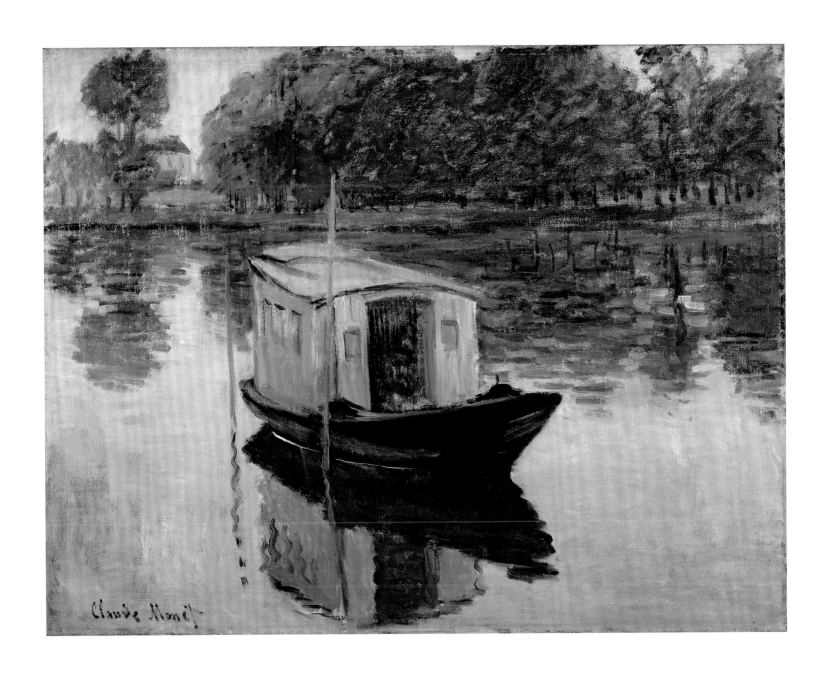

102. Claude Monet

The Studio Boat (Le bateau-atelier), 1874
Oil on canvas
19⅝ × 25¼ in. (50 × 64 cm)
Kröller-Müller Museum, Otterlo,
The Netherlands. KM 111.222
(DW323)

103. Ludovic-Napoléon Lepic

The Port (Le port), ca. 1867–1869
Oil on canvas
38⅝ × 51³⁄₁₆ in. (98 × 130 cm)
Courtesy Galerie Thierry Mercier, Paris

104. Ludovic-Napoléon Lepic

*Design for a table service (Dessin d'un
service de table)*, 19th century
Black ink, purple watercolor, and graphite
11⅜ × 13¹¹⁄₁₆ in. (28.9 × 34.8 cm)
Fine Arts Museums of San Francisco.
Museum purchase, Achenbach Foundation
for Graphic Arts Endowment Fund,
1988.2.42

105. **Ludovic-Napoléon Lepic**

*Boats on the Beach at Berck (Bateaux sur
la plage de Berck)*, ca. 1876
Oil on canvas
30 × 40 in. (76.2 × 101.6 cm)
Fine Arts Museums of San Francisco.
Museum purchase, Grover A. Magnin
Bequest Fund, 1987.5

106. Claude Monet

The Port at Argenteuil (Le bassin d'Argenteuil), 1872
Oil on canvas
23⅝ × 31¾ in. (60 × 80.5 cm)
Musée d'Orsay, Paris. Comte Isaac de Camondo Bequest, RF 2010
(DW225)

107. Claude Monet

Boats Moored at Le Petit-Gennevilliers
(*Barques au repos, au Petit-Gennevilliers*)
(traditionally *Sailboats on the Seine*), 1874
Oil on canvas
21¼ × 25⅝ in. (54 × 65 cm)
Fine Arts Museums of San Francisco. Gift of
Bruno and Sadie Adriani, 1962.23
(DW227)

108. Claude Monet

*Bridge at Argenteuil, Gray Weather (Le pont
d'Argenteuil, temps gris)*, ca. 1874–1876
Oil on canvas
24 × 31⅝ in. (61 × 80.5 cm)
National Gallery of Art, Washington, DC.
Ailsa Mellon Bruce Collection, 1970.17.44
(DW316)

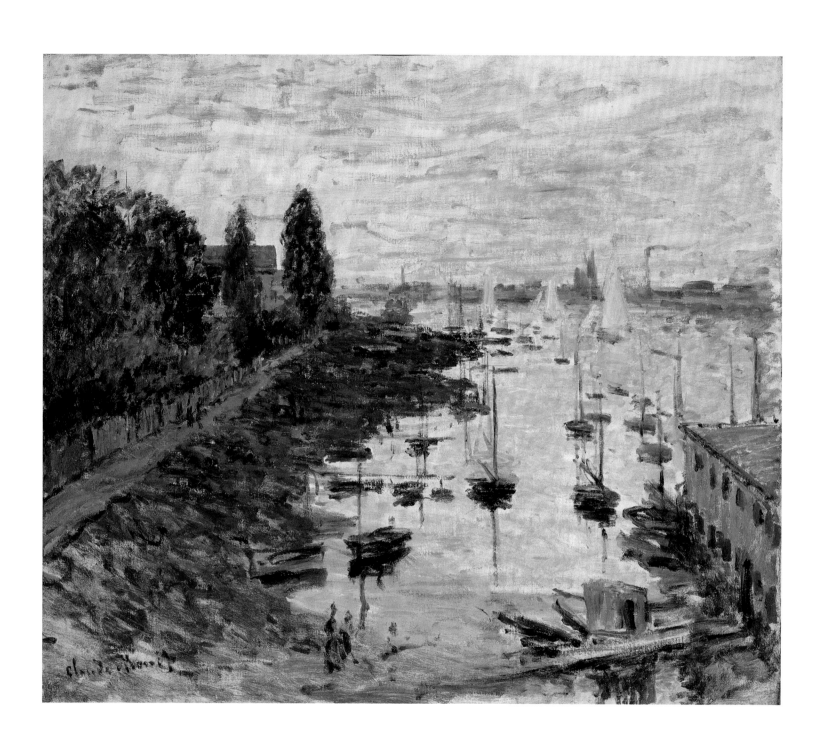

109. Claude Monet

The Port of Argenteuil (Le bassin d'Argenteuil), 1874
Oil on canvas
21⅞ × 26¼ in. (53 × 65 cm)
Indiana University Art Museum,
Bloomington. 76.15
(DW335)

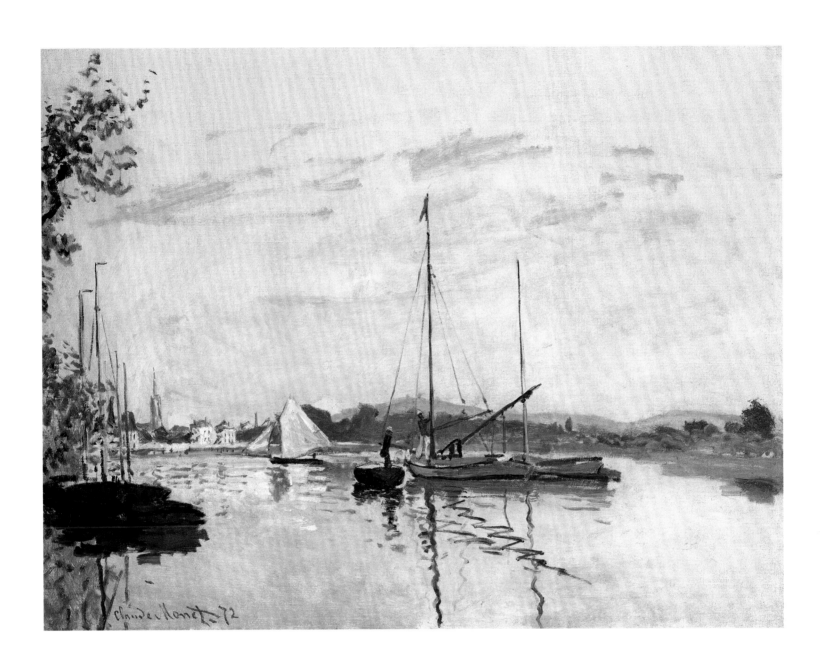

110. Claude Monet

Argenteuil, 1872
Oil on canvas
19¼ × 25⅝ in. (49 × 65 cm)
Musée d'Orsay, Paris. RF 1961-4
(DW230)

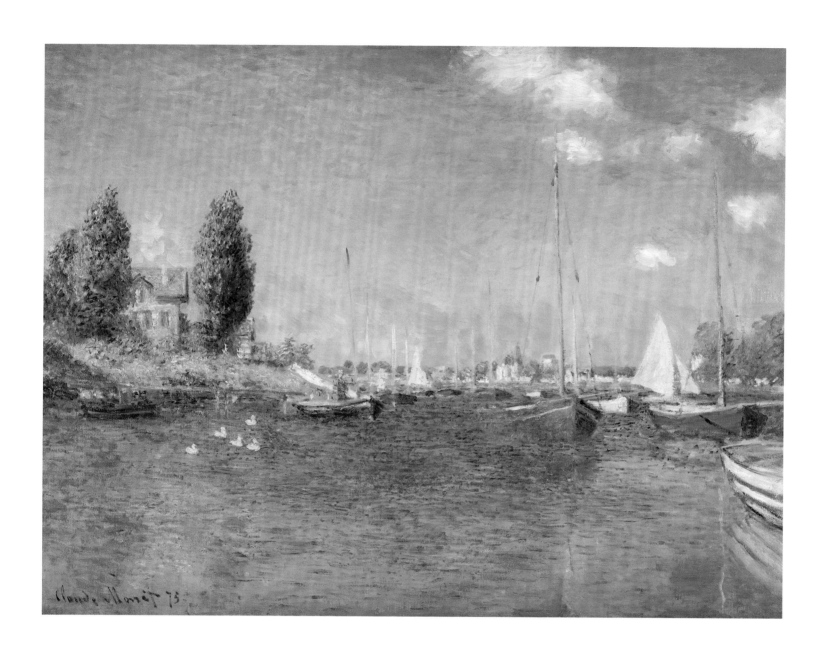

111. Claude Monet

Red Boats, Argenteuil (Les bateaux rouges, Argenteuil), 1875
Oil on canvas
23½ × 31⅝ in. (60 × 81 cm)
Fogg Art Museum, Harvard Art Museums,
Cambridge, Massachusetts. Bequest from
the Collection of Maurice Wertheim, Class
of 1906, 1951.54
(DW369)

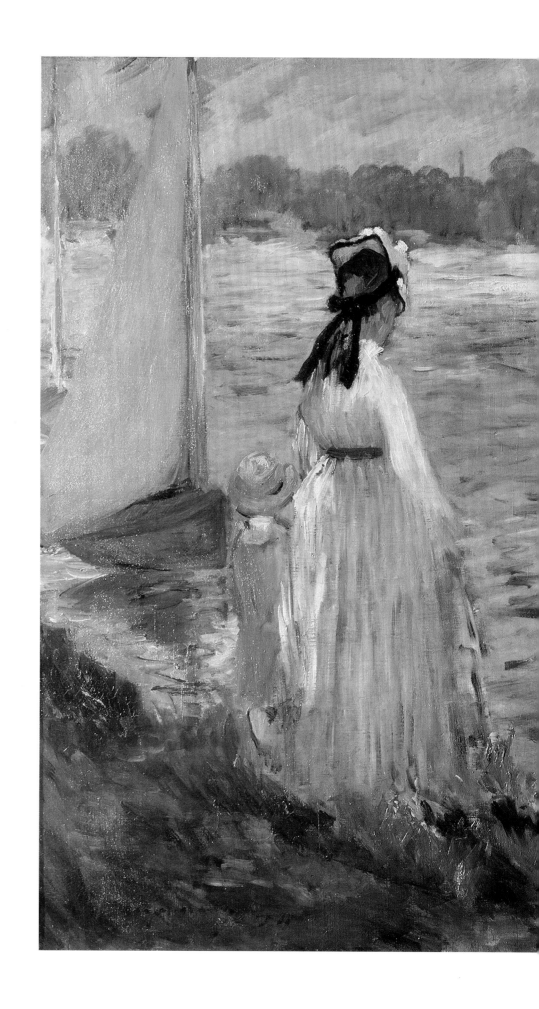

112. Édouard Manet
The Banks of the Seine at Argenteuil
(*Bords de la Seine à Argenteuil*), 1874
Oil on canvas
24⅜ × 40½ in. (62 × 103 cm)
Private collection, on extended loan to
The Courtauld Gallery, London.
LP.1997.XX.14
(R&W220)

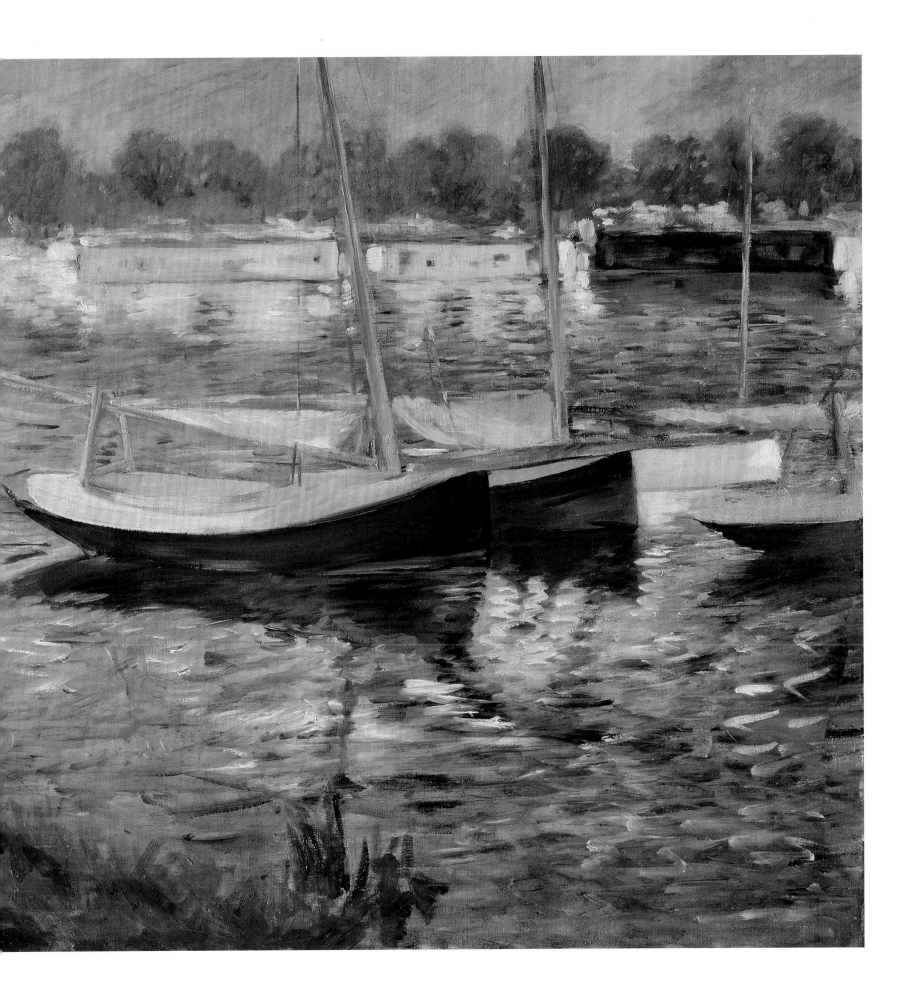

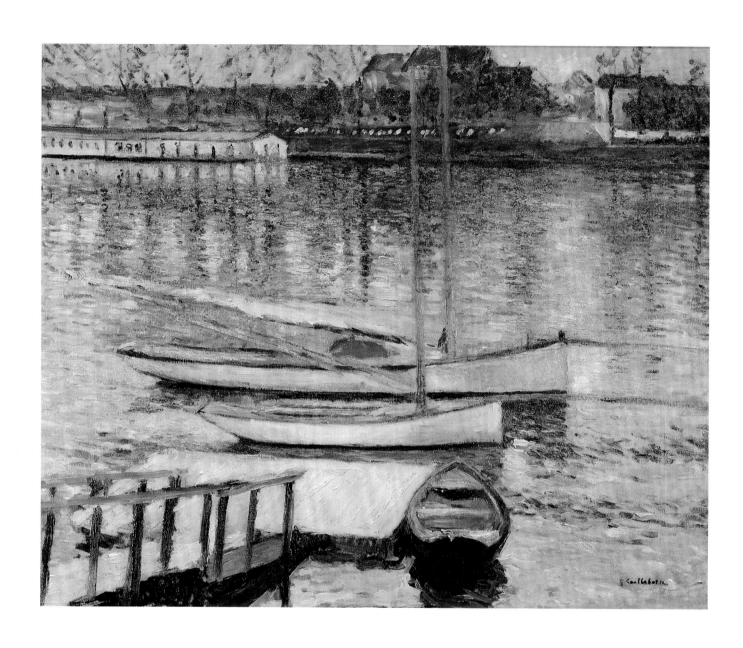

113. Gustave Caillebotte

Sailboats Moored on the Seine at Argenteuil
(*Voiliers au mouillage sur la Seine à Argenteuil*), 1883
Oil on canvas
23⅝ × 28¾ in. (60 × 73 cm)
McMaster Museum of Art, McMaster
University, Hamilton, Ontario, Canada. Gift
of Herman H. Levy O.B.E., 1984.007.0015
(MB273)

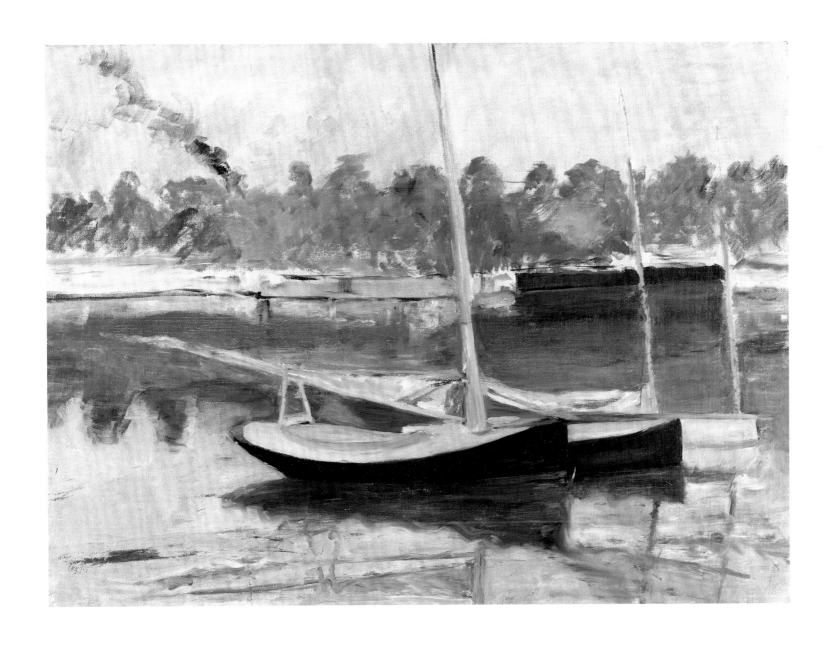

114. Édouard Manet
View of Argenteuil (Vue d'Argenteuil), 1874
Oil on canvas
23⅝ × 31⅞ in. (60 × 81 cm)
Amgueddfa Cymru-National Museum of
Wales, Cardiff. Bequest of Margaret Davies,
1963, inv. no. 1052, NMW A 2467
(R&W222)

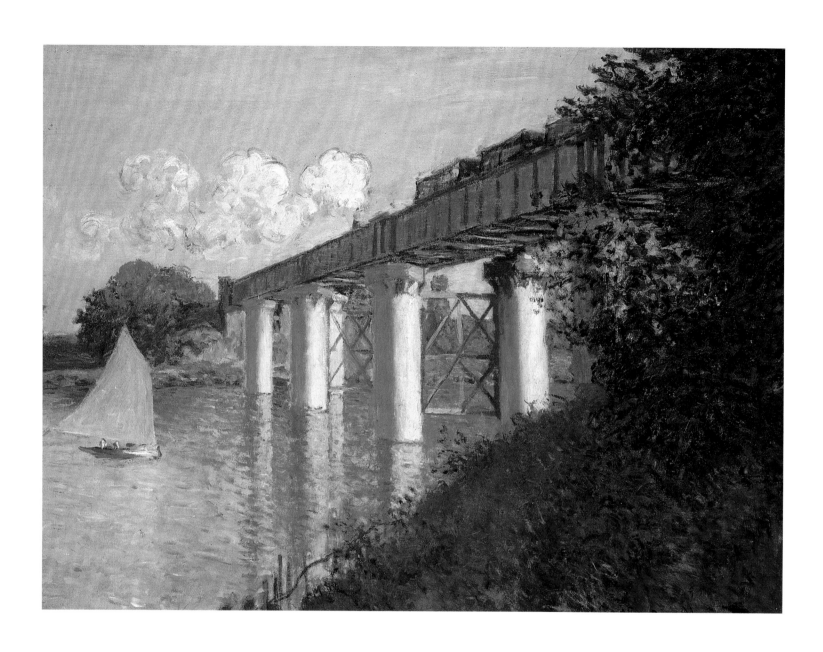

115. Claude Monet

The Railway Bridge at Argenteuil (Le pont du chemin de fer, Argenteuil), 1874
Oil on canvas
21½ × 28⅞ in. (54.5 × 73.5 cm)
Philadelphia Museum of Art. John G.
Johnson Collection, J.1050
(DW318)

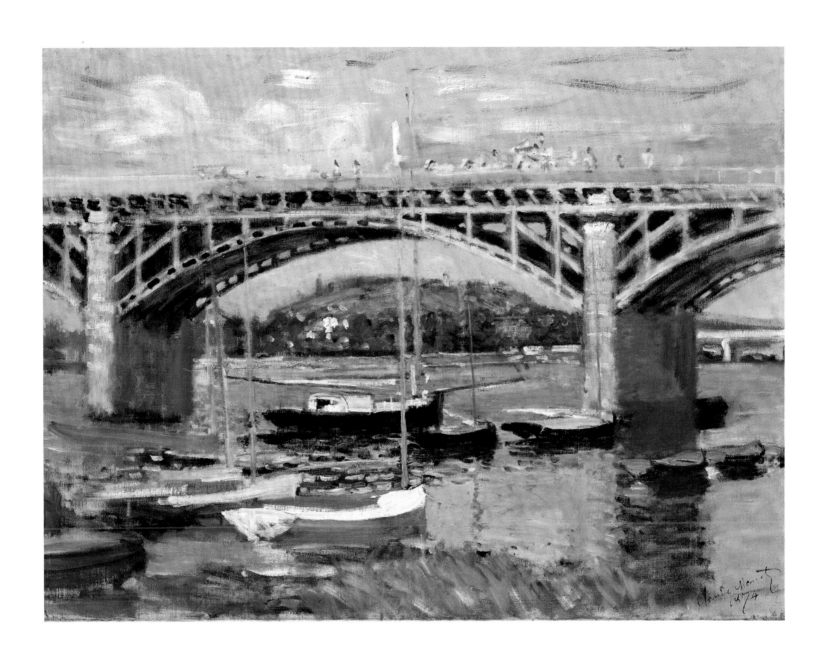

116. Claude Monet

The Bridge at Argenteuil (Le pont d'Argenteuil), 1874
Oil on canvas
23½ × 32 in. (58 × 80 cm)
Neue Pinakothek, Bayerische
Staatsgemäldesammlungen, Munich. Tschudi
Contribution, 8642
(DW313)

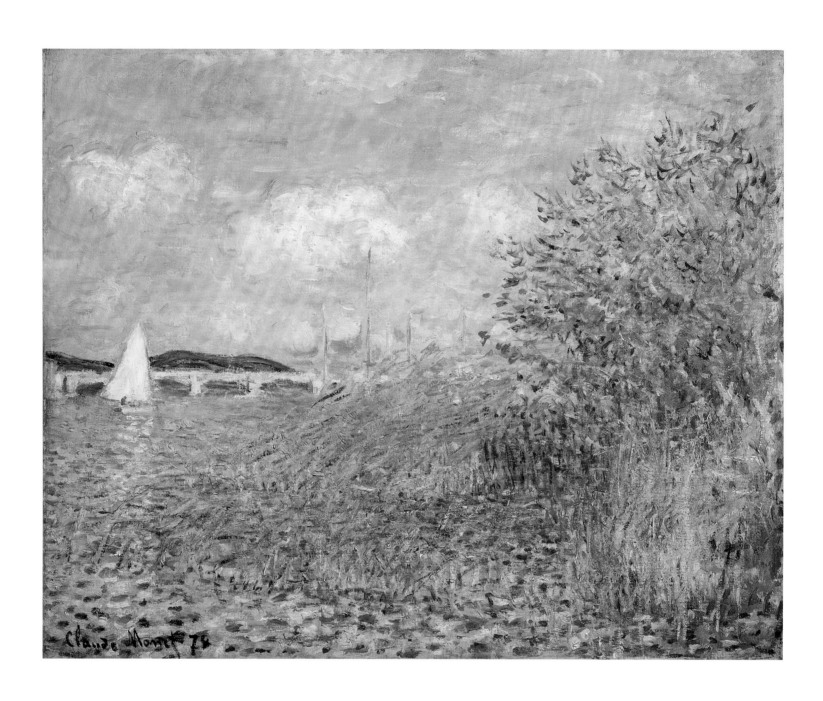

117. Claude Monet

The Seine at Argenteuil (La Seine à Argenteuil), 1874
Oil on canvas
21¼ × 25⅝ in. (54 × 65 cm)
Private collection
(DW330)

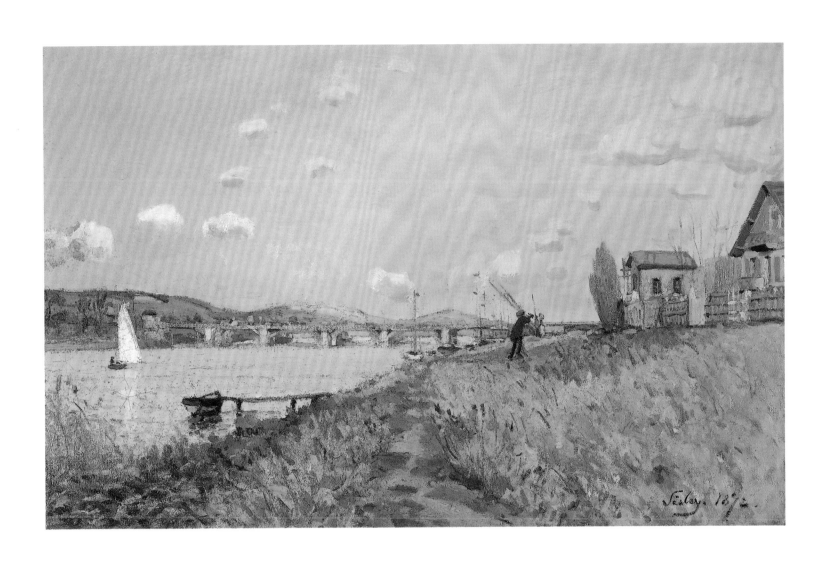

118. Alfred Sisley

The Bridge at Argenteuil (Le pont d'Argenteuil), 1872
Oil on canvas
15 × 24 in. (38 × 61 cm)
Memphis Brooks Museum of Art, Tennessee.
Gift of Mr. and Mrs. Hugo N. Dixon, 54.64
(FD30)

119. **Édouard Manet**

Argenteuil, 1874
Oil on canvas
58⅝ × 45¼ in. (149 × 115 cm)
Musée des Beaux-Arts, Tournai, Belgium.
Inv. no. 438
(R&W221)

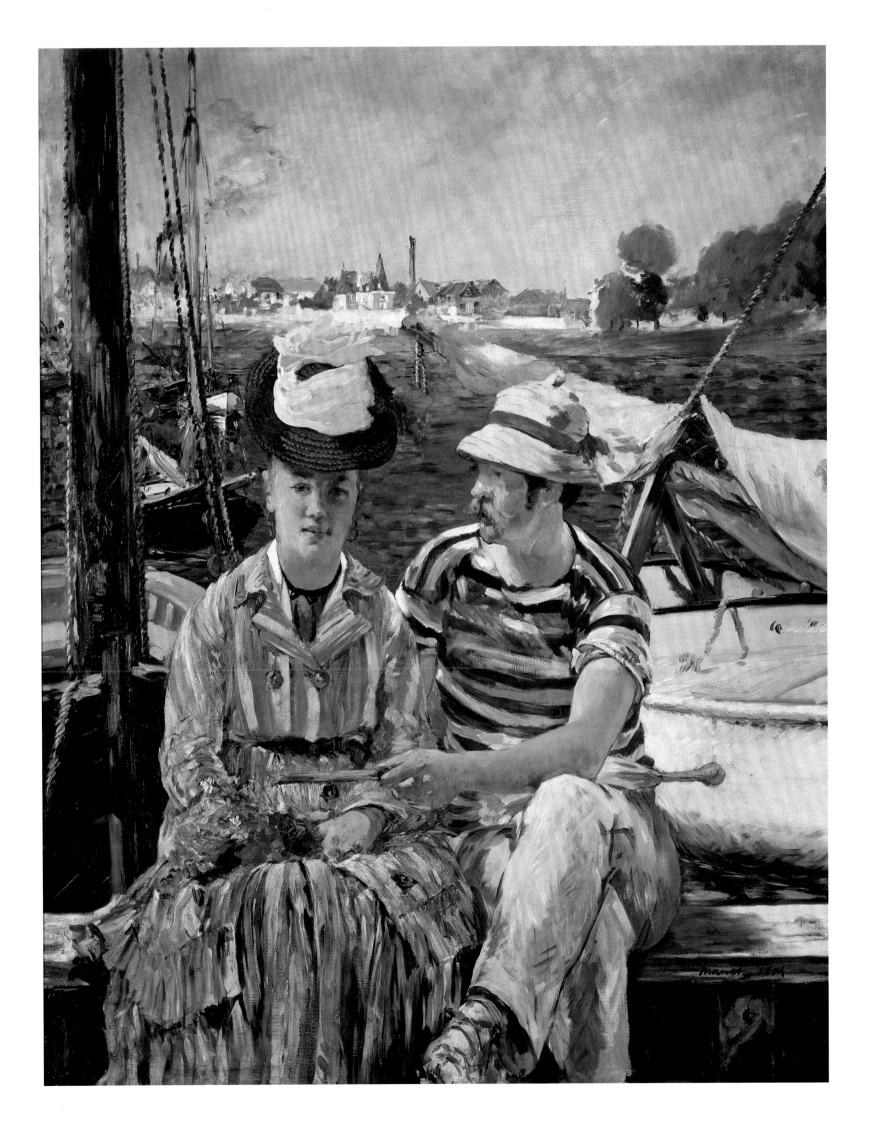

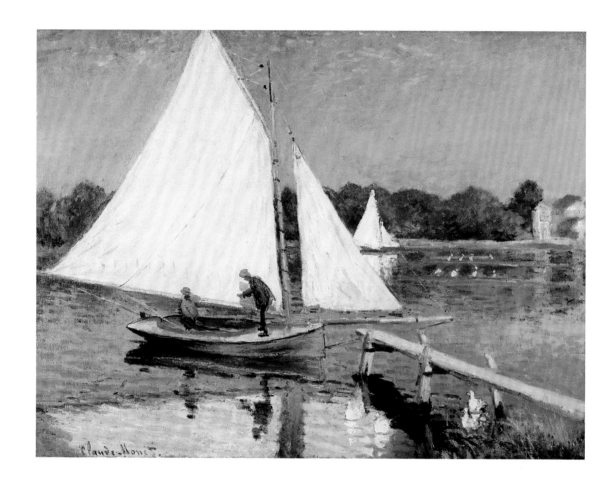

120. Claude Monet

Boaters at Argenteuil (Canotiers à Argenteuil), 1873–1874
Oil on canvas
23½ × 31½ in. (60 × 81 cm)
Helly Nahmad Gallery, New York
(DW324)

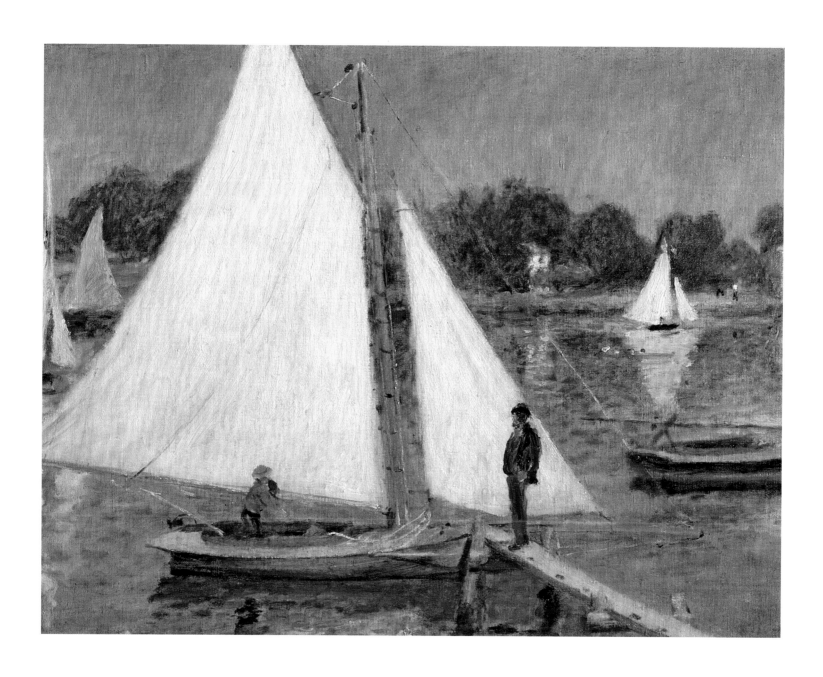

121. Pierre-Auguste Renoir

Seine at Argenteuil (The Sails) (La Seine à Argenteuil [Les voiles]), 1874
Oil on canvas
19¾ × 25¾ in. (51 × 65 cm)
Portland Art Museum, Oregon. Bequest of
Winslow B. Ayer, 35.26
(G-P&MD126)

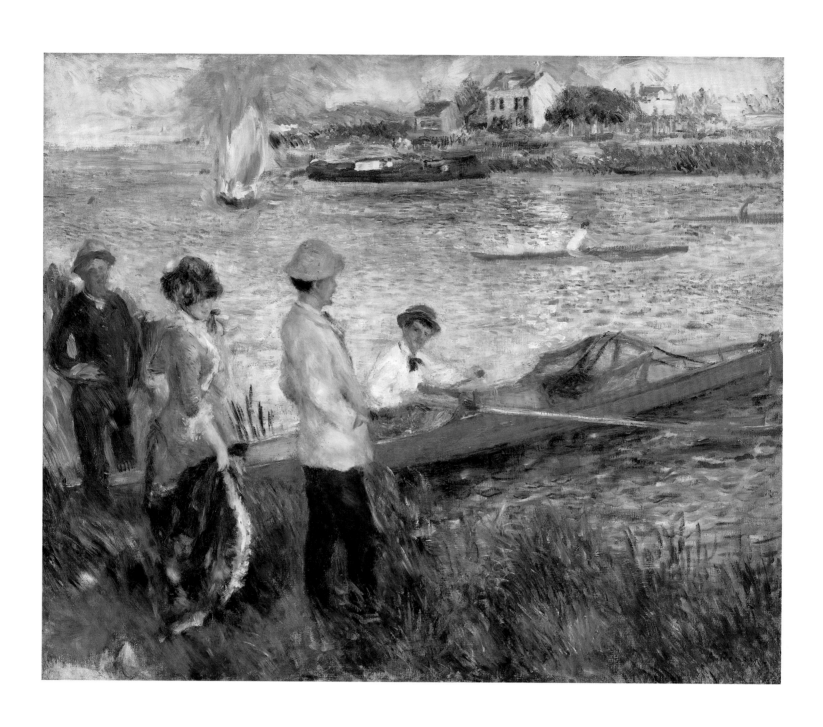

122. Pierre-Auguste Renoir

Oarsmen at Chatou (Les canotiers à Chatou), 1875–ca. 1879
Oil on canvas
31½ × 39⅜ in. (80 × 100 cm)
National Gallery of Art, Washington, DC.
Gift of Sam A. Lewisohn, 1951.5.2
(G-P&MD217)

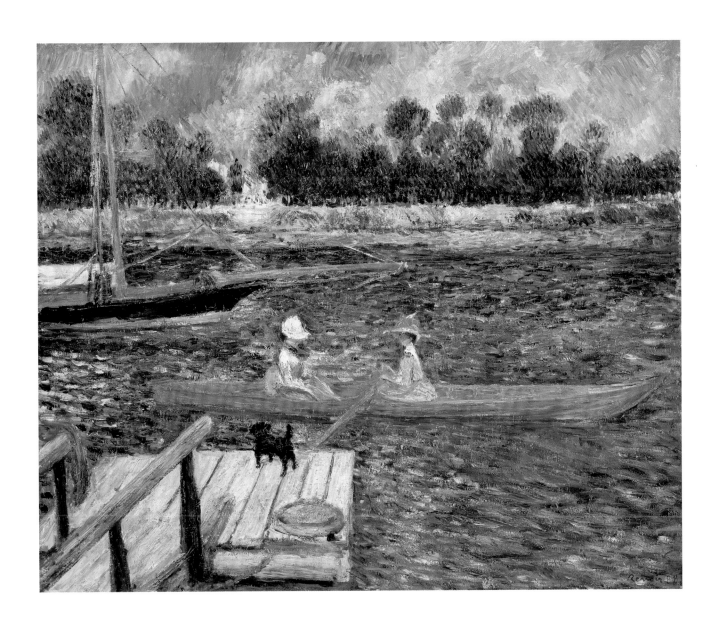

123. Pierre-Auguste Renoir

*The Seine at Argenteuil (La Seine à
Argenteuil [Le canot rouge])*, 1888
Oil on canvas
21¼ × 25⁹⁄₁₆ in. (54 × 65 cm)
The Barnes Foundation, Philadelphia. BF126
(G-P&MD831)

124. Édouard Manet

The Sea (La mer) from the book *Le fleuve*
by Charles Cros (Paris: Librairie de
l'Eau-Forte, 1874)
Etching
3⅛ × 5½ in. (8 × 14 cm)
Fine Arts Museums of San Francisco. Bruno
and Sadie Adriani Collection, 1957.121
(H155g)

125. Claude Monet

*Regatta at Argenteuil (Les barques, régates
à Argenteuil)*, ca. 1874
Oil on canvas
25⅝ × 39⅜ in. (60 × 100 cm)
Musée d'Orsay, Paris. RF 2008
(DW339)

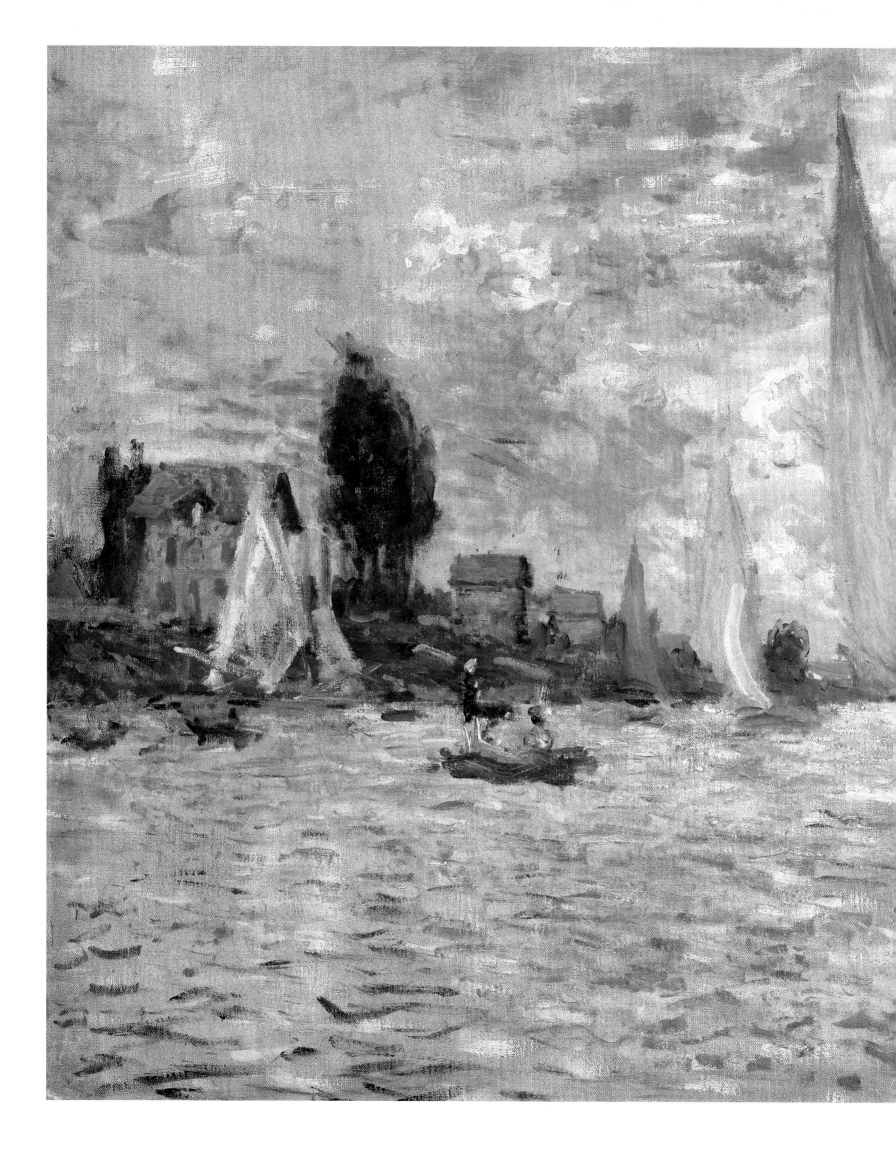

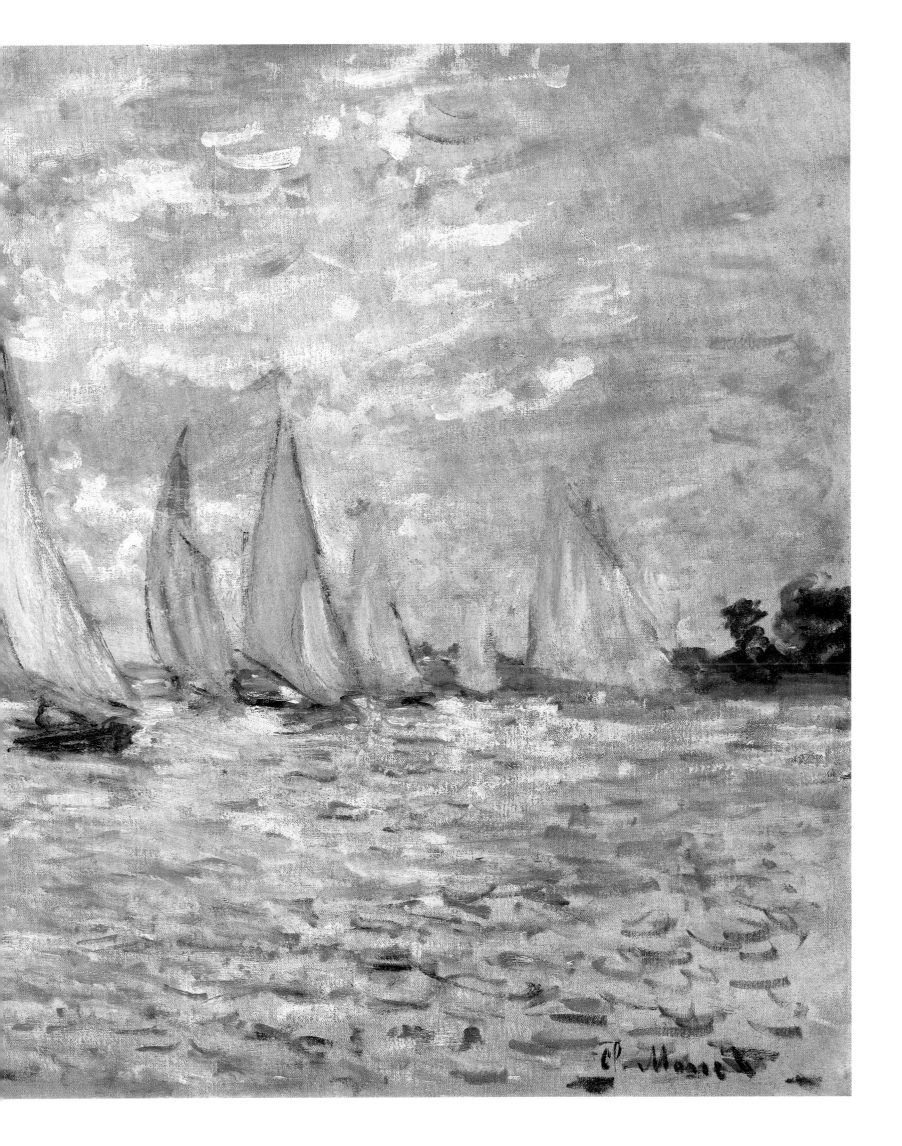

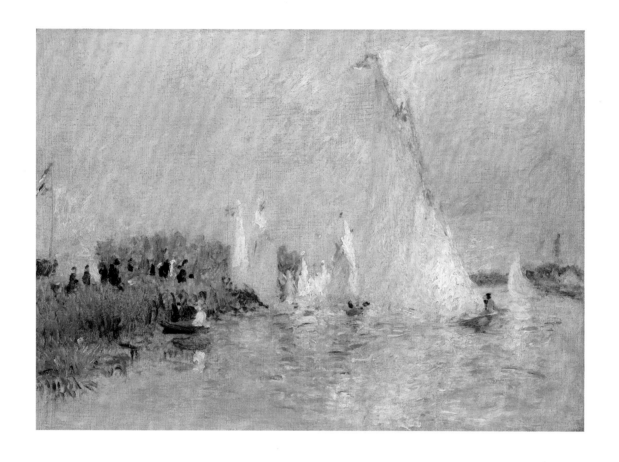

126. Pierre-Auguste Renoir

Regatta at Argenteuil (Régates à Argenteuil), 1874
Oil on canvas
12⅝ × 17¾ in. (32 × 45 cm)
National Gallery of Art, Washington, DC.
Ailsa Mellon Bruce Collection, 1970.17.59
(G-P&MD128)

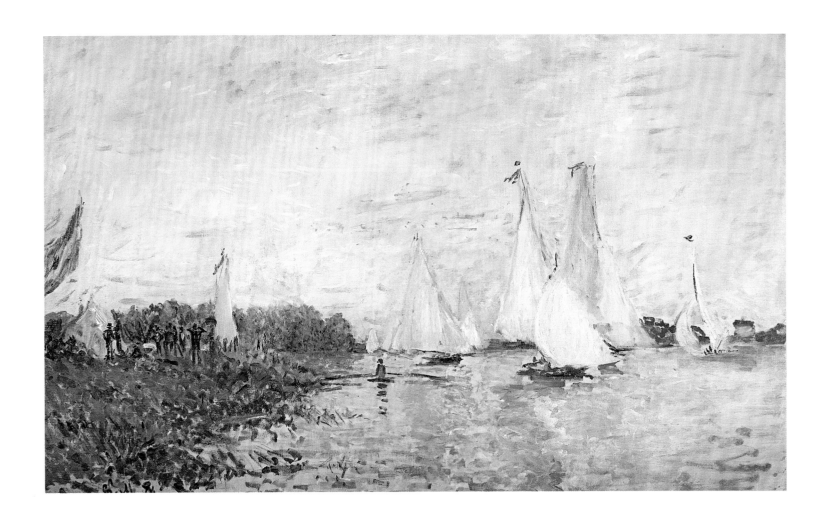

127. Claude Monet

Regatta at Argenteuil (Régates à Argenteuil), 1874
Oil on canvas
23¼ × 39 in. (59 × 99 cm)
Private collection
(DW340)

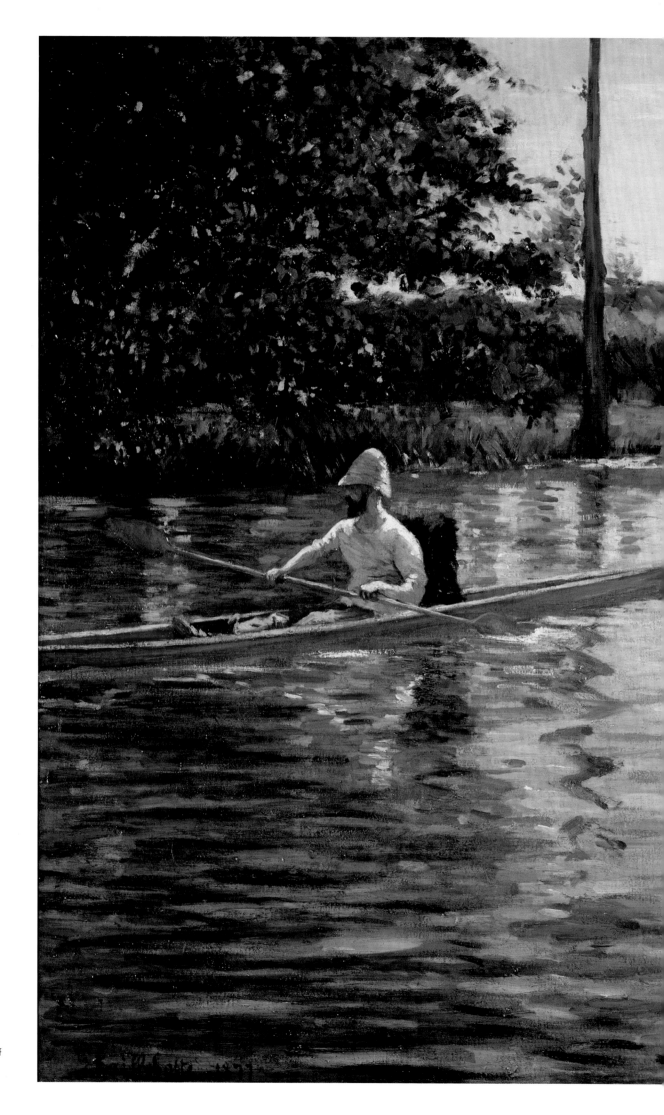

128. Gustave Caillebotte

Skiffs on the Yerres (Périssoires sur l'Yerres), 1877
Oil on canvas
40½ × 61⅜ in. (103 × 156 cm)
Milwaukee Art Museum. Gift of the Milwaukee Journal Company, in honor of Miss Faye McBeath, M1965.25
(MB86)

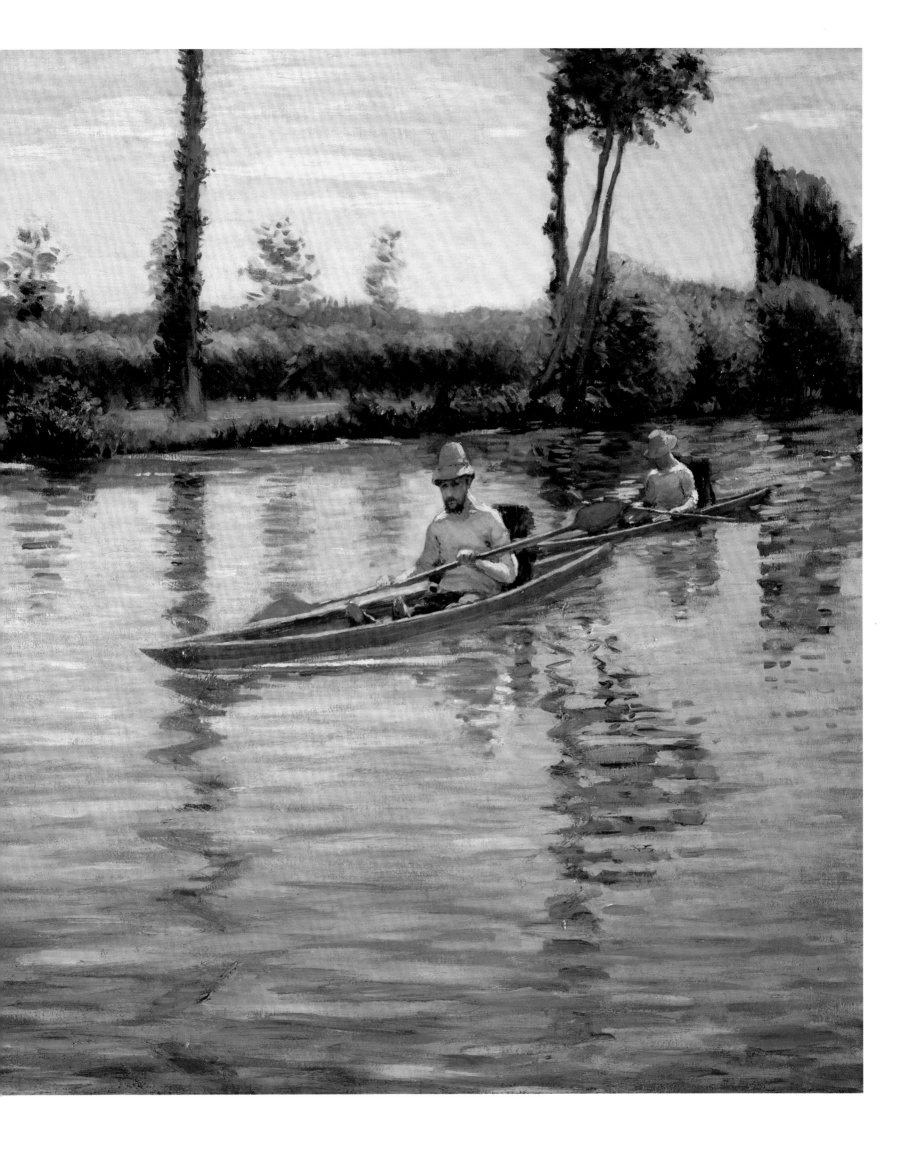

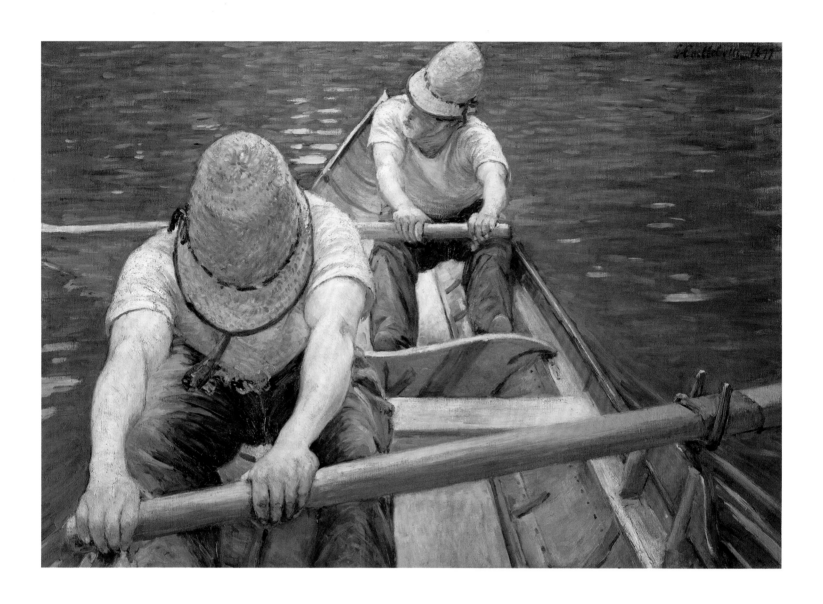

129. Gustave Caillebotte

*Oarsmen Rowing on the Yerres (Canotiers
ramant sur l'Yerres)*, 1877
Oil on canvas
31⅞ × 45⅝ in. (81 × 116 cm)
Private collection
(MB83)

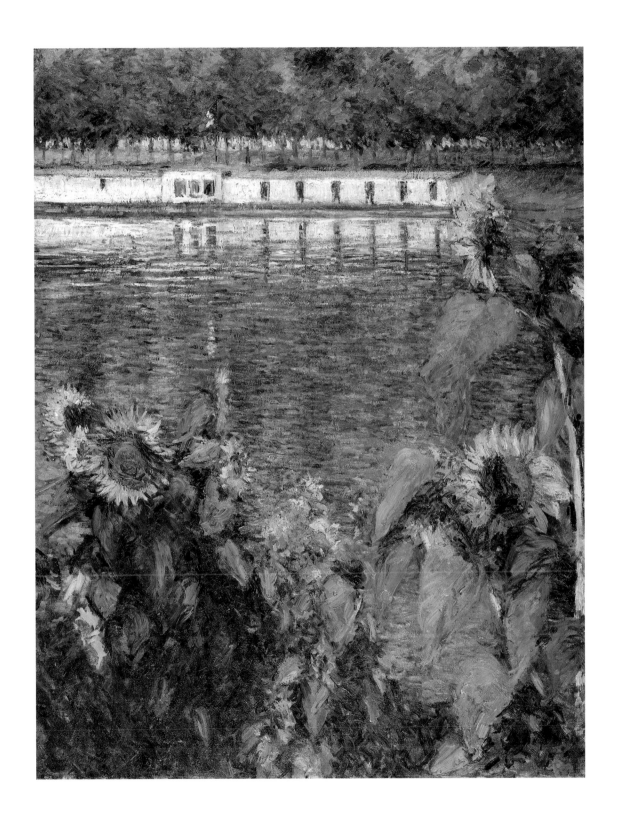

130. Gustave Caillebotte

Sunflowers along the Seine (Soleils, au bord de la Seine), ca. 1885–1886
Oil on canvas
36¼ × 28¾ in. (92 × 73 cm)
Private collection
(MB336)

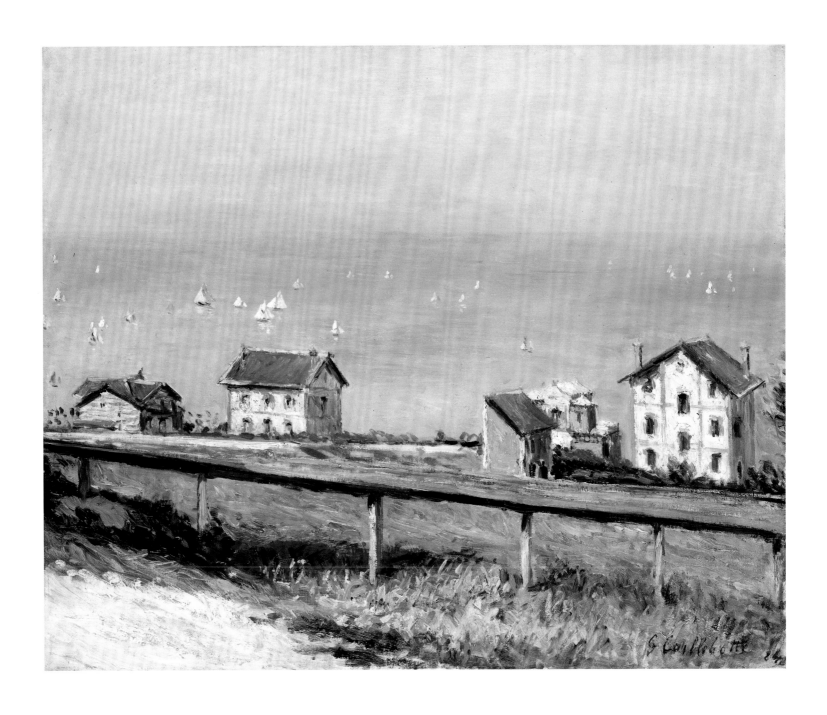

131. Gustave Caillebotte

Regatta at Trouville (Régates à Trouville), 1884
Oil on canvas
23⅝ × 28⅜ in. (60 × 72 cm)
Toledo Museum of Art, Ohio. Gift of
The Wildenstein Foundation, 1953.69
(MB311)

132. Gustave Caillebotte

Regatta at Argenteuil (Régates à Argenteuil), 1893
Oil on canvas
61⅞ × 46⅛ in. (157 × 117 cm)
Private collection
(MB475)

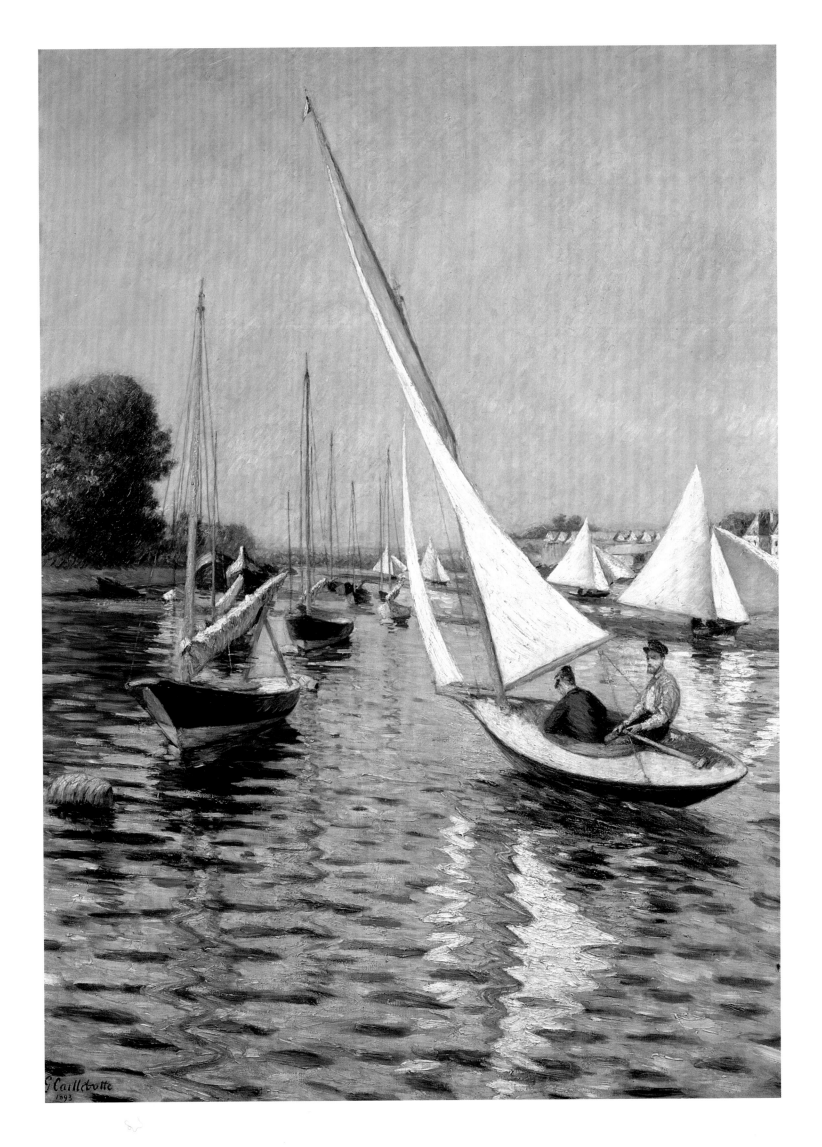

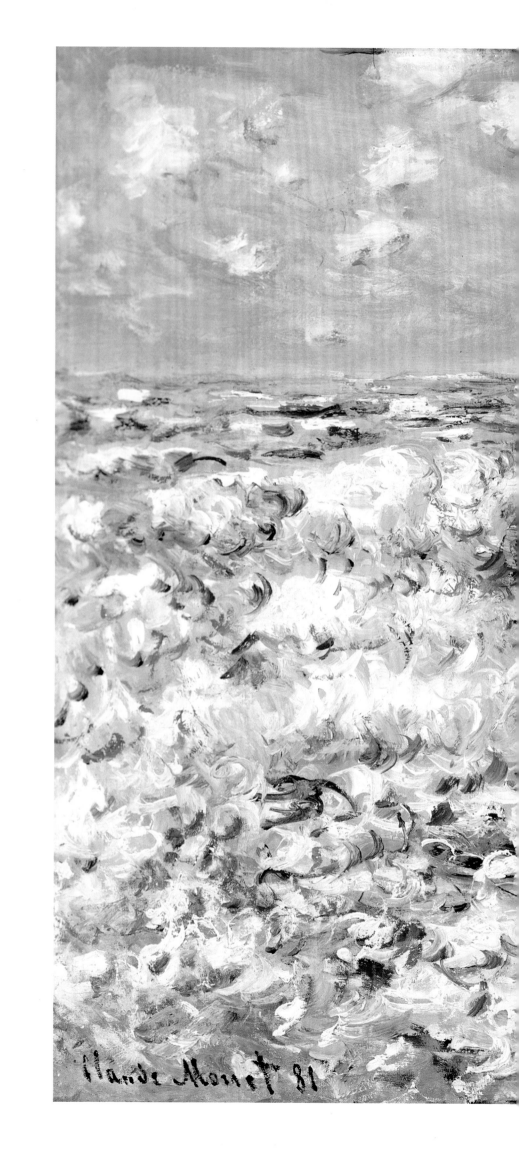

133. Claude Monet

Waves Breaking (Vagues déferlantes), 1881
Oil on canvas
23½ × 32 in. (59.7 × 81.3 cm)
Fine Arts Museums of San Francisco. Gift of
Prentis Cobb Hale, 1970.10
(DW661)

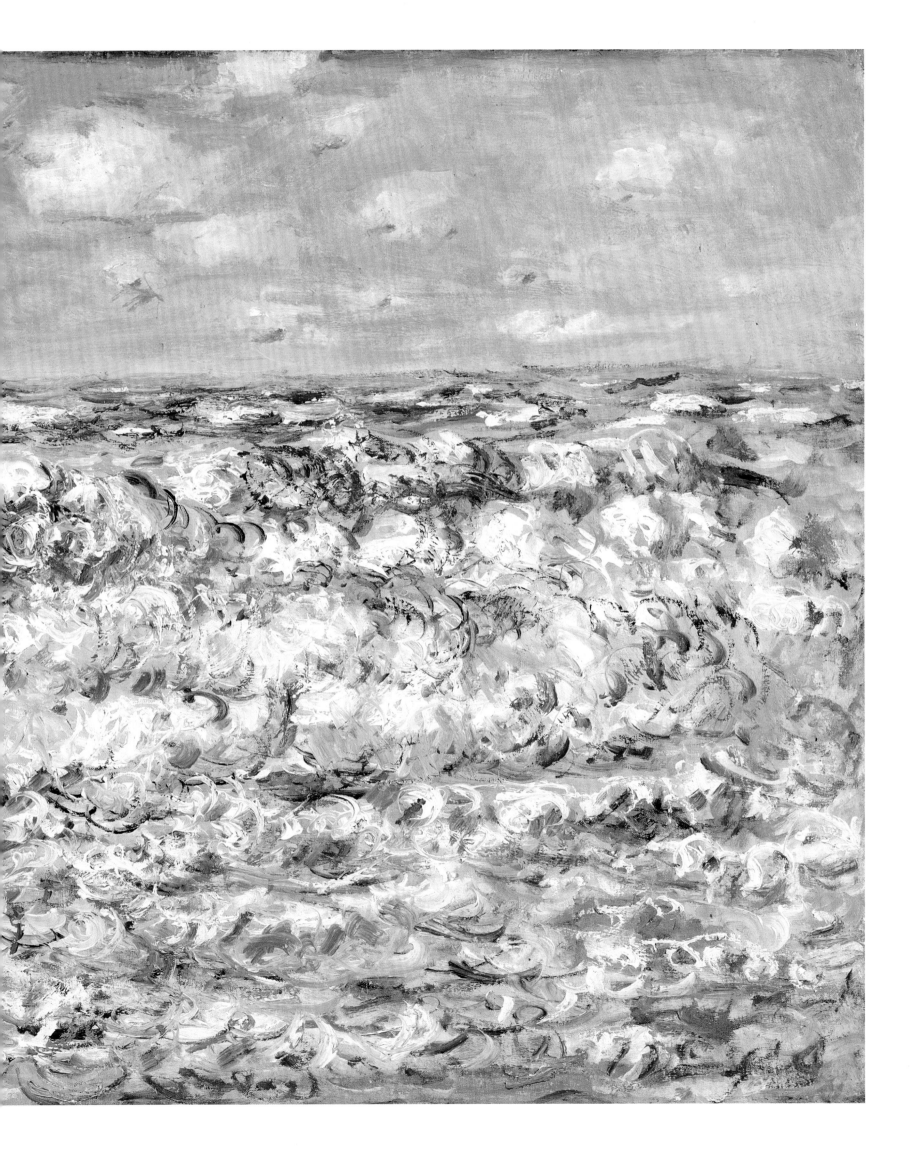

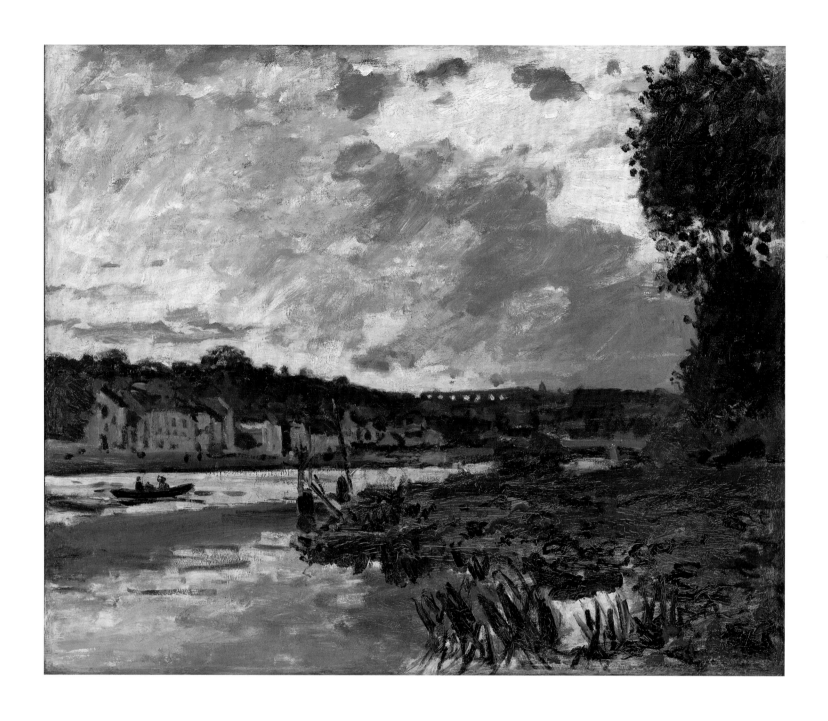

134. Claude Monet

The Seine at Bougival in the Evening
(La Seine à Bougival, le soir), 1869
Oil on canvas
23⅝ × 28⅞ in. (60 × 73.3 cm)
Smith College Museum of Art, Northampton,
Massachusetts. Purchased, SC 1946.4
(DW151)

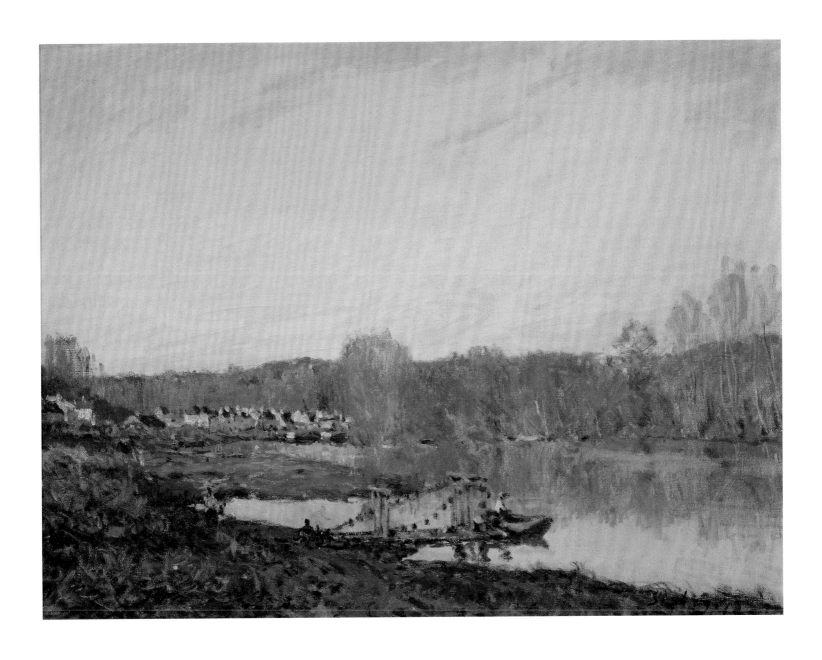

135. Alfred Sisley

Autumn: Banks of the Seine near Bougival
(*Bords de la Seine—Automne*), 1873
Oil on canvas
18⅛ × 24 in. (46 × 61 cm)
Montreal Museum of Fine Arts. Adaline
Van Horne Bequest, 1945.924
(FD94)

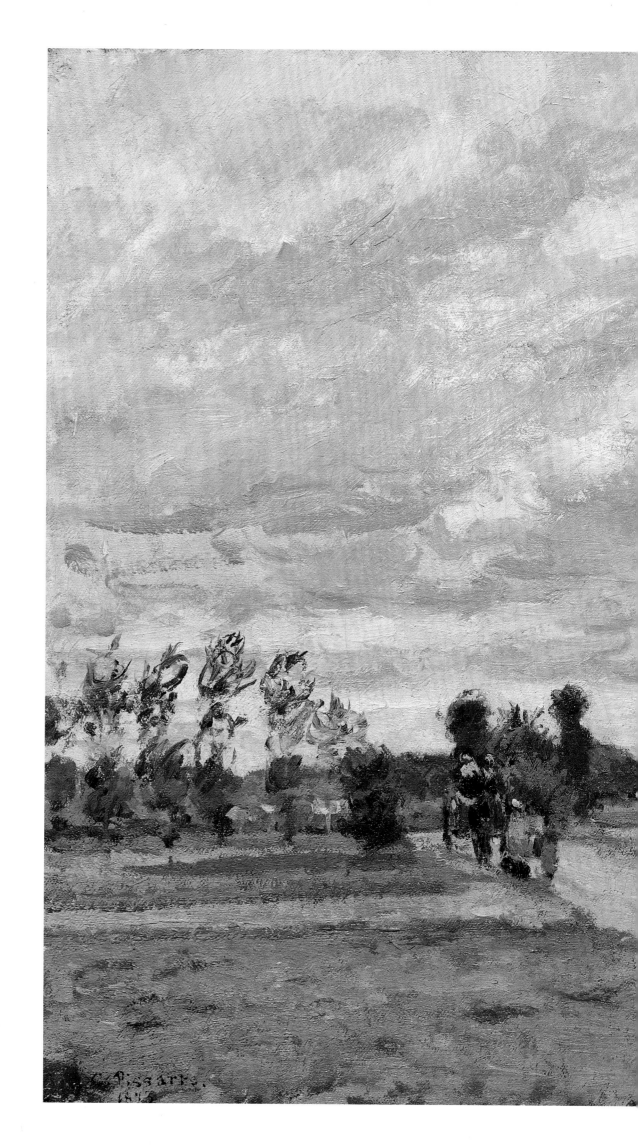

136. Camille Pissarro

*The Route d'Auvers on the Banks of the Oise,
Pontoise (La route d'Auvers au bord de
l'Oise, Pontoise)*, 1873
Oil on canvas
15 × 21¾ in. (38.1 × 57.8 cm)
Indianapolis Museum of Art. Presented to the
Art Association by James E. Roberts, 40.252
(P&D-RS303)

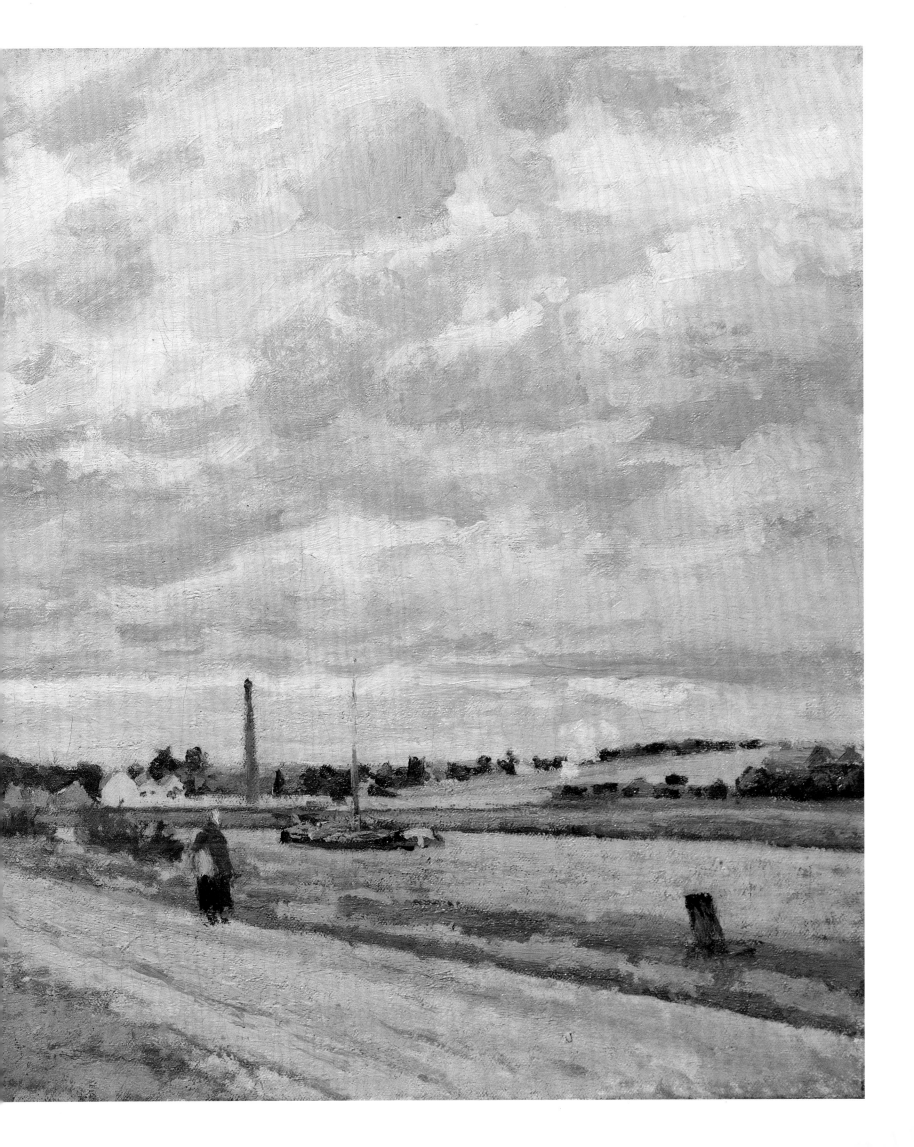

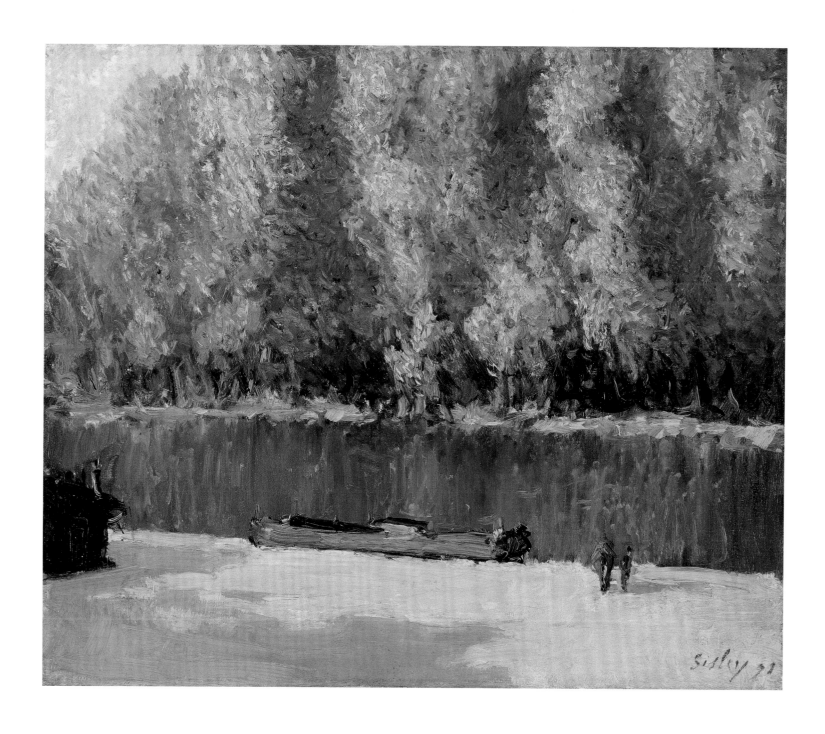

137. Alfred Sisley

Banks of the Loing (Bords du Loing), 1891
Oil on canvas
14 × 17½ in. (35.6 × 44.5 cm)
Fine Arts Museums of San Francisco.
Bequest of Whitney Warren, Jr., in memory
of Mrs. Adolph B. Spreckels, 1988.10.41
(FD768)

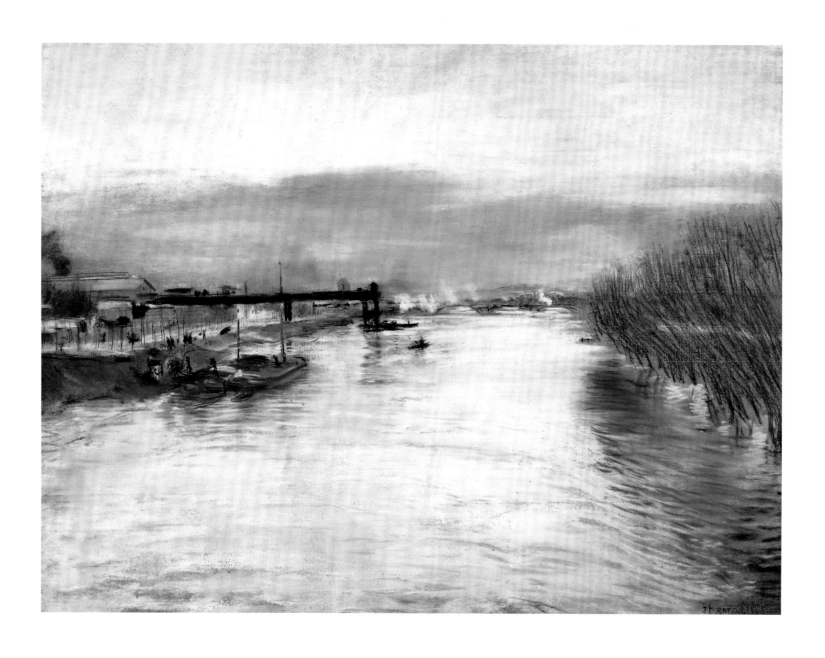

138. Jean-François Raffaëlli

The Seine at Billancourt (La Seine à Billancourt), ca. 1878
Pastel on paper
18⅜ × 24⅝ in. (46.7 × 62.5 cm)
Collection of David and Constance Yates

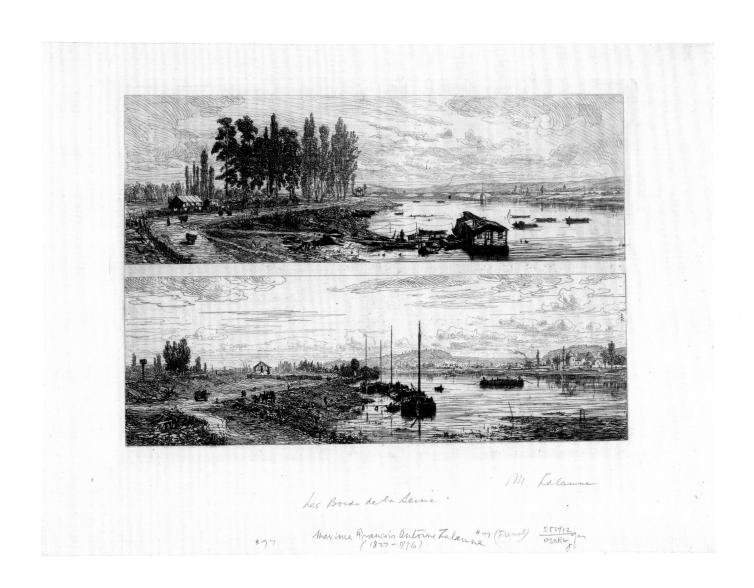

139. Maxime Lalanne

*The Banks of the Seine from Bezons, The
Banks of the Seine around Argenteuil
(Le bords de la Seine à Bezons, Les bords
de la Seine près Argenteuil)*, 1869
Etching
7³⁄₁₆ × 10³⁄₁₆ in. (18.3 × 25.8 cm)
Fine Arts Museums of San Francisco.
Achenbach Foundation for Graphic Arts,
1963.30.31899
(V56 i/iv, V57 i/iv)

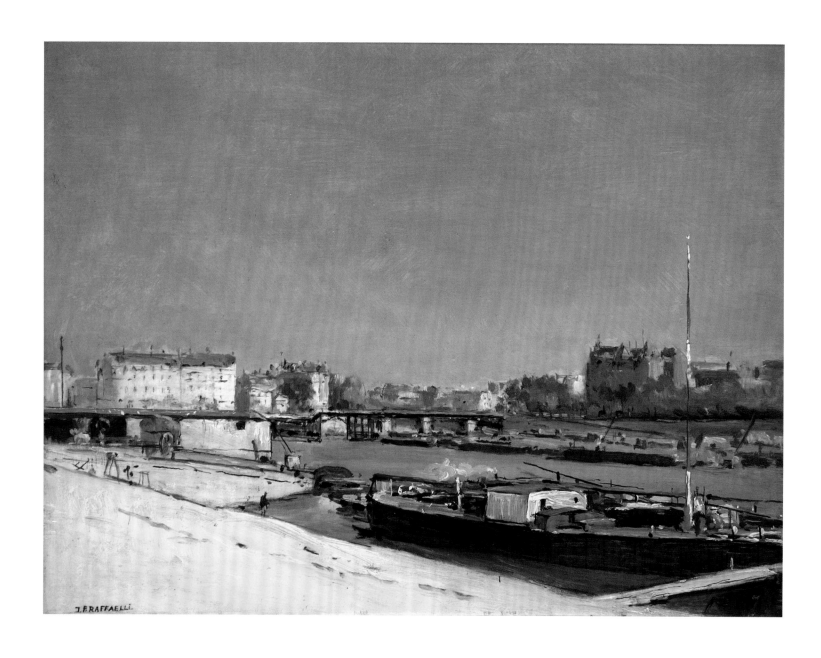

140. Jean-François Raffaëlli
View of the Right Bank of the Seine, Paris
(*Vue sur la rive droite de la Seine, Paris*),
ca. 1880s
Oil on canvas
12 × 16 1/10 in. (30.5 × 42 cm)
Private collection

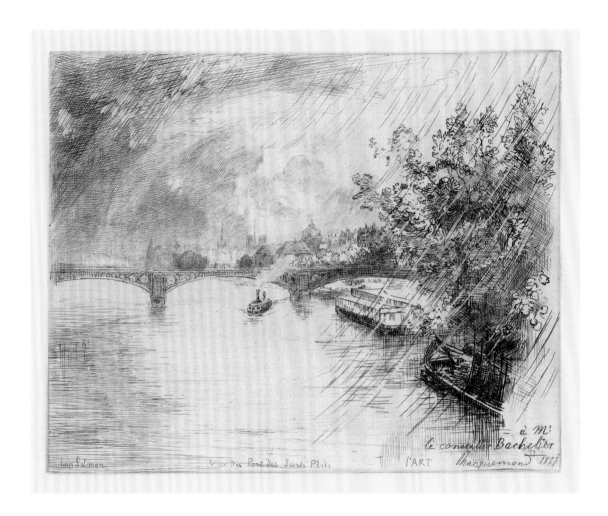

141. Félix Bracquemond

View from the Pont des Saints-Pères
(*Vue du pont des Saints-Pères*), published
in *L'Art* (vol. 12, 1878), 1877
Etching
7¹¹⁄₁₆ × 9¾ in. (19.5 × 24.7 cm)
Fine Arts Museums of San Francisco.
Achenbach Foundation for Graphic Arts,
1963.30.1240
(B217 iv/iv)

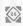

142. Henri Rivière

*From the Pont d'Austerlitz (Du pont
d'Austerlitz)*, plate 26 from the book
Les trente-six vues de la Tour Eiffel
(Paris: Eugène Verneau, 1902)
Color lithograph
6¹¹⁄₁₆ × 8⁵⁄₁₆ in. (17 × 21.1 cm)
Fine Arts Museums of San Francisco.
Museum purchase, Achenbach Foundation
for Graphic Arts Endowment Fund,
1983.1.2.26

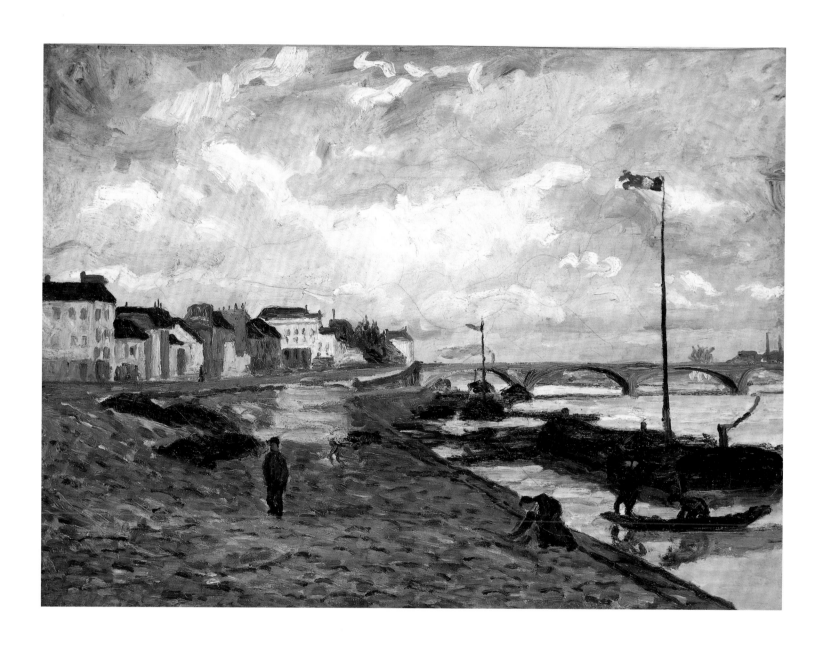

143. Jean-Baptiste-Armand
Guillaumin

The Seine (La Seine), 1874
Oil on canvas
17⅞ × 24¼ in. (45.4 × 61.6 cm)
Fine Arts Museums of San Francisco. Gift of
Mr. and Mrs. Louis A. Benoist, 1956.17

144. Camille Pissarro

Harbor at Dieppe (*Le port de Dieppe*), 1902
Oil on canvas
18⅜ × 21¾ in. (46.7 × 55.2 cm)
Fine Arts Museums of San Francisco.
Mildred Anna Williams Collection, 1940.52
(P&D-RS1444)

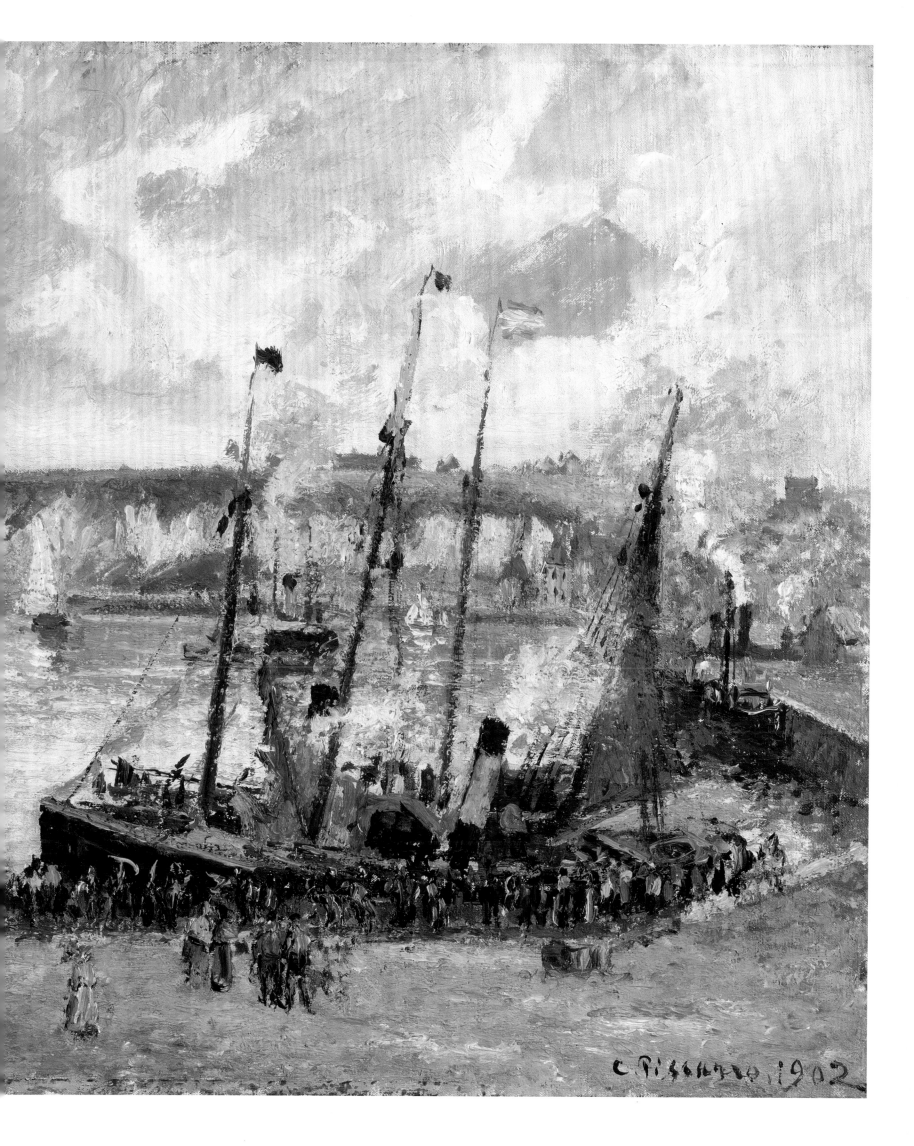

C. Pissarro 1902

145. Gustave Le Gray
Lighthouse and Jetty, Le Havre (Phare et jetée du Havre), 1857
Albumen silver print
12³⁄₁₆ × 15⁷⁄₈ in. (31 × 40.3 cm)
The J. Paul Getty Museum, Los Angeles.
85.XM.153

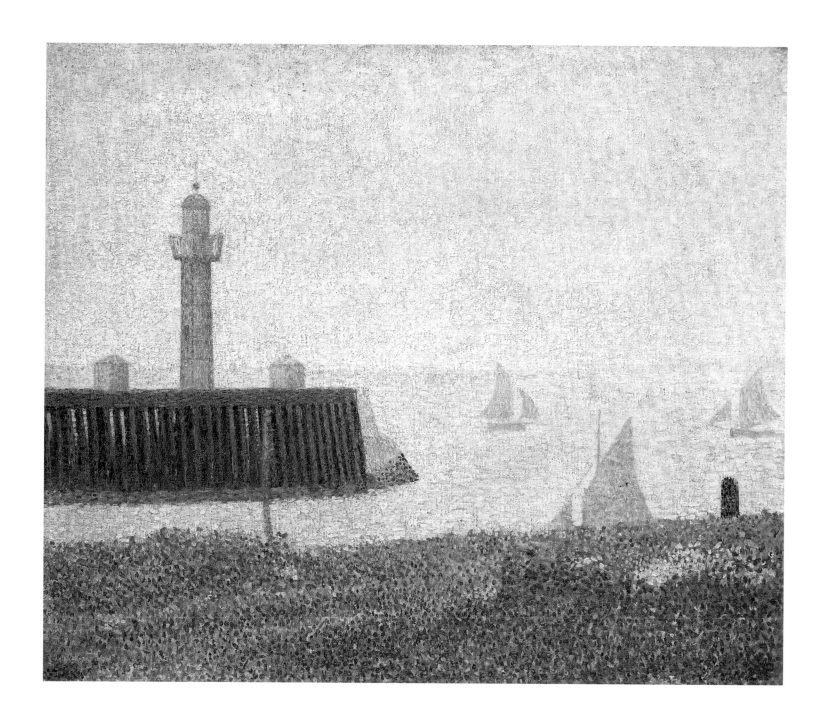

146. Georges Seurat

Harbor Entrance at Honfleur (Bout de jetée, Honfleur), 1886
Oil on canvas
18⅛ × 21⅝ in. (46 × 55 cm)
Kröller-Müller Museum, Otterlo,
The Netherlands. KM 101.824
(D&R163)

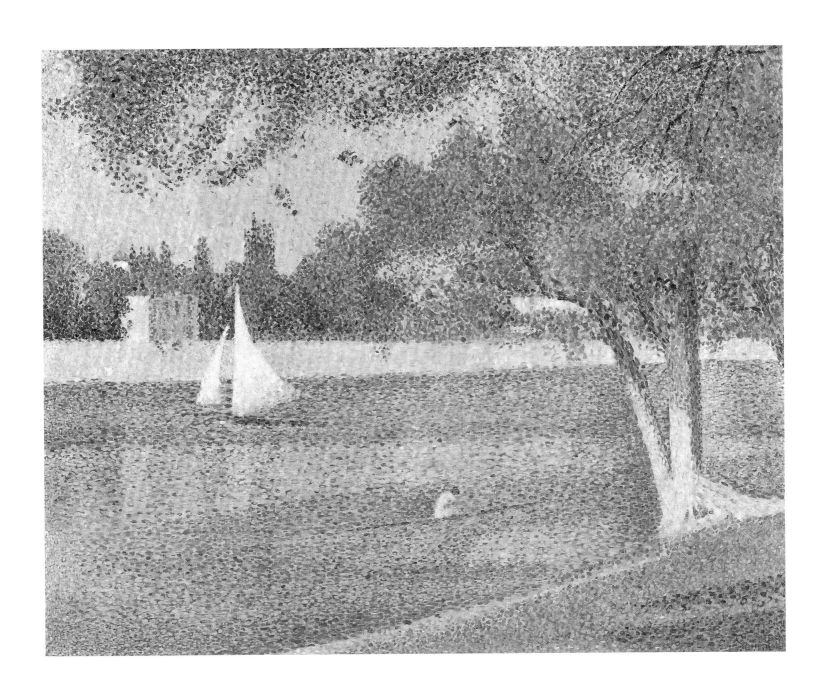

147. Georges Seurat

*The Seine at the Grande Jatte in the Spring
(The Banks of the Seine) (La Seine à la
Grande Jatte, printemps [Au bords de
la Seine]),* 1888
Oil on canvas
25⅝ × 31⅞ in. (65.1 × 81 cm)
Royal Museums of Fine Arts of Belgium,
Brussels. 5091
(D&R183)

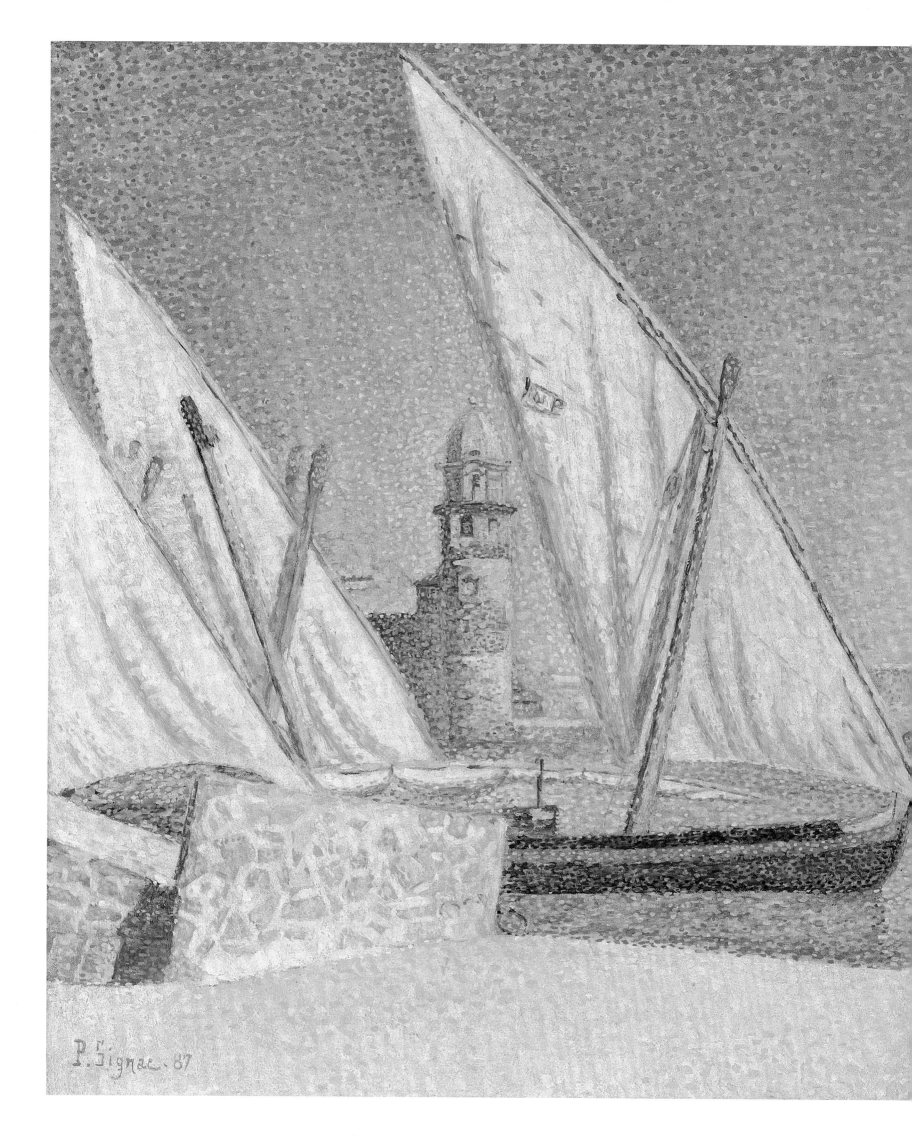

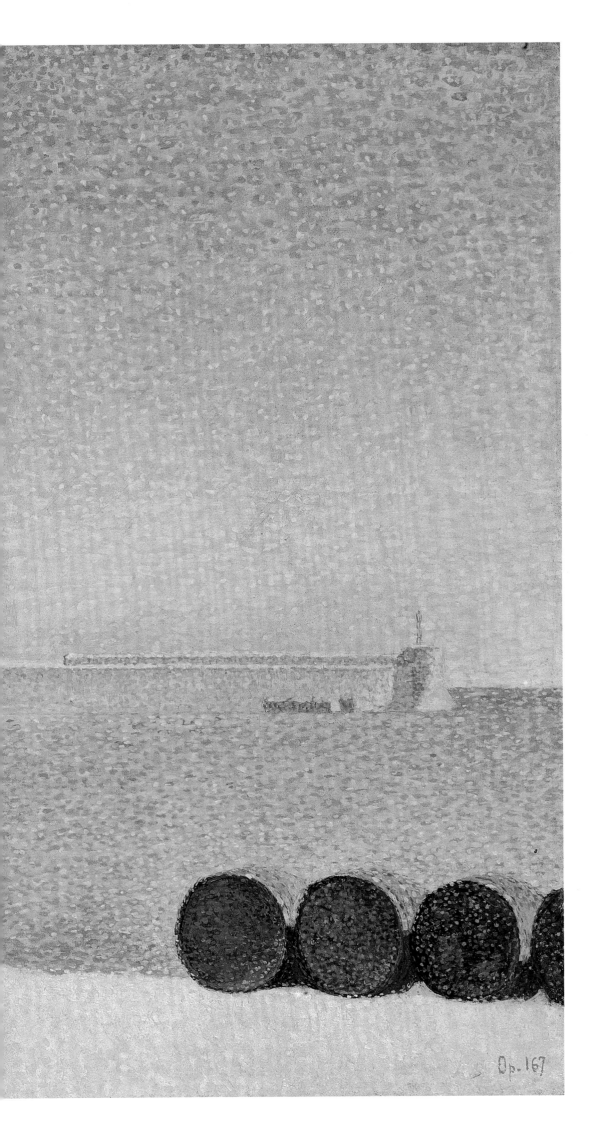

148. Paul Signac
Collioure: Ships (Collioure. Les balancelles
[Opus 167]), 1887
Oil on canvas
18⅛ × 23¼ in. (46 × 59 cm)
Private collection
(FC155)

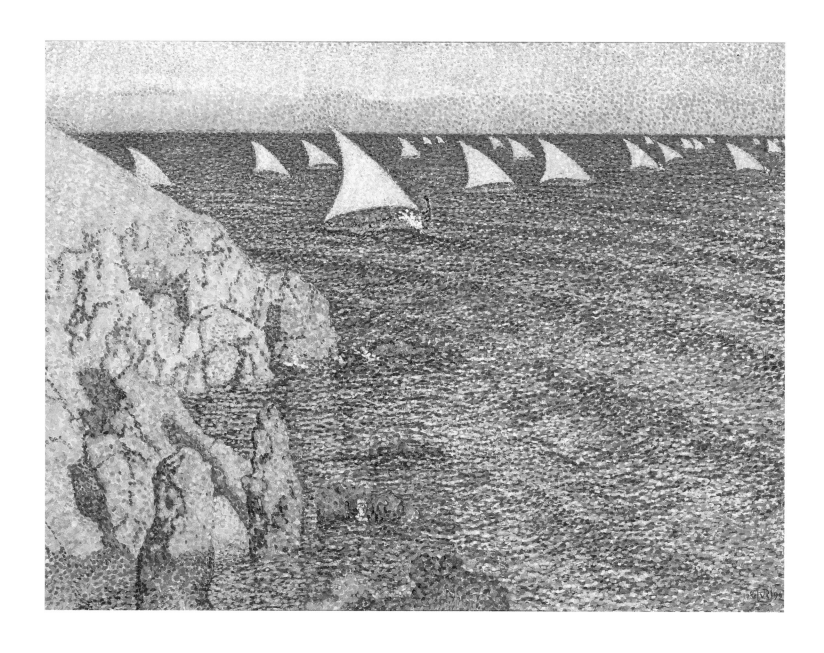

149. Théo (Théophile) van
Rysselberghe

The Regatta (La régates), 1892
Oil on canvas
24 × 31¾ in. (61 × 80.6 cm)
Museum of Fine Arts, Boston. Scott M. Black
Collection, 2.1996.4

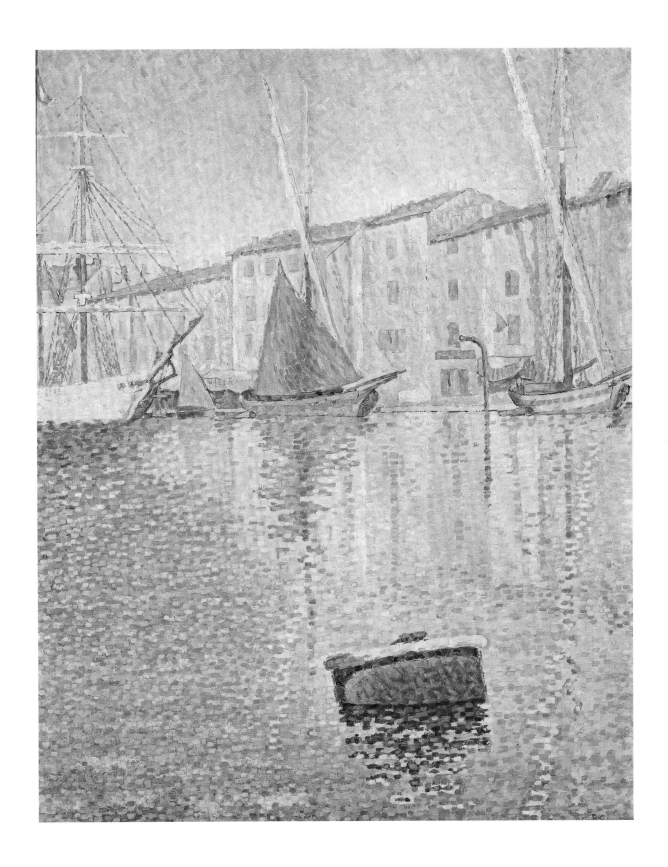

150. Paul Signac

Saint-Tropez. The Red Buoy (Saint-Tropez.
La bouée rouge), 1895
Oil on canvas
32 × 26 in. (81 × 65 cm)
Musée d'Orsay, Paris. RF 1957-12
(FC284)

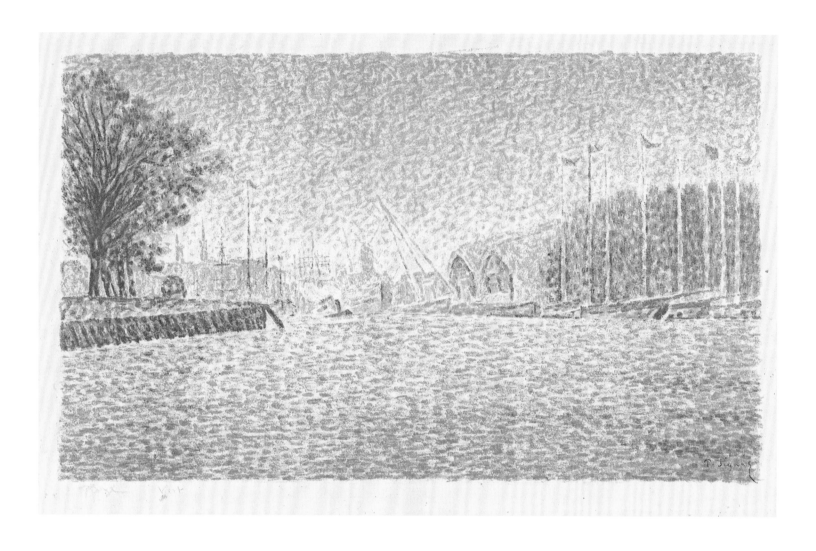

151. Paul Signac

At Flushing, Netherlands (À Flessingue, aux Pays-Bas), 1895
Color lithograph
9³⁄₁₆ × 16 in. (23.4 × 40.6 cm)
Fine Arts Museums of San Francisco.
Achenbach Foundation for Graphic Arts,
1963.30.2148
(KW11 i/iii)

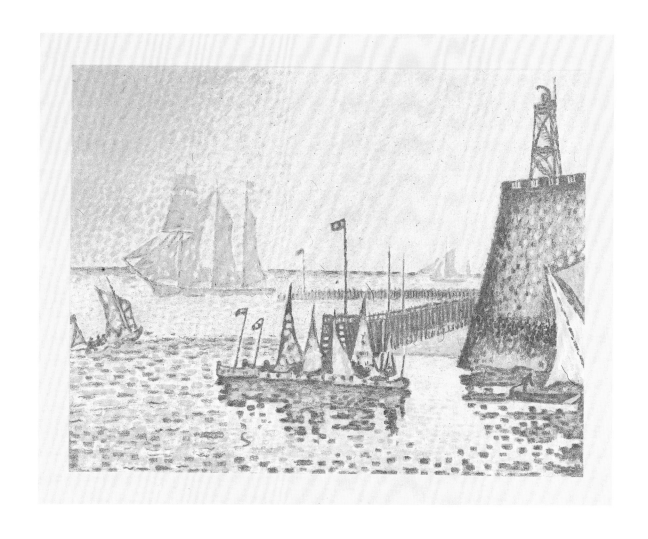

152. Paul Signac

Evening (Le Soir [Abend—La jetée de Flessingue]), published in Pan (vol. 4, no. 1, 1898), 1898
Color lithograph
7⅝ × 10¹⁄₁₆ in. (19.4 × 25.5 cm)
Fine Arts Museums of San Francisco. Gift of Henry R. and Galen Howard Hilgard, 1995.116.1
(KW20)

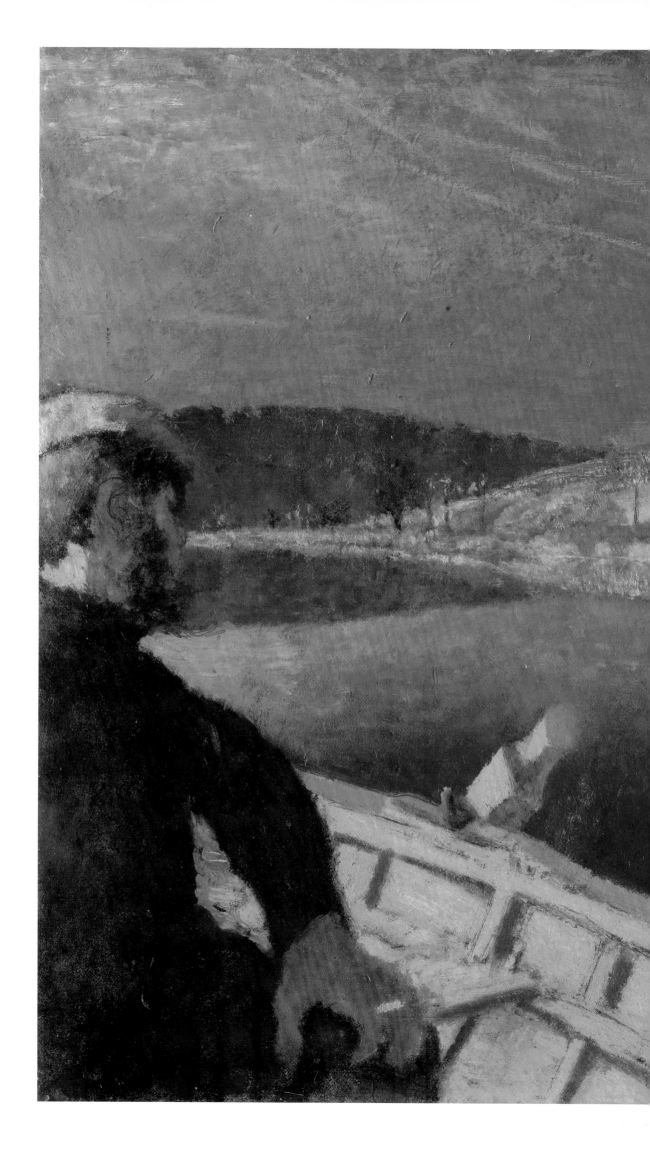

153. Édouard Vuillard
The Boatman (Le passeur), 1897
Oil on cardboard, mounted on
cradled panel
20⅛ × 29⅜ in. (51 × 74.5 cm)
Musée d'Orsay, Paris. RF 1977-385
(S&C VI-92)

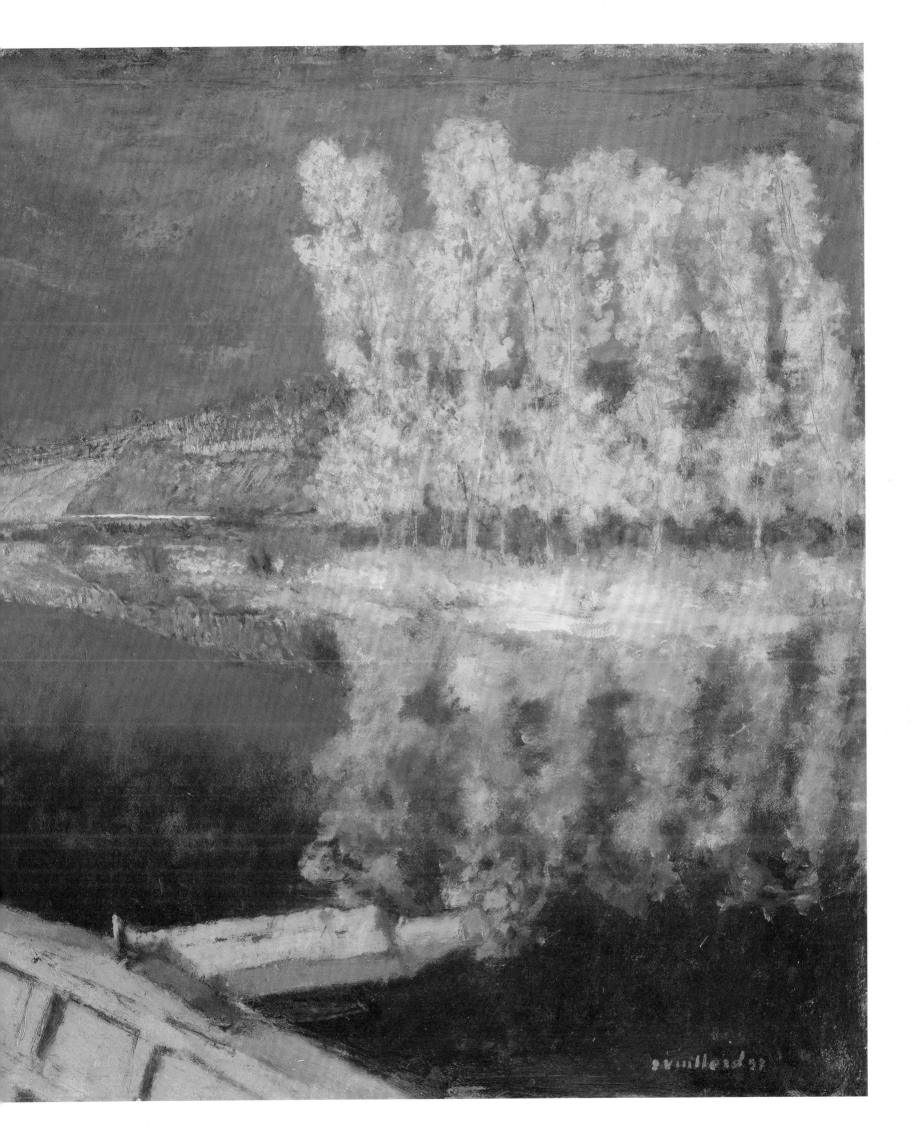

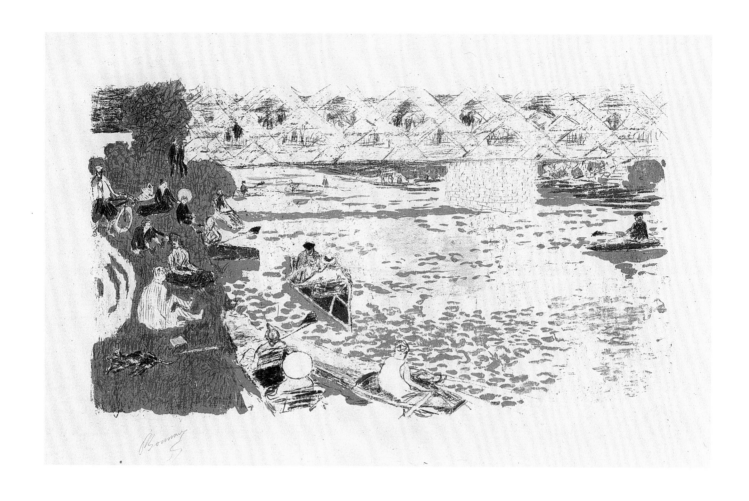

154. Pierre Bonnard
Rowing (Canotage), 1896–1897
Color lithograph
10½ × 18½ in. (27 × 47 cm)
Van Gogh Museum, Amsterdam

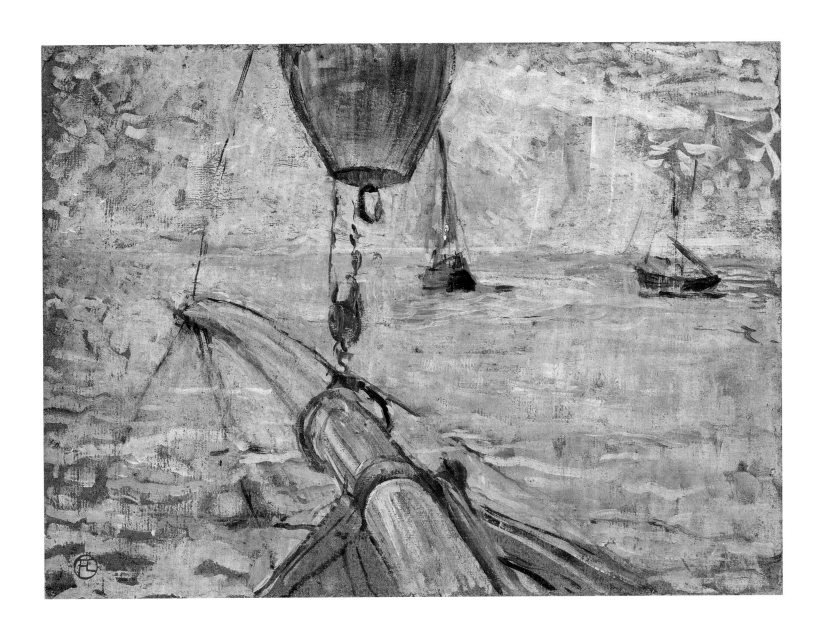

155. Henri de Toulouse-Lautrec

*The Harbour of Arcachon Seen from the Prow
of the "Cocorico"* (*Vue du bassin d'Arcachon du
beaupré du yacht "Cocorico"*), 1889
Oil on cardboard
10⅝ × 14⅝ in. (26.8 × 37 cm)
Musée Toulouse-Lautrec, Albi, France. Gift of
Countess A. de Toulouse-Lautrec, 1922
(MD P.333)

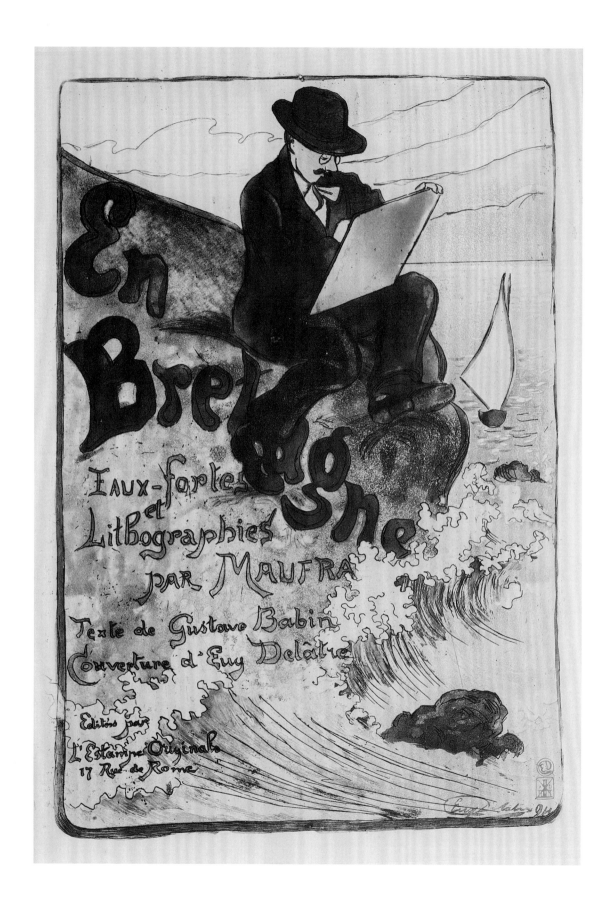

157. Eugène Delâtre

Cover for the album *In Brittany, Engravings and Lithographs by Maufra* (*En Bretagne, eaux-fortes et lithographies par Maufra*), 1894
Color etching and aquatint
18 × 12½ in. (45.7 × 31.8 cm)
Zimmerli Art Museum at Rutgers University, New Brunswick, New Jersey. Museum Purchase, 1986.0120

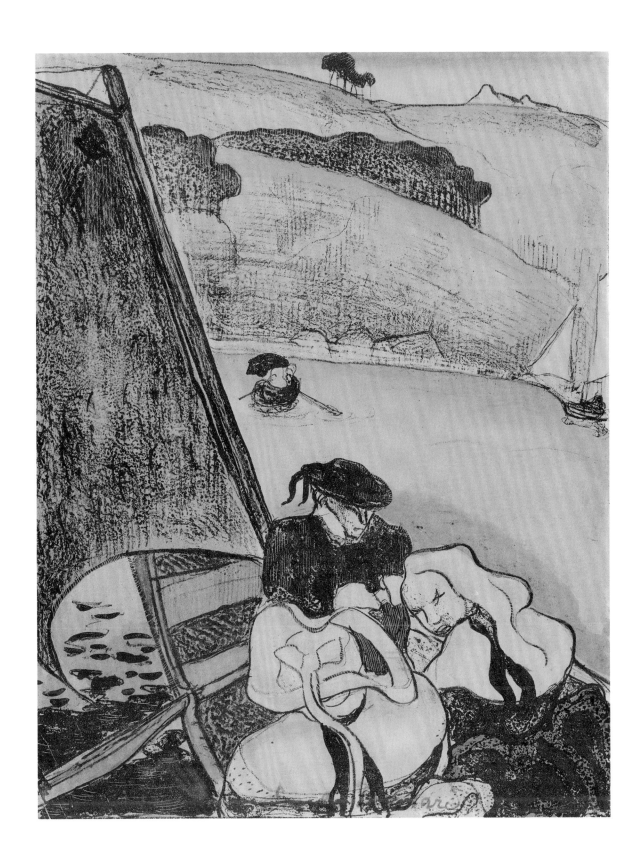

158. Émile Bernard
Bretons in a Ferryboat (*Le retour du pardon
ou Bretons en barque*), 1889
Zincograph with hand coloring
12⅜ × 9¾ in. (31.3 × 24.7 cm)
Van Gogh Museum, Amsterdam
(Vincent Van Gogh Foundation)
(DM10)

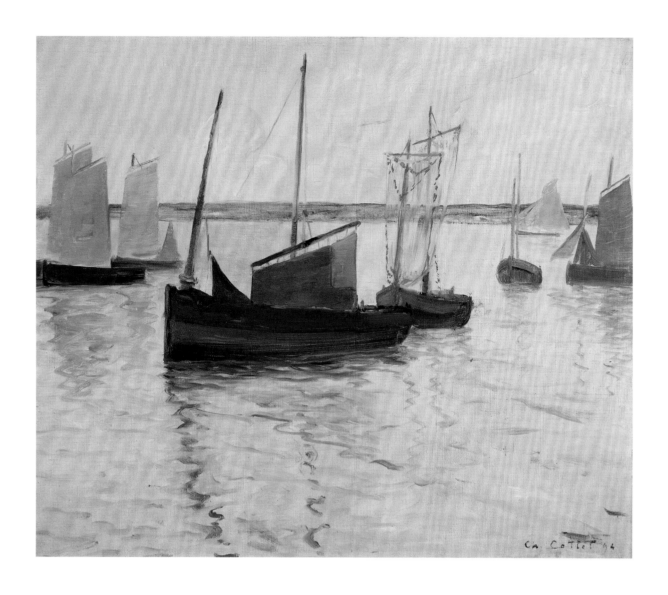

159. Charles Cottet

Breton Seascape (Marine Breton), 1894
Oil on canvas
20¹¹⁄₁₆ × 25 in. (52.5 × 63.5 cm)
Zimmerli Art Museum at Rutgers University,
New Brunswick, New Jersey. Gift of Harold
and Barbara Kaplan, 1986.1099

160. Eugène Delâtre

Woman Rowing (La rameureuse), 1894
Watercolor
11 × 13¹³⁄₁₆ in. (28 × 34.5 cm)
Private collection

161. Théo (Théophile) van Rysselberghe

By the Sea (Au bord de la mer), 1899
Color lithograph
9 × 16⅓ in. (23.8 × 41.5 cm)
Private collection

162. Théo (Théophile) van
Rysselberghe

Fishing Fleet (*Flotille de pêche*), from the
seventh album of *L'estampe originale*, 1893,
published 1894

Etching and aquatint with burnishing, from
two plates, in brown, on tan laid paper,
tipped to tan wove paper
9¾ × 12½ in. (23.8 × 31.7 cm)
Private collection

163. Maurice Denis

Page 5 of *The Voyage of Urien* (*Le voyage d'Urien*), 1893

Book illustrated with lithographs in two colors

8 1/16 × 7 9/16 in. (20.5 × 19.2 cm)

Private collection

(PC39)

164. Maurice Denis
Page 32 of *The Voyage of Urien*
(*Le voyage d'Urien*), 1893
Book illustrated with lithographs in
two colors
8 1/16 × 7 9/16 in. (20.5 × 19.2 cm)
Private collection
(PC46)

165. Henri Gustave Jossot

Wave (La vague), from the sixth album of
L'estampe originale, 1894
Color lithograph
20⅝ × 13¾ in. (52.5 × 35 cm)
Private collection

166. Maurice Denis

*Wallpaper design in two colors: green and
rose (Papier peint aux deux couleurs: vert
et rose)*, 1893
Color lithograph
36⁵⁄₁₆ × 19¾ in. (92.3 × 50.1 cm)
Fine Arts Museums of San Francisco.
Achenbach Foundation for Graphic Arts,
1963.30.1450
(CD71–74)

167. Henri Rivière
The First Quarter Moon (Le premier quartier), 1901
Color lithograph
23 11/16 × 9 1/2 in. (60.2 × 24.2 cm)
Zimmerli Art Museum at Rutgers University, New Brunswick, New Jersey. Gift of Frederick Mezey, 1997.0265

168. Henri Rivière

Night at Sea (Nuit en mer), no. 2 from the
series *Aspects de la nature*, 1897
Color lithograph
21¼ × 32¹¹⁄₁₆ in. (54 × 83 cm)
Zimmerli Art Museum at Rutgers University,
New Brunswick, New Jersey. Gift of Sara
and Armond Fields, 83.078.008

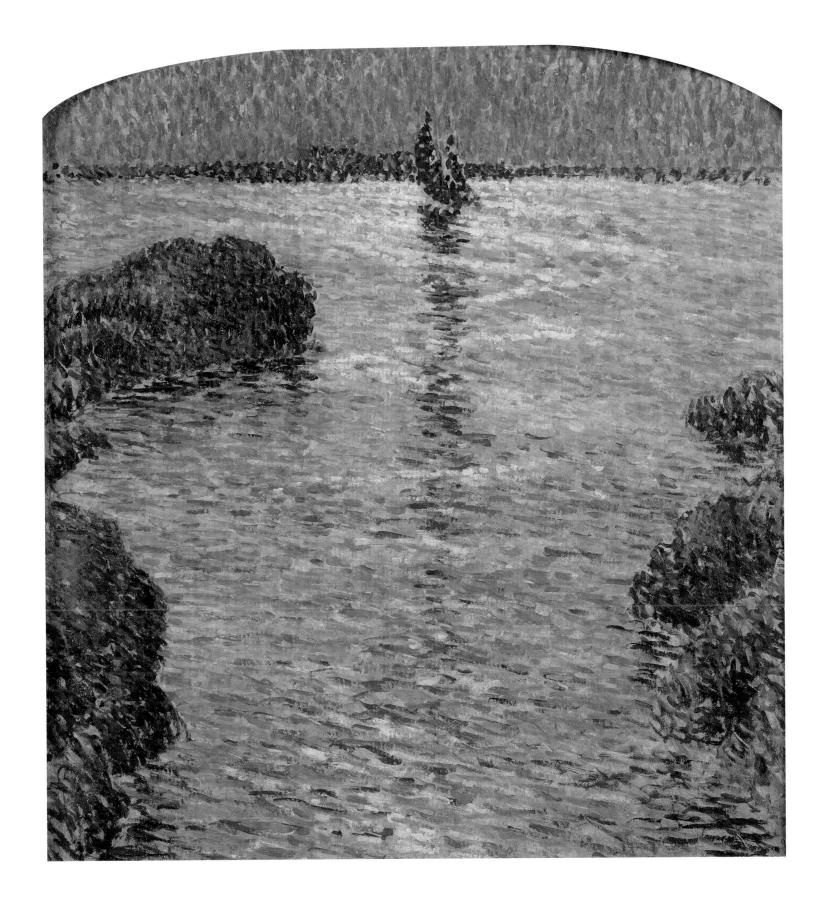

169. Ernest Lucien Bonnotte
Symbolist Seascape (Marine symboliste),
ca. 1900
Oil on cardboard
26 × 21 in. (65 × 54 cm)
Private collection

170. André Derain

Fishing Boats at Collioure (Barques de pêches à Collioure), 1905
Oil on canvas
15⅛ × 18¼ in. (38.2 × 46.3 cm)
The Museum of Modern Art, New York.
The Philip L. Goodwin Collection, 100.1958
(MK75)

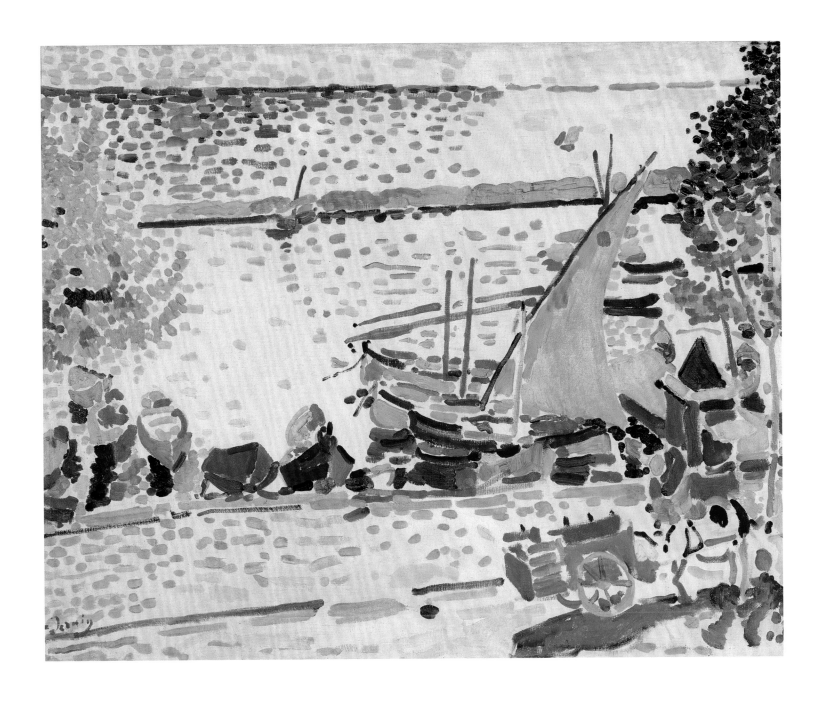

171. André Derain

The Port of Collioure (Le port de Collioure), 1905
Oil on canvas
28 × 35 in. (72 × 91 cm)
Musée d'Art Moderne, Troyes, France.
MNLP 57
(MK62)

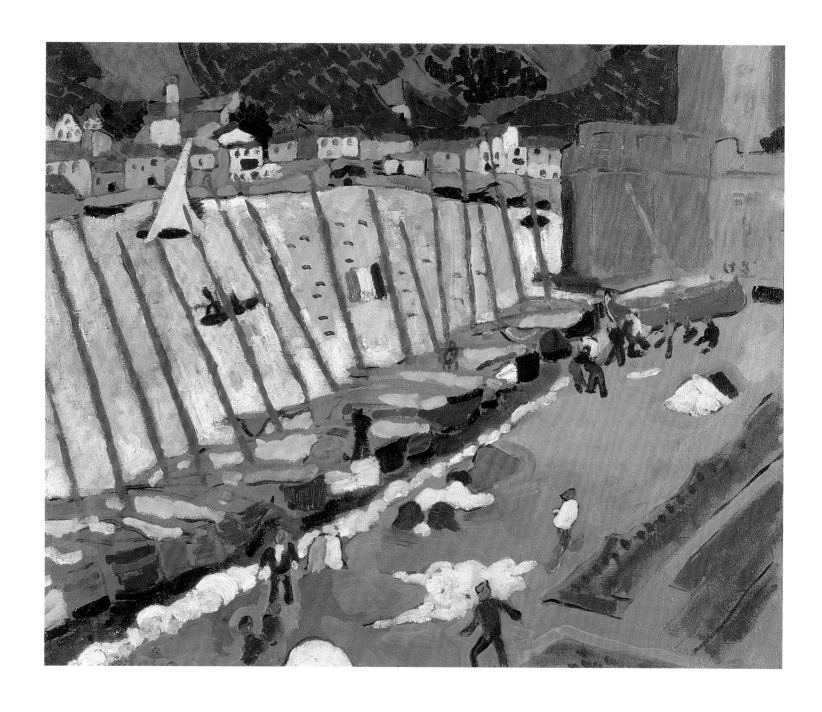

172. André Derain

The Port of Collioure (Port de Collioure),
1905
Oil on canvas
23⅝ × 28¾ in. (60 × 73 cm)
Musée National d'Art Moderne, Centre
Georges Pompidou, Paris. AM 4367P
(MK74)

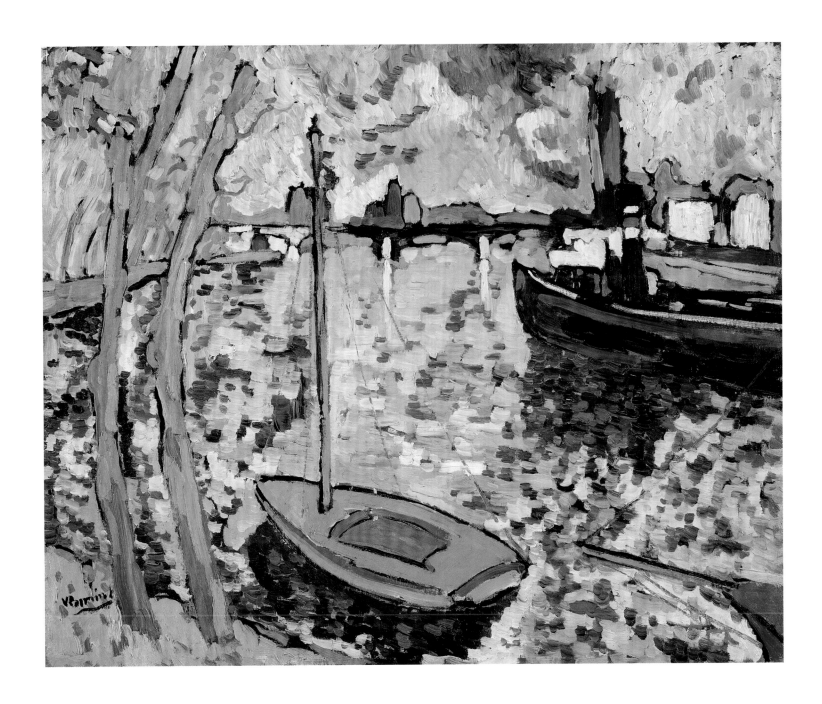

173. Maurice de Vlaminck

The Seine at Chatou (La Seine à Chatou),
1906
Oil on canvas
32½ × 40⅛ in. (82.5 × 102 cm)
The Metropolitan Museum of Art, New York.
Jacques and Natasha Gelman Collection,
1998, 1999.363.84
(VB&S129)

GUSTAVE CAILLEBOTTE (1848–1894): THE INTERSECTION OF ART AND SAILING; A BOATING CHRONOLOGY

Compiled by Gilles Chardeau

174. Photograph by Martial Caillebotte of Gustave Caillebotte working on a boat plan, February 1892. Private Collection

Family Background

The Caillebotte family is originally from Ger (Normandy), inland from the English Channel. In 1830 Martial, Gustave's father, takes over the family textile business in nearby Domfront and moves it to Paris. In 1844 Martial and his third wife, Céleste Daufresne (1819–1878), move to 160 rue du Faubourg Saint-Denis (the street number later became 152, as the result of cadastral changes); Martial establishes his "military beds service" business at this address.

1848

AUGUST 19: Gustave Caillebotte, the first child of this third marriage, comes into the world, born at the family home.

1851

JANUARY 27: René Caillebotte is born.

1853

APRIL 7: Martial Caillebotte, named for his father, is born.

1860

MAY 12: Martial Caillebotte Sr. purchases a country property of more than twenty-seven acres in Yerres, along the river of the same name. The proximity of this house to the river nurtures Gustave's long fascination and association with water and water sports.

1870

JULY 6: Gustave earns his law degree at the age of twenty-two.

JULY 19: France declares war on Prussia. Gustave is called up to serve in the Seine department's national militia. The Yerres property is occupied by the French army. Two small paintings by Gustave capture this; they are early evidence of his interest in painting and, later, in boating.

1873

JANUARY: After a brief stint in the military, Gustave sits for and passes the entry exam for the École nationale et spéciale des Beaux-Arts. The faculty members, each with his own painting school, are Jean-Léon Gérome, Isidore Pils, Alexandre Cabanel, and Adolphe Yvon.

1874

A superstructure is built atop the Paris family house to provide Gustave with an artist's studio.

APRIL 15–MAY 15: The first Impressionist exhibition takes place. Gustave Caillebotte meets Henri Rouart, his neighbor on rue de Lisbonne who was, like himself, born into upper-middle-class society. Edgar Degas, a friend of Rouart's, has a childhood friend, Paul Valpinçon, who is also Caillebotte's third cousin. Degas had intended for Caillebotte to participate in the exhibition. Although this proves impossible, it is undoubtedly on this occasion that Caillebotte meets the members of the group.

DECEMBER 24: Martial Caillebotte Sr. dies at the age of seventy-five. He leaves his wife and children a comfortable fortune that will allow them to face the future without financial worries.

1875

Caillebotte wishes to show at the Salon, but his great masterpiece *The Floor Scrapers* (now at the Musée d'Orsay, Paris) is rejected by the Salon jury.

1876

FEBRUARY: Pierre-Auguste Renoir and Rouart invite Caillebotte to show in the second Impressionist exhibition. Caillebotte accepts and shows eight paintings. In this exhibition—as in the subsequent ones—he not only exhibits his own work but also takes on the role of organizer, spending time and money to make the show a success. Gustave becomes an intimate of the group, many of whom are boating enthusiasts.

NOVEMBER 1: René Caillebotte dies. The tragic, premature loss affects Gustave deeply. Two days later the artist draws up his first will, in which he leaves his collection of Impressionist paintings to the French state. He also leaves money for an 1878 exhibition, which will include the painters Degas, Claude Monet, Renoir, Camille Pissarro, Paul Cézanne, Alfred Sisley, and Berthe Morisot.

Gustave and his brother, Martial, join the Paris sailing club the Cercle de la Voile.

1877

APRIL 4–30: The third Impressionist exhibition takes place. Caillebotte shows six canvases and lends eight paintings from his collection: three by Degas, one by Monet, three by Pissarro, and one by Renoir. It should be noted that Caillebotte is by and large the exhibition organizer, sparing no effort to make it a success: he chooses the painters (only Édouard Manet does not participate), finds and rents the exhibition space, selects the fabrics for the walls, lays out the catalogue, sees to it that the invitations are sent, helps Renoir hang the paintings, and pays for the newspaper advertisements.

1878

Gustave buys his first racing yacht—the *Iris*—and wins his first races. He becomes backer of *Le Yacht*, France's first yachting periodical.

1879

APRIL 10–MAY 11: The fourth Impressionist exhibition takes place. Caillebotte shows twenty-five canvases, plus three ex-catalogue. Ten of his paintings depict river activities (see ill. 128).

The two Caillebotte brothers live together at 31 boulevard Haussmann. The Yerres property is sold.

1880

JANUARY 9: Gustave joins the board of directors of the Paris Cercle de la Voile, becoming one of two vice presidents of the executive committee; Martial is also a prominent member of the club.

MARCH: The Caillebotte brothers enter several regattas at Argenteuil. With Martial at the tiller of *Condor*, Gustave mans the *Inès*.

APRIL 1–10: The fifth Impressionist exhibition takes place. Caillebotte exhibits eleven paintings.

SUMMER: Gustave and Martial win several races in regattas at Le Havre, Trouville, and Fécamp. From then on Gustave races his boats yearly, usually with Martial, in regattas in the open waters off Normandy as well as on the Seine at Argenteuil. Gustave begins designing his own yachts.

1881

MAY 7: Inseparable, the two brothers buy property at Petit-Gennevilliers on the left bank of the Seine, across from Argenteuil and close to the Cercle de la Voile marina. This will facilitate their passion for the water and sailing.

DECEMBER: Gustave is appointed president of the subcommittee of the Société des Régates, the racing club serving the seaside communities of Cabourg on the Normandy coast, including Dives-sur-Mer, Beuzeval, and Houlgate.

1882

MARCH 1–31: The seventh Impressionist exhibition takes place. (The group now calls itself the "Independents.") Caillebotte shows seventeen paintings; among the works known today are three coastal views of Normandy and a fishing scene.

JUNE: The yacht *Jack* is constructed at the boatyard of Texier, Jr., in Argenteuil, from Caillebotte's plans. Caillebotte will design twenty-five sailboats during his lifetime.

1883

Gustave launches the *Cul-Blanc*. Her design innovations include a lead bar attached below the keel (replacing the interior ballast) and sails made of silk. The Caillebotte brothers win numerous regattas with her, both in coastal waters and on the Seine.

1884

At the end of the year a large modern shipyard named Chantier Luce opens at Petit-Gennevilliers, very near Caillebotte's property. The artist is the silent partner, and all his subsequent boats are built there.

1885

The French sailboat-racing community adopts a standardized national handicap rule, called the "Caillebotte rule."

1887

MAY 24: Gustave buys Martial's share of the property they had purchased jointly at Petit-Gennevilliers. Gustave increases his property to more than two and one-half acres.

Gustave's fastest yacht, *Thomas*, is launched. She was designed by Maurice Chevreux, a naval architect and technical manager of the Luce boatyard, and built in a mere six weeks.

1888

WINTER: Gustave makes Petit-Gennevilliers his primary residence, keeping a pied-à-terre in Paris, at 29 boulevard de Rochechouart.

FEBRUARY: Caillebotte shows eight canvases at the fifth exhibition of Les XX, in Brussels; one is a river scene.

MAY 6: Gustave is elected alderman of Petit-Gennevilliers.

MAY 25–JUNE 25: Caillebotte exhibits six canvases in the group show *Impressionist and Post-Impressionist Painters* at Durand-Ruel's Paris gallery; three are water scenes.

SEPTEMBER: Renoir and his companion stay with Caillebotte at his home in Petit-Gennevilliers. For the rest of his life Caillebotte hosts regular gatherings of his close friends from the Impressionist group. The friends meet every month, either in Paris or at Petit-Gennevilliers, to talk of painting, art, and literature, as well as politics, philosophy, and sailing.

Thanks to *Thomas*, the painter becomes the champion yacht racer of 1888 and 1889.

1889

NOVEMBER 5: In a codicil to his will, Gustave confirms his earlier wills, in addition leaving Charlotte Berthier the little house on the Petit-Gennevilliers property that is "presently rented to Monsieur Luce," the boatbuilder for Gustave's boatworks, Chantier Luce.

Following the introduction of a new class of racing yacht with the maximum sail area not to exceed thirty square meters (323 square feet), Gustave produces no fewer than eleven designs for yachts in two years. Among them, *Lézard* and *Roastbeef* are historic models of their kind.

1891

SEPTEMBER 14: Monet asks Caillebotte to lend him a flat-bottomed boat on which he can work and paint.

OCTOBER 30: Gustave, as alderman, opposes a tax on boat moorage space that, in his opinion, would discourage yachting.

1892

MARCH 5: *Le Yacht* announces completion of the yacht *Roastbeef*, built at Chantier Luce.

MARCH 29: Caillebotte writes to Paul Signac, who, like himself, is a great amateur yachtsman, to thank the artist for selecting him to sponsor the yachting association.

1893

Caillebotte and his yacht *Dahud* win eleven of fourteen races.

1894

EARLY FEBRUARY: On behalf of the Paris Cercle de la Voile, which must leave its marina at Argenteuil owing to the construction of a new bridge, Gustave purchases a piece of land in Meulan-en-Yvelines, farther downstream on the Seine.

FEBRUARY 21: Gustave Caillebotte dies of a stroke at his home in Petit-Gennevilliers. Five days later he is buried in the family crypt at Père-Lachaise cemetery in Paris.

MARCH 11: Renoir, Gustave's executor, accompanied by Martial, informs the director of the Beaux-Arts, Henry Roujon, of Gustave's bequest of his collection, comprising some sixty works.

JUNE 4–16: Durand-Ruel holds a Caillebotte retrospective with 122 canvases.

1896

FEBRUARY 26: After much negotiation, the French state agrees to exhibit forty works from Caillebotte's collection at the Musée du Luxembourg. Not until 1929 will these paintings enter the Musée du Louvre, later becoming among the most celebrated holdings of the Musée d'Orsay.

Caillebotte's Legacy

Gustave Caillebotte was long one of the most neglected and least known of the Impressionist painters. While his celebrated bequest introduced Impressionism into the official French museums, it also undermined his own fame. For too long he was considered a patron of the arts rather than a talented painter in his own right. However, today he is recognized both as a great innovator in the art of painting and for his technical and aesthetic innovations in the world of sailing and boat design.

SELECTED BIBLIOGRAPHY

BOOKS AND ARTICLES

Bailly-Herzberg 1972
Bailly-Herzberg, Janine. L'Eau-forte de peintre au dix-neuvième siècle: La Société des Aquafortistes, 1862–1867. 2 vols. Paris: L. Laget, 1972.

Berson 1996
Berson, Ruth. The New Painting: Impressionism, 1874–1886. 2 vols. San Francisco: Fine Arts Museums of San Francisco, 1996.

Blum 2010
Blum, Shirley Neilson. Henri Matisse: Rooms with a View. London: Thames and Hudson, 2010.

Bonaparte 1844
Bonaparte, Louis-Napoléon. De l'extinction du paupérisme. Paris, 1844.

Boswell 1960
Boswell, James. Boswell's Life of Johnson. 2 vols. New York: E. P. Dutton, 1960.

Burty 1862
Burty, Philippe. "Six eaux-fortes, par M. Jongkind." La Chronique des arts et de la curiosité, no. 17 (March 23, 1862): 3.

Cézanne 1976
Paul Cézanne: Letters. Edited by John Rewald. 4th ed. Oxford: Bruno Cassirer, 1976.

Charles 1980
Charles, Daniel. Le yachting, une histoire d'hommes et de techniques. Paris: Éditions maritimes et d'outre-mer, 1980.

Charles 1994
Charles, Daniel. Le Mystère Caillebotte—l'oeuvre architecturale de Gustave Caillebotte, peintre impressionniste, jardinier, philatéliste et régatier. Grenoble: Glénat, 1994.

Charles 1998
Charles, Daniel. Histoire du yachting. Paris: Arthaud, 1998.

Clark 1985
Clark, T. J. The Painting of Modern Life. Paris in the Art of Manet and His Followers. London: Thames and Hudson, 1985.

Constable 1970
Constable, John. "The History of Landscape Painting." In John Constable's Discourses. Edited by R. B. Beckett. Ipswich, UK: Suffolk Records Society, 1970.

Darien 1897
Darien, Georges. Le Voleur. Paris: Stock, 1897.

Distel 1990
Distel, Anne. Impressionism: The First Collectors. New York: Harry N. Abrams, 1990.

Eitner 1955
Eitner, Lorenz. "The Open Window and the Storm-Tossed Boat: An Essay in the Iconography of Romanticism." Art Bulletin 37 (1955): 281–90.

Flam 1986
Flam, Jack. Matisse: The Man and His Art, 1869–1918. London: Thames and Hudson, 1986.

Flam 1995
Flam, Jack. Matisse on Art. Berkeley: University of California Press, 1995.

Flaubert 1975
Flaubert, Gustave. Sentimental Education. Translated by Robert Baldick. Harmondsworth, UK: Penguin Books, 1975.

Fowle 2010
Fowle, Frances. Van Gogh's Twin: The Scottish Art Dealer Alexander Reid. Edinburgh: National Galleries of Scotland, 2010.

Frèches-Thory and Terrasse 1991
Frèches-Thory, Claire, and Antoine Terrasse. The Nabis: Bonnard, Vuillard, and Their Circle. New York: Harry N. Abrams, 1991.

Frey 1994
Frey, Julia. Toulouse-Lautrec: A Life. New York: Viking, 1994.

Guichet 2002
Guichet, Nicolas. "Les clippers de Seine (1847–1887)." Le Chasse-Marée, no. 155 (October 2002): 36–51.

Hamerton 1864
Hamerton, Philip Gilbert. "Modern Etching in France." Fine Arts Quarterly Review 2 (January–May 1864): 87–88.

Herbert 1988
Herbert, Robert. Impressionism: Art, Leisure, and Parisian Society. New Haven and London: Yale University Press, 1988.

Herbert 1994
Herbert, Robert. Monet on the Normandy Coast: Tourism and Painting, 1867–1886. New Haven and London: Yale University Press, 1994.

Herbert 2001
Herbert, Robert. "An Anarchist's Art." New York Review of Books (December 20, 2001): 20–25.

House 2004
House, John. Impressionism: Paint and Politics. New Haven and London: Yale University Press, 2004.

Jacquin 1845
Jacquin, Jules. Manuel universel et raisonné du canotier. Paris: Dauvin et Fontaine, 1845.

Judt 2010
Judt, Tony. "The Glory of the Rails." New York Review of Books (December 23, 2010): 60–61.

Judt 2011
Judt, Tony. "Bring Back the Rails!" New York Review of Books (January 1, 2011): 34–35.

Karr 1858
Karr, A., et al. Le Canotage en France. Paris: Taride, 1858.

Lécureur 2009
Lécureur, Michel. Dans les pas de Guy de Maupassant. Cully, France: Orep Editions, 2009.

Lloyd 1986
Lloyd, Christopher. "Camille Pissarro and Rouen." In Studies on Camille Pissarro, edited by Christopher Lloyd. London and New York: Routledge and Kegan Paul, 1986.

Mainardi 1989
Mainardi, Patricia. Art and Politics of the Second Empire: The Universal Expositions of 1855 and 1867. New Haven and London: Yale University Press, 1989.

Mainardi 1994
Mainardi, Patricia. The End of the Salon: Art and the State in the Early Third Republic. Cambridge and New York: Cambridge University Press, 1994.

Maupassant 2004
Maupassant, Guy de. A Parisian Affair and Other Stories. Translated by Sîan Miles. London: Penguin Books, 2004.

Maupassant 2008
Maupassant, Guy de. Afloat. Translated by Douglas Parmée. New York: New York Review of Books, 2008.

Maupassant 2009
Maupassant, Guy de. A Day in the Country and Other Stories. Translated by David Coward. Oxford: Oxford University Press, 2009.

Melot 1978
Melot, Michel. L'œuvre gravé de Boudin, Corot, Daubigny, Dupré, Jongkind, Millet, Théodore Rousseau. Paris: Arts et Métiers Graphiques, 1978.

Monet 1900
Monet, Claude. "Mon histoire." Collected by Thiébault-Sisson. Le Temps (November 26, 1900).

Perruchot 1962
Perruchot, Henri. Toulouse-Lautrec. Translated by Humphrey Hare. London: Readers Union, 1962.

Price 2010
Price, Aimee Brown. Pierre Puvis de Chavannes. 2 vols. New Haven and London: Yale University Press, 2010.

Rewald 1946 [1973]
Rewald, John. The History of Impressionism. 4th ed. New York: Museum of Modern Art, 1973.

Rewald 1989
Rewald, John. Cézanne and America: Dealers, Collectors, Artists, and Critics, 1891–1921. London: Thames and Hudson, 1989.

Rewald and Weitzenhoffer 1984
Rewald, John, and Frances Weitzenhoffer. Aspects of Monet: A Symposium on the Artist's Life and Times. New York: Harry N. Abrams, 1984.

Robb 2007
Robb, Graham. The Discovery of France. London: Picador, 2007.

Saint-Simon 1802
Saint-Simon, Henri de. Lettres d'un habitant de Genève à ses contemporains. Paris, 1802.

Savoye 1958
Savoye, Jean. "Les Temps héroïques." In Cercle de la Voile de Paris, 1858–1958. Privately printed, 1958.

Schapiro 1997
Schapiro, Meyer. Impressionism: Reflections and Perceptions. New York: George Braziller, 1997.

Smith 1995
Smith, Paul. Impressionism beneath the Surface. New York: Harry N. Abrams, 1995.

Smith 1997
Smith, Paul. Seurat and the Avant-Garde. New Haven and London: Yale University Press, 1997.

Spurling 1998
Spurling, Hilary. The Unknown Matisse; A Life of Henri Matisse, Volume One; 1869–1908. London: Hamish Hamilton, 1998.

Sueur-Hermel 2009
Sueur-Hermel, Valérie. Henri Rivière: Entre impressionnisme et japonisme. Paris: Bibliothèque nationale de France, 2009.

Thomson (B.) 1983
Thomson, Belinda. The Post-Impressionists. Oxford: Phaidon, 1983.

Thomson (B.) 2000
Thomson, Belinda. Impressionism: Origins, Practice, Reception. London: Thames and Hudson, 2000.

Thomson (R.) 1985
Thomson, Richard. Seurat. Oxford: Phaidon, 1985.

Thomson (R.) 1998
Thomson, Richard. Framing France: The Representation of Landscape in France, 1870–1914. Manchester and New York: Manchester University Press, 1998.

Tucker 1982
Tucker, Paul Hayes. Monet at Argenteuil. New Haven and London: Yale University Press, 1982.

Tucker 1995
Tucker, Paul Hayes. Claude Monet: Life and Art. New Haven and London: Yale University Press, 1995.

Ward 1991
Ward, Martha. "Impressionist Installations and Private Exhibitions." Art Bulletin 73 (1991): 599–622.

Weitzenhoffer 1986
Weitzenhoffer, Frances. The Havemeyers: Impressionism Comes to America. New York: Harry N. Abrams, 1986.

Whitfield 1991
Whitfield, Sarah. Fauvism. London: Thames and Hudson, 1991.

Zola 2004
Zola, Émile. Thérèse Raquin. Translated by Robin Buss. London: Penguin Books, 2004.

EXHIBITION CATALOGUES

Amsterdam 1986
Boyle-Turner, Caroline. The Prints of the Pont-Aven School: Gauguin and His Circle in Brittany. Washington, DC: Smithsonian Institution Traveling Exhibition Service, 1986. Exhibition at the Rijksmuseum, Amsterdam, and eleven other venues.

Amsterdam 1991
Boyer, Patricia Eckert, and Phillip Dennis Cate. L'Estampe originale: Artistic Printmaking in France, 1893–1895. Amsterdam: Van Gogh Museum, 1991.

Atlanta/Seattle/Denver 1999
Dumas, Ann, et al. Impressionism: Paintings Collected by European Museums. Atlanta: High Museum of Art; Seattle: Seattle Art Museum; Denver: Denver Art Museum, 1999.

Atlanta/Minneapolis 2000
Dumas, Ann, and David A. Brenneman. Degas and America: The Early Collectors. Atlanta: High Museum of Art; Minneapolis: Minneapolis Institute of Arts, 2000.

Atlanta/Denver/Seattle 2007
Dumas, Ann, ed. Inspiring Impressionism: The Impressionists and the Art of the Past. Denver: Denver Art Museum, 2007. Exhibition also at the High Museum of Art, Atlanta, and the Seattle Art Museum.

Boston 1984
Murphy, Alexandra R. Jean-François Millet. Boston: Museum of Fine Arts, 1984.

Boston/Chicago/London 1989
Tucker, Paul Hayes. Monet in the '90s: The Series Paintings. Boston: Museum of Fine Arts, 1989. Exhibition also at the Art Institute of Chicago and the Royal Academy of Arts, London.

Boston/London 1998
Tucker, Paul Hayes. *Monet in the 20th Century*. Boston: Museum of Fine Arts; London: Royal Academy of Arts, 1998.

Bremen/Copenhagen/Madrid 2008
Fonsmark, Anne-Birgitte, et al. *Gustave Caillebotte*. Ostfildern, Germany: Hatje Cantz, 2008. Exhibition at the Kunsthalle Bremen, the Ordrupgaard, Copenhagen, and the Museo Thyssen-Bornemisza, Madrid.

Chicago/Amsterdam/London 1994
Druick, Douglas D., et al. *Odilon Redon: Prince of Dreams, 1840–1916*. Chicago: Art Institute of Chicago; Amsterdam: Van Gogh Museum; London: Royal Academy of Arts, 1994.

Cleveland/Amsterdam 2009
Lemonedes, Heather, et al. *Paul Gauguin: The Breakthrough into Modernity*. Cleveland: Cleveland Museum of Art; Amsterdam: Van Gogh Museum, 2009.

Edinburgh 1986
Clarke, Michael. *French Impressionism and Its Origins: Lighting Up the Landscape*. Edinburgh: National Galleries of Scotland, 1986.

Edinburgh 1994
Thomson, Richard. *Monet to Matisse: Landscape Painting in France, 1874–1914*. Edinburgh: National Galleries of Scotland, 1994.

Edinburgh 2008
Fowle, Frances. *Impressionism and Scotland*. Edinburgh: National Galleries of Scotland, 2008. Exhibition also at the Kelvingrove Art Gallery and Museum, Glasgow.

London 1997
Leighton, John, and Richard Thomson. *Seurat and the Bathers*. London: National Gallery, 1997.

London 2012
Gallagher, Ann. *Damien Hirst*. London: Tate Publishing, 2012.

London/Amsterdam/Williamstown 2000
Brettell, Richard R. *Impressionism: Painting Quickly in France, 1860–1890*. Williamstown, MA: Sterling and Francine Clark Art Institute, 2000. Exhibition also at the National Gallery, London, and the Van Gogh Museum, Amsterdam.

London/Boston 1995
House, John. *Landscapes of France: Impressionism and Its Rivals*. London: Hayward Gallery, South Bank; Boston: Museum of Fine Arts, 1995.

London/Paris/Baltimore 1992
Stevens, MaryAnne, ed. *Alfred Sisley*. London: Royal Academy of Arts; Paris: Musée d'Orsay; Baltimore: Walters Art Gallery, 1992.

Los Angeles/Chicago/Paris 1984
Belloli, Andrea P. A., ed. *A Day in the Country: Impressionism and the French Landscape*. Los Angeles County Museum of Art, 1984. Exhibition also at the Art Institute of Chicago and the Galeries nationales d'exposition du Grand Palais, Paris.

New York 2011
Rewald, Sabine. *Rooms with a View: The Open Window in the Nineteenth Century*. New York: The Metropolitan Museum of Art, 2011.

Paris 2000
Cachin, Françoise. *Mediterranée: De Courbet à Matisse*. Paris: Galeries nationales du Grand Palais, 2000.

Paris 2011
Dixmier, Michel, and Henri Viltard. *Jossot: Caricatures de la révolte à la fuite en Orient, 1866–1951*. Paris: Bibliothèque Forney, 2011.

Paris/Amsterdam/New York 2001
Ferretti-Bocquillon, Marina, et al. *Signac, 1863–1935*. Paris: Galeries nationales du Grand Palais; Amsterdam: Van Gogh Museum; New York: The Metropolitan Museum of Art, 2001.

Paris/London 1975
Herbert, Robert. *Jean-François Millet*. Paris: Galeries nationales d'exposition du Grand Palais; London: Hayward Gallery, South Bank, 1975.

Paris/Montpellier 2011
Ripetti, Rodolphe. *Odilon Redon: Prince du Rêve, 1840–1916*. Paris: Musée d'Orsay, 2011. Exhibition also at the Musée Fabre, Montpellier.

Paris/New York 1994
Tinterow, Gary, and Henri Loyrette. *Origins of Impressionism*. New York: The Metropolitan Museum of Art, 1994. Exhibition also at the Galeries nationales du Grand Palais, Paris.

Michigan/Dallas 2009
McNamara, Carole, et al. *The Lens of Impressionism: Photography and Painting along the Normandy Coast, 1850–1874*. Ann Arbor: University of Michigan Museum of Art, 2009. Exhibition also at the Dallas Museum of Art.

Washington 1996
Rathbone, Eliza E., et al. *Impressionists on the Seine: A Celebration of Renoir's "Luncheon of the Boating Party."* Washington, DC: Phillips Collection, 1996.

Washington/Hartford 2000
Tucker, Paul Hayes. *The Impressionists at Argenteuil*. Washington, DC: National Gallery of Art; Hartford: Wadsworth Atheneum Museum of Art, 2000.

Washington/Worcester/Chapel Hill 1982
Grad, Bonnie Lee, and Timothy A. Riggs. *Visions of City and Country: Prints and Photographs of Nineteenth-Century France*. Worcester, MA: Worcester Art Museum, 1982. Exhibition also at the National Gallery of Art, Washington, DC, and Ackland Art Museum, University of North Carolina, Chapel Hill.

Washington/San Francisco 1986
Moffett, Charles S. *The New Painting: Impressionism, 1874–1886*. San Francisco: Fine Arts Museums of San Francisco, 1986. Exhibition also at the National Gallery of Art, Washington, DC.

CATALOGUES RAISONNÉS

A note to the reader: Because titles of these artists' works often vary among institutions and private collections, this volume provides catalogue raisonné numbers (in parentheses) for illustrated paintings and works on paper. Please see below for the key to the cited catalogues raisonnés.

Paintings

DM
Émile Henri Bernard
Morane, Daniel. *Émile Bernard: Catalogue raisonné de l'oeuvre grave*. Paris: Musée Pont-Aven, 2000.

MB
Gustave Caillebotte
Berhaut, Marie. *Gustave Caillebotte: Catalogue raisonné des peintures et pastels*. Paris: Wildenstein Institute, 1994.

JR
Paul Cézanne
Rewald, John. *The Paintings of Paul Cézanne: A Catalogue Raisonné*. New York: Harry N. Abrams, 1996.

AR
Jean-Baptiste-Camille Corot
Robaut, Alfred. *L'Oeuvre de Corot: Catalogue raisonné et illustré, précédé de l'histoire de Corot et de ses oeuvres, par Étienne Moreau-Nélaton*. Paris: L. Laget, 1965.

RH
Charles-François Daubigny
Hellebranth, Robert. *Charles-François Daubigny: 1817–1878*. Morges, Switzerland: Matute, 1996.

PC
Maurice Denis
Cailler, Pierre. *Catalogue raisonné de l'oeuvre gravé et lithographié de Maurice Denis*. Geneva: Éditions Pierre Cailler, 1968.

MK
André Derain
Kellermann, Michel. *André Derain: Catalogue raisonné de l'oeuvre peint*. Paris: Editions Galerie Schmit, 1992.

R&W
Édouard Manet
Rouart, Denis, and Daniel Wildenstein. *Édouard Manet: Catalogue raisonné*. Lausanne, Switzerland: Bibliotheque des arts, 1975.

D&C
Henri Matisse
Deryng, Xavier, and Massimo Carra. *Tout l'oeuvre peint de Matisse: 1904–1928*. Paris: Flammarion, 1982.

DW
Claude Monet
Wildenstein, Daniel. *Monet: Or the Triumph of Impressionism*. Paris: Wildenstein Institute, 1996.

P&D-RS
Camille Pissarro
Pissarro, Joachim, and Claire Durand-Ruel Snollaerts. *Pissarro: Critical Catalogue of Paintings*. Paris: Wildenstein Institute Publications, 2005.

AP
Pierre Puvis de Chavannes
Price, Aimée Brown. *Pierre Puvis de Chavannes*. New Haven and London: Yale University Press, 2010.

AW
Odilon Redon
Wildenstein, Alec. *Odilon Redon: Catalogue raisonné de l'oeuvre peint et desinné*. Paris: Wildenstein Institute, 1992.

G-P&MD
Pierre-August Renoir
Dauberville, Guy-Patrice, and Michel Dauberville. *Renoir: Catalogue raisonné des tableaux, pastels, dessins, et aquarelles*. Paris: Éditions Bernheim-Jeune, 2007.

RF
Théo (Théophile) van Rysselberghe
Feltkamp, Ronald. *Théo van Rysselberghe: Monographie et catalogue raisonné*. Paris: Editions de l'Amateur, 2003.

D&R
Georges Seurat
Dorra, Henri, and John Rewald. *Seurat*. Paris: Les Beaux-arts, 1959.

FC
Paul Signac
Cachin, Françoise. *Signac: Catalogue raisonné de l'oeuvre peint*. Paris: Gallimard, 2000.

FD
Alfred Sisley
Daulte, François. *Alfred Sisley: Catalogue raisonné de l'oeuvre peint*. Lausanne, Switzerland: Durand-Ruel, 1959.

MD
Henri de Toulouse-Lautrec
Dortu, M.G. *Toulouse-Lautrec et son oeuvre*. New York: Collector's Edition, 1971.

VB&S
Maurice de Vlaminck
Vallès-Bled, Maïthé, and Timothy Stroud. *Vlaminck: Catalogue critique des peintures et céramiques de la période fauve*. Paris: Wildenstein Institute, 2008.

S&C
Édouard Vuillard
Salomon, Antoine, and Guy Cogeval. *Vuillard: The Inexhaustible Glance: Critical Catalogue of Paintings and Pastels*. Paris: Wildenstein Institute, 2003.

Works on Paper

B
Félix Bracquemond
Beraldi, Henri. *Les Graveurs du XIXe siècle, guide de l'amateur d'estampes modernes*. Paris: Librairie L. Conquet, 1885–1892.

MD
Charles-François Daubigny
Melot, Michel. *Graphic Art of the Pre-Impressionists*. Translated by Robert Erich Wolf. New York: Harry N. Abrams, 1981.

CD
Maurice Denis
Cailler, Pierre. *Catalogue raisonné de l'oeuvre gravé et lithographié de Maurice Denis*. Geneva: Editions Pierre Cailler, 1968.

CI
Eugène Isabey
Curtis, Atherton. *Catalogue de l'oeuvre lithographié de Eugène Isabey*. Paris: Paul Prouté, 1939.

MJ
Johan Barthold Jongkind
Melot, Michel. *Graphic Art of the Pre-Impressionists*. Translated by Robert Erich Wolf. New York: Harry N. Abrams, 1981.

V
Maxime Lalanne
Villet, Jeffrey M. *Etchings of Maxime Lalanne: A Catalogue Raisonné*. Washington, DC: King, 2003.

H
Édouard Manet
Harris, Jean C. *Édouard Manet Graphic Works: A Definitive Catalogue Raisonné*. New York: Collector's Editions, 1970.

K-W
Paul Signac
Kornfeld, Eberhard W., and Peter A. Wick. *Catalogue raisonné de l'oeuvre gravé et lithographié de Paul Signac*. Berne, Switzerland: Kornfeld and Klipstein, 1974.

W-K
Henri de Toulouse-Lautrec
Wittrock, Wolfgang. *Toulouse-Lautrec: The Complete Prints*. Edited by Catherine E. Kuehn. London: For Sotheby's Publications by P. Wilson Publishers; New York: Harper & Row, 1985.

ACKNOWLEDGMENTS

The Fine Arts Museums of San Francisco wish to thank our President of the Board of Trustees, Diane B. Wilsey, who brought together this exhibition and publication. Dr. Lynn Federle Orr and Melissa Buron, Assistant Curator of European Paintings, shepherded this project through various stages. Also at the Fine Arts Museums, Richard Benefield, Deputy Director; Michele Gutierrez-Canepa, Chief Administrative Officer and Chief Financial Officer; and Julian Cox, Founding Curator of Photography and Chief Administrative Curator, are thanked for their myriad contributions.

The Fine Arts Museums also extend their gratitude to the exhibition's three guest curators: Phillip Dennis Cate, Daniel Charles, and Christopher Lloyd. Their individual and combined expertise has brought this project to fruition and has extended the scholarship on this important subject. Thanks are also given to Gilles Chardeau for his assistance and for sharing his knowledge of Gustave Caillebotte's life.

A special mention goes to Leslie Dutcher, Director of Publications, who oversaw this beautiful book with the assistance of Danica Hodge, Editor; Lucy Medrich, Associate Editor; and Diana Murphy; and with the early help of the Museums' former Director of Publications, Karen A. Levine. Thanks are also given to Elisa Urbanelli for her fine editing, to Roy Brooks for his elegant design, to Alexandra Bonfante-Warren for her expert translations, and to Margaret Rennolds Chace at Skira Rizzoli for her care toward the many publishing details. At Rizzoli we also thank Charles Miers, Publisher; Maria Pia Gramaglia, Production Director; and Kayleigh Jankowski, Design Coordinator. The book is published with the generous assistance of the Andrew W. Mellon Foundation Endowment for Publications.

Appreciation is further given to the Museums' exhibitions team: Krista Brugnara, Director of Exhibitions; Therese Chen, Director of Collections Management; Bill White, Exhibition Designer; Bill Huggins, Lighting Designer; Juliana Pennington, Senior Graphic Designer; Elise Effmann Clifford, Head Paintings Conservator; and Craig Harris, Manager of Installation and Preparation. Hilary Magowan, Exhibitions Coordinator, has capably and perceptively overseen the formulation of both the exhibition checklist and publication details. Suzy Peterson, Executive Assistant for the Art Division, gracefully managed the checklists and loan paperwork. Our further thanks go to the members of the Museums' extended staff, who create the solid foundation for all of our efforts, and to the Peabody Essex Museum for their partnership. Finally we acknowledge our late Director of Museums, John E. Buchanan, Jr., for recognizing the importance of this project and for having the vision to present it at the time of the America's Cup in San Francisco.

The exhibition is supported by an indemnity from the Federal Council on the Arts and the Humanities. The Museums are also grateful to the many lenders to our exhibition for sharing their artworks with us. Gratitude is further given to the early patronage of Mrs. George F. Jewett, Major Patron; and the Estate of Donald Casey and the Lois E. Kalb Trust.

PICTURE CREDITS

Published by the Fine Arts Museums of San Francisco and Skira Rizzoli Publications, Inc., on the occasion of the exhibition *Impressionists on the Water* on view at the Legion of Honor Museum, San Francisco, from June 1 to October 6, 2013 and at the Peabody Essex Museum, Salem, Massachusetts, from November 9, 2013 to February 9, 2014.

Impressionists on the Water is organized by the Fine Arts Museums of San Francisco.

MAJOR PATRON
Mrs. George F. Jewett

Generous support is also provided by the Estate of Donald Casey and the Lois E. Kalb Trust.

The catalogue is published with the assistance of the Andrew W. Mellon Foundation Endowment for Publications.

The exhibition is supported by an indemnity from the Federal Council on the Arts and the Humanities.

Library of Congress Catalog Control Number: 2013932085

ISBN 978-0-8478-4025-0 (hardcover)
ISBN 978-0-8478-4037-3 (paperback)

Cover image:
Claude Monet
The Port at Argenteuil (Le bassin d'Argenteuil), 1872
(detail, ill. 106)

pp. 2–3:
Gustave Caillebotte
Skiffs on the Yerres (Périssoires sur l'Yerres), 1877
(detail, ill. 128)

p. 4:
Pierre-Auguste Renoir
Seine at Argenteuil (The Sails) (La Seine à Argenteuil [les voiles]), 1875
(detail, ill. 121)

p. 6:
Claude Monet
Boats Moored at Le Petit-Gennevilliers (Barques au repos, au Petit-Gennevilliers) (traditionally Sailboats on the Seine), 1874
(detail, ill. 107)

p. 8:
Claude Monet
Regatta at Sainte-Adresse (Les régates à Sainte-Adresse), 1867
(detail, ill. 20)

p. 42:
Johan Barthold Jongkind
The Estacade Bridge, Paris, 1853
(detail, ill. 48)

p. 76:
Eugène Isabey
Fishing Boats in a Stormy Sea (Bateaux de pêche dans une mer agitée), 1830
(detail, ill. 74)

Picture credits appear on page 223.

First published in the United States of America in 2013 by

Skira Rizzoli Publications, Inc.
300 Park Avenue South
New York, NY 10010
www.rizzoliusa.com

in association with

Fine Arts Museums of San Francisco
Golden Gate Park
50 Hagiwara Tea Garden Drive
San Francisco, CA 94118-4502
www.famsf.org

For the Fine Arts Museums of San Francisco:
Leslie Dutcher, Director of Publications
Danica Hodge, Editor
Lucy Medrich, Associate Editor

For Skira Rizzoli Publications, Inc.:
Margaret Rennnolds Chace, Associate Publisher

Edited by Elisa Urbanelli
Translated text by Alexandra Bonfante-Warren
Designed by Roy Brooks, Fold Four, Inc.
Color separations by Professional Graphics, Inc., Rockford, Ill.

2013 2014 2015 2016 / 10 9 8 7 6 5 4 3 2 1

Printed in Italy